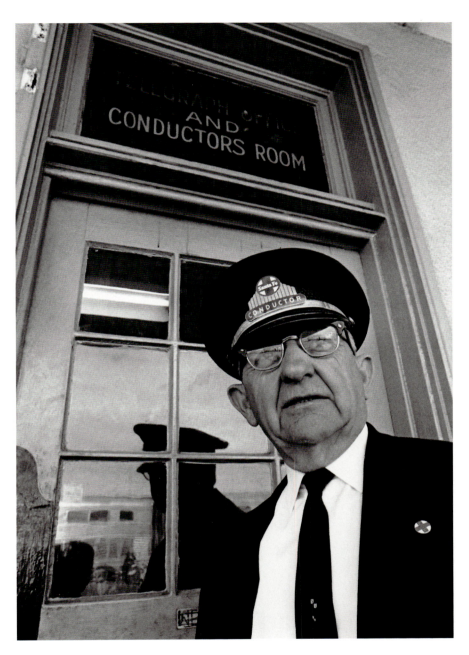

To be a good journalist,
I have to be the best artist that I can…
I find absolutely no conflict between the two.

W. Eugene Smith

· MASTERS OF ·

1

RAILROAD PHOTOGRAPHY SERIES

ONE TRACK MIND

PHOTOGRAPHIC ESSAYS ON WESTERN RAILROADING

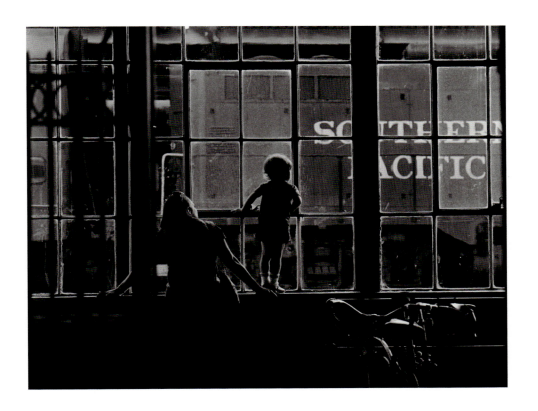

TED BENSON

The BOSTON
MILLS PRESS

Cataloguing in Publication Data
Benson, Frederick W., 1948-
One track mind: photographic essays on Western railroading
(Masters of railroad photography)
ISBN 1-55046-273-3

1. Railroads – West (U.S.). 2. Railroads – West (U.S.)
– Pictorial works. I. Title. II. Series.

TF23.6.B46 2000

03 02 01 00 99 1 2 3 4 5

Masters of Railroad Photography Series editor, Greg McDonnell

Published in 1999 by Boston Mills Press
132 Main Street, Erin, Ontario, Canada N0B 1T0
Tel: 519-833-2407 Fax: 519-833-2195
e-mail: books@bostonmillspress.com www.bostonmillspress.com

An affiliate of Stoddart Publishing Co. Limited
34 Lesmill Road, Toronto, Ontario, Canada M3B 2T6
Tel: 416-445-3333 Fax: 416-445-5967
e-mail: gdsinc@genpub.com

Distributed in Canada by General Distribution Services Ltd.
325 Humber College Blvd, Toronto, Canada M9W 7C3
Orders: 1-800-387-0141 Ontario & Quebec
Orders: 1-800-387-0172 NW Ontario & other provinces
Fax: 416-213-1917 customer.service@ccmail.gw.genpub.com
EDI Canadian Telebook S1150391

Distributed in the United States by General Distribution Services Inc.
85 River Rock Drive, Suite 202, Buffalo, New York 14207-2170
Toll-free: 1-800-805-1083 Toll-free fax: 1-800-481-6207
e-mail: gdsinc@genpub.com www.genpub.com
PUBNET 6307949

Book design by Chris McCorkindale and Sue Breen
McCorkindale Advertising & Design

Printed in Hong Kong, China by
Book Art Inc., Toronto

THE CANADA COUNCIL | LE CONSEIL DES ARTS
FOR THE ARTS | DU CANADA
SINCE 1957 | DEPUIS 1957

*We acknowledge for their financial support of our publishing
program the Canada Council, the Ontario Arts Council, and
the Government of Canada through the Book Publishing
Industry Development Program (BPIDP).*

Front Dust Jacket: *Sundown at Chinese*. The last light of a balmy spring afternoon silhouettes a pair of Sierra Railroad Baldwins as 2-8-0 No. 28 and Mikado No. 34 double-head an excursion train back to Jamestown, California (page 167). April 24, 1974.

Page One: *Conductor Dewey and Number One*. Ten days away from its final run, Santa Fe's *San Francisco Chief* pauses outside the telegraph office at Richmond, California. His days in blue serge equally numbered, conductor H. C. Dewey ponders the onset of Amtrak and its conspicuous absence from the San Joaquin Valley. April 20, 1971.

Page Three: *A New Generation of Railfans*. Trainwatching on the eve of CalTrain's assumption of Southern Pacific's Peninsula Service brings a mother and son down to the depot in San Jose, California, where engine 3189 awaits the 8 p.m. departure of Train 65 for San Francisco (page 148). June 4, 1985.

Page Five: *Muscle Machines at Seventh Street*. Southern Pacific passenger power rests between Peninsula Service assignments at the San Francisco engine terminal. April 2, 1973.

Page 176: *Sunset on the Santa Fe*. Monsoon season produces an atmospheric end to the day east of Needles, California. September 10, 1973.

Rear Dust Jacket: *Warbonnets on Tehachapi*. Santa Fe Extra 850 East, the 952 train featuring boxcars of wine for Eastern markets, approaches Tunnel Two above Caliente, California, behind four sparkling new General Electric DASH8-40CW units (page 86). June 16, 1992.

Publishing Notes

"Out Where a Train Is a Train" and "Her Spirit Will Never Die" are excerpted from articles in the March 1966 and January 1973 issues of *Trains* Magazine. None of their editorial content is reproduced in this publication. "The Railroad of My Father's Youth" is abridged from the May 1982 issue of *Trains*. All copyrighted material is used with the gracious permission of *Trains* editor Kevin P. Keefe and Kalmbach Publishing Company. Additional research for this book was provided by Mark Acuna, Greg Brown, Brian Curnow, Michael Pechner, David Stanley and Eugene Vicknair.

Technical Notes

The photographs for *One Track Mind* were made with Kodak Plus-X, Tri-X and Verichrome Pan films using Hasselblad, Mamiya, Nikon, Pentax and Yashica cameras in 35mm and 120 formats. Enlargements were printed on Ilford Multigrade IV and Kodak Polymax resin-coated papers using an Omega D-2V enlarger equipped with Ilfospeed variable-contrast lamphead. All negatives and prints were processed by the photographer. Goudy is used for the titles and body type in *One Track Mind*. Captions are set in Trade Gothic Condensed.

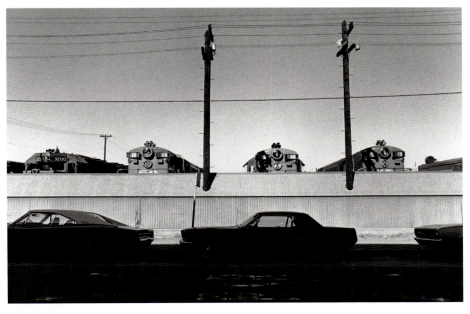

Muscle Machines at Seventh Street—4/2/73

CONTENTS

"YOU DIDN'T EVEN NEED A CAMERA"

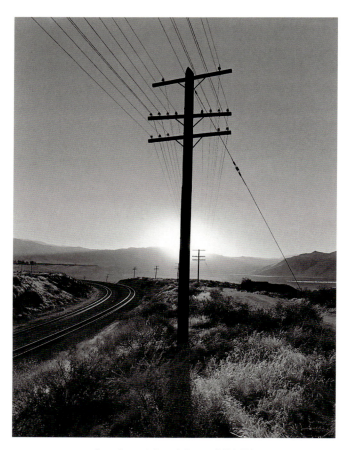

Sunrise at Sand Cut—9/10/96

"One Track Mind." That's a clever title for a book of railroad photography, and I can see why Ted would enjoy it. But those three words definitely do not describe Ted Benson.

Railroading is a wonderful world of technology and geography and humanity. To some it's nuts and bolts and the number of louvers on the car body of a Sacramento-rebuilt SD9E. To others, it's a 2-mile-long stack train rendered miniscule by a desert with a mountain backdrop. And to a few, it's the quiet moments in a weather-beaten interlocking tower as a night-weary operator contemplates job obsolescence at age 34.

Railroading is constant change tinged by an ongoing sense of loss. The future never seems to be quite as intriguing as the past, and elements of stability, class and quality are being left behind by soul-less corporations run by lawyers with all the permanence of a cursor on a computer screen. Two quick clicks and everything is gone.

It takes a Ted Benson to see and interpret and preserve the passing scene in both words and pictures. That is not a task for a person with a one track mind. It requires a well-rounded human being who participates in life even

as he absorbs and records it. It was Ted's distinctive black-and-white photography that attracted my attention 20 years ago, but it wasn't until I met him and had a chance to spend some time with him lineside that I began to appreciate the breadth and depth of his personality.

He was not what I had anticipated. He was tall and gangly with a head of hair left over from a Haight-Ashbury pot party (page 175.) He spoke with a quietly relaxed voice in what would have been a drawl in any place other than California. He carried himself with an easy confidence and an almost self-deprecating shyness. He radiated a street-smart wisdom without an in-your-face attitude. On our first outing along the Sierra Railroad, I managed to snap myself in the crotch as I climbed over a barbed-wire fence, uttering the immortal word "Aaargh!"

Ted looked around calmly and observed, "More the 'Aaack!' side of 'Aaargh!'" That's when we realized that we were both fans of Bill the Cat from the *Bloom County* comic strip. I don't trust anyone who doesn't read the funnies.

Ted reads the funnies and listens to Bruce Springsteen music and can tell an SD70MAC from an AC4400CW at a glance. In railroading, he has a reverence for both the detail and the overall drama—without overlooking the human element.

When it comes to photography, Ted is a versatile craftsman, able to summon up the right equipment and approach for any situation. That kind of background does not come easily. It requires years of darkroom time and the discipline of black and white, where only a true understanding of light yields consistent results. Just as a musician must master his instrument before he can create credible sound (don't tell that to Neil Young), Ted had to master the mundane before he could use it to capture the fleeting images of his reality.

And "versatile" is a good word to sum up his talents with a camera. While many Dick Steinheimer wannabees are forever trying to mash more and more silhouetted and glinted SD45's into a telephoto-compressed frame, Ted is all over the place with heavy glass and the light touch of a 20mm wide angle, capturing people and their machines in an amazing range of tones and shapes. And Ted honors the mastery of the living legends such as Stein, who pioneered the "Western" style of rail photography.

The photos and words that are included between these covers speak for themselves. I have long regarded Ted Benson as the best living photographer in the rail photo hobby field. And one of the reasons for it is the way he has integrated his avocation into a "real" life. He has been happily married for 29 years to a very remarkable woman, Liz, and has two daughters, Amy and Jessica.

One of the unexpected pleasures of being considered a friend by Ted Benson is being included on his Christmas card list. Ted's Christmas messages are always worth reading. Through them I was able to share the joy of Amy's birth from 3,000 miles away. And as he turned 50, in 1998, Ted communicated the pangs and pride of a parent watching his offspring leave the nest. As Amy reflects on Jessica's influence: "She made me believe in myself...take responsibility for my actions, reach for the stars...and never give up." Kids like that are not the product of absentee parents.

While his photography requires time and travel, Ted keeps that balanced with his home life. His 1998 Christmas letter included these lines, sentiments that directly apply to his work and the book you hold in your hands:

"Too much of the time has been measured by outrageously long hours pursuing dreams that ultimately wind up on a dusty bookshelf. If anyone deserves a lifetime achievement award, it's Liz. She's shared her life with a

perpetual dreamer and put up with more flights of fancy than any woman should have to endure…"

The love and support of Liz and the girls is evident in the personality and work of a man who can see the world of railroading in all its infinitely varied moods and capture those images for others to share. What sets Ted apart from other competent and even brilliant photographers is his ability to mix visuals with written images.

How do you say goodbye to a lifelong friend like the Southern Pacific Company? Benson did it by spending the last day before its merger into the Union Pacific photographing the Espee at one of his favorite haunts: Tehachapi Loop.

He prepared an article for *Railfan & Railroad* depicting that day, September 10, 1996. "A Typical Tehachapi Tuesday" included Ted's black-and-white photos and thumbnail layouts of how he wanted the article arranged —when you're offered "suggestions" from someone with Ted's talents, it behooves an editor to pay attention.

He introduced the subject with some Springsteen lyrics and went through the last 24 hours of the Southern Pacific's corporate history as it played out on Tehachapi's legendary mountain stage. Fifteen minutes before midnight, hammering north toward Modesto in his trusty Ford van, he began to overtake a westbound freight. His "last picture" of the SP had been nearly four hours earlier, of this same train at Bakersfield. What followed was Benson at his finest, with his cameras buried out of reach in the dark.

In his words:

"This was no time for sweet country music on the radio. With three hours sleep in the past 48, I needed a strong dose of rock 'n' roll. That favorite old tape from 1984 is back in the tape deck, filled with pearls from Springsteen, Mellencamp, Steve Miller and Little Steven. I'm still hanging on the train's rear end two miles south of the hamlet of Fairmead when Neil Young unexpectedly pops out of the speakers. You want a definition of 'serendipity'? This is it. The godfather of grunge is chugging into "Southern Pacific."

'Down the mountainside to the coastline,
Past the angry tide,
The mighty diesel whines…'

I put my foot into Goldie, ratcheting the old girl up to 80 m.p.h. We've got to get to the head end. Fifteen cars… ten…five. Extra 9801 West and Neil Young arrive at Fairmead right on the chorus:

'Roll on…'
Honk!
'Southern Pacific…'
Honk!
'On your silver rails…'
Honk! Hooooonk!
'In the moonlight.'

"You couldn't improve on an ending like this. The only thing missing is the moonlight."

With Ted Benson there, you didn't even need a camera.

Jim Boyd, Editor Emeritus
Railfan & Railroad Magazine
March 11, 1999

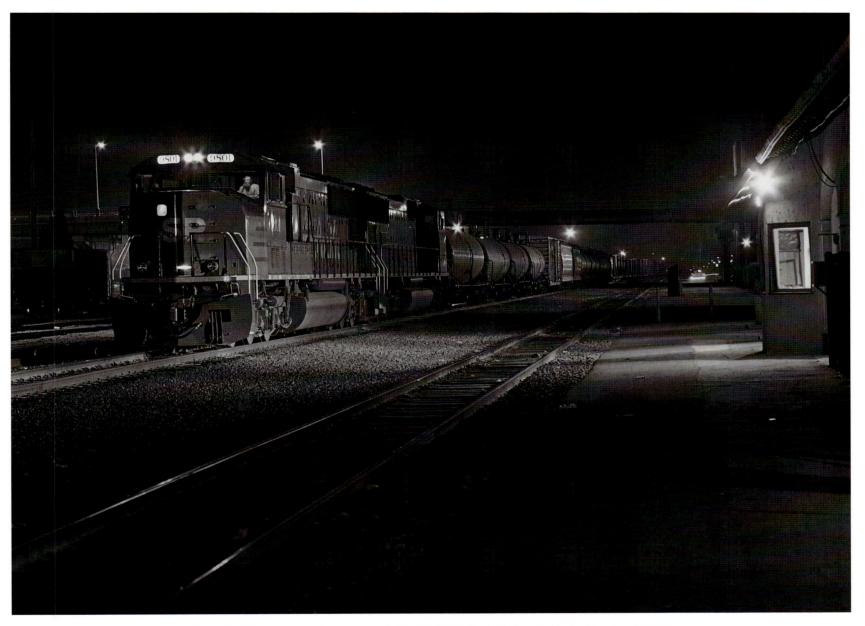

The only thing missing is the moonlight—SP 9801 West, Bakersfield, California. 9/10/96

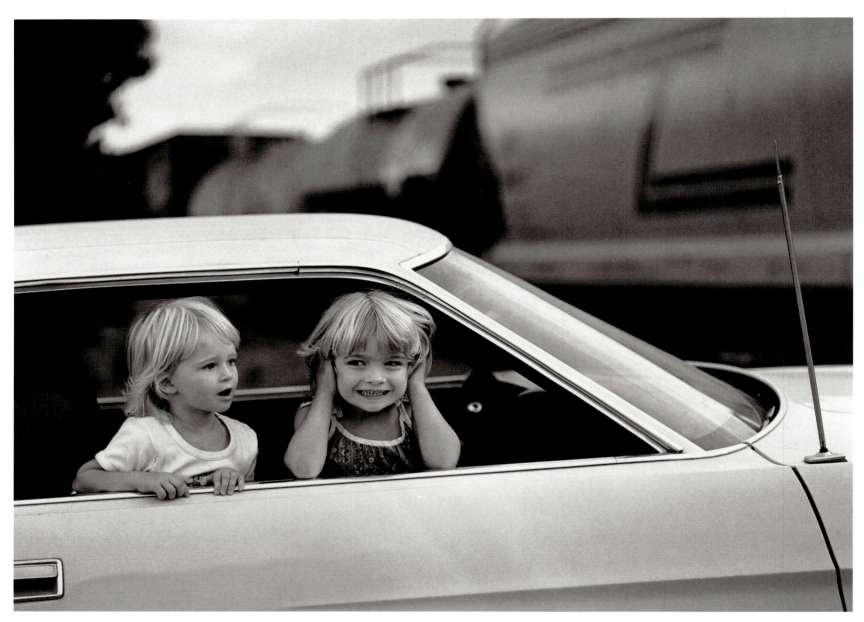

Two-dimensional memories—Amy and Jessica on the Tidewater Southern, Modesto, California. 8/30/83

ONE FOR THE GIRLS

"You guys want to go chase the Tidewater?"

Amy and Jessica nod in the affirmative, sold before I can even mention ice cream at the end of the excursion. Ten minutes later, my father's old Ford is trackside, providing the girls refuge from the crash of couplers and a ringing EMD prime mover.

We've followed the Tidewater Southern through Modesto on a number of occasions in 1983, documenting the demise of the old Western Pacific in the months since the Union Pacific merger. On this August evening, the Stockton Hauler pulls 10 years off the calendar as it switches McHenry station behind a GP7, Western Pacific No. 709.

The kids aren't impressed by old diesels. Their evening's highlight is a walk down a canal bank after the train heads into town, admiring the sunset and a pasture full of horses. As we know, there's a lot more to chasing trains than the train.

Pictures become souvenirs at times like this...two-dimensional memories of something more fully realized, like the love of a woman who was there at the dawn of a dream and has followed its realization down more back roads than we could ever imagine.

The trains are a part of those memories. I will never fully explain why railroads affect me the way they do. What is it about the all-encompassing presence of an enterprise so awe-inspiring that its mere passage becomes a siren song to follow? Words and pictures are a way of explaining the fascination on the printed page. At that, they're incomplete. I simply explore the present and past. Liz touches the future, as a mother and educator. For us, that future will include watching life unfold for two special young women—children themselves not so long ago, when ice cream and old diesels made a day complete.

This one's for the girls—and the children to come.

CHAPTER ONE

REQUIEM FOR AN INTERURBAN

Raindrops coursing down the windows of a 60-ton General Electric steeplecab locomotive framed the morning in a natural sadness. Turning from the gloom outside, the conductor spoke to a visiting journalist, measuring the moment with a voice as weary as Ecclesiastes'.

"Son, this won't be your last story like this. Railroading is dead and I predict you'll write the obituary of all of them."

Forty-four years of electric railroading out of Oakland, California, were ending for the Sacramento Northern Railway on Thursday, February 28, 1957, and conductor Walter Butterfield offered a working man's epitaph for a way of life whose boundaries stretched far beyond the 14 miles between Oakland and West Lafayette. As an industry, the basic concept of flanged wheel on steel rail was too efficient to die. But for the lifestyle, the signs of decay were everywhere. The weakest branches of the great steel tree were the first to be pruned. The final act had begun for California's second-largest interurban, grinding up Shafter Avenue and into Oakland *Tribune* reporter Jack Ryan's notebook "as the slanting rain beat a soft requiem on the venerable cars."

Two years into a 13-year career with the Santa Fe Railway that paralleled the SN and Southern Pacific between Pittsburg and Port Chicago, switchman E. C. Sherrick was thinking about everything but the end of railroading in 1957. Hiring out on SP in 1954, Charlie Sherrick worked one month on the west side of the San Joaquin Valley at Mendota before railroad officials discovered he was only 17. A year later, Charlie stepped onto the footboard of a Santa Fe diesel at Riverbank and never looked back. Tiring of the vagaries of a life dictated by assignments between San Francisco, Stockton, Oakland, Richmond and Riverbank, Sherrick approached the Central California Traction Company in 1968.

"Ever been 'Rule G'd?'" inquired CCT General Manager George Lorenz as he looked over Sherrick's sparkling service record. "It seems to be one of the 'requirements' around here." Charlie was well aware of the Traction Company's reputation for hiring misfits from other carriers, particularly those with a taste for alcohol. Booze had never been a problem for Sherrick. "Everybody wondered why I wanted to work with the lushes at the CCT," he recalled with a grin. "Being home every night had a lot to do with it."

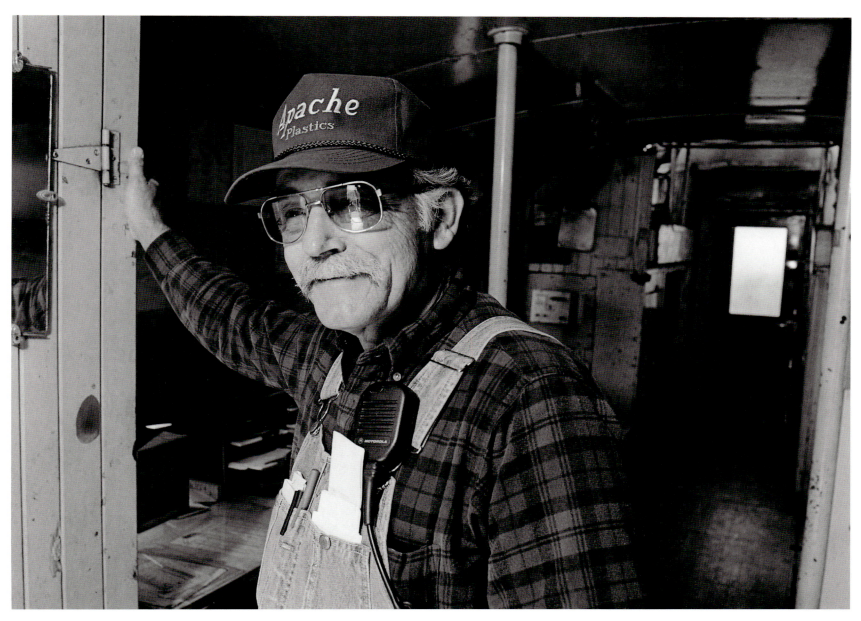

The light to a world all but gone—Charlie Sherrick on CCT caboose 24. Polk, California. 5/26/98

Sherrick's first switch key, 1955

Central California Traction was a railroad in transition in 1968. It had been 22 years since the substations were shut down, but over those two decades, little else had changed. Opened in 1910 to provide a fast, frequent, electrified alternative to SP and Western Pacific passenger service between the port and capital cities, the Traction Company still connected Stockton, Lodi and Sacramento with an arrow-straight, 44-mile mainline. Freight-only since 1933 and owned in thirds by Santa Fe, SP and WP since 1928, CCT remained a valuable freight feeder in the late 1960s. Traditional carloadings of wine and table grapes were supplemented by raw and processed food products along with a growing list of non-agricultural items. One generation of lightweight General Electric diesels had been replaced by a trio of used 660-h.p. Alco units, and growing tonnage presaged larger locomotives in the not-so-distant future. Charlie Sherrick made a wise move. CCT was a good place to grow seniority "whiskers."

Thirty years later, the warm spring sun filtering through CCT caboose 24 was the light to a world of traditional

railroading all but vanished in America. Weathering the storms of mega-mergers sweeping the west for the last three decades, California's last interurban survived. The fact that Charlie Sherrick still worked out of a caboose was remarkable in itself. While his wheel reports reflected the contemporary nature of commerce—cherries, grapes and asparagus long replaced by canned goods, corn syrup, fatty acid and plastic pellets—Sherrick's train was a throwback to 1968 with a Rock Island GP18 on one end and a Santa Fe Ce-1 on the other. In the spring of 1998, CCT was a picture too good to last.

No longer merger-resistant, the Traction Company felt the squeeze of two-thirds owner Union Pacific paying 66 percent of the bills and receiving 33 percent of the business. CCT may have looked like Santa Fe's line to Sacramento in public timetable maps from the 1960s, but by 1998, Santa Fe had become a minority voice, its own corporate identity merged with Burlington Northern. When UP approached BNSF with a haulage agreement for the Sacramento traffic, CCT's fate was sealed.

That spring, another conductor welcomed a journalist into his lair, opening the door to a way of railroading once so common as to be taken for granted. Sherrick's three decades at the Traction Company dovetailed neatly with my own photojournalism career. Now, Charlie circled the calendar with a retirement date while his railroad pondered a dramatically different future. From the macro focus of mega-merger, CCT emerged in micro focus—one little 44-mile railroad symbolizing so much of what attracted so many to the industry—and so much of what was gone.

Walt Butterfield's words came back to haunt me, as they had for 30 years.

"Railroading is dead." Maybe the old conductor was right. Maybe I *would* write the obituary of all of them.

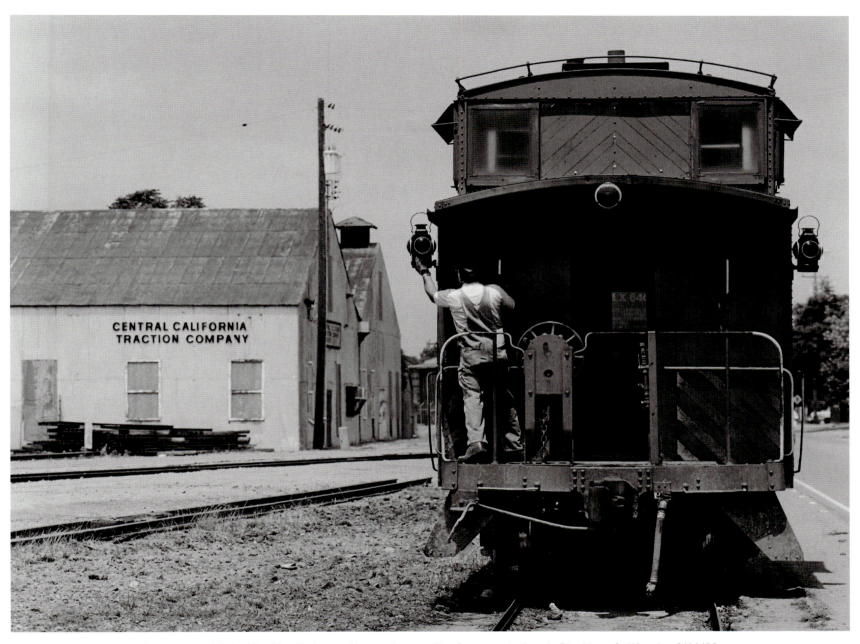

In memory of Rule 19—Charlie hangs the markers on the Sacramento Local. Stockton, California. 6/11/98

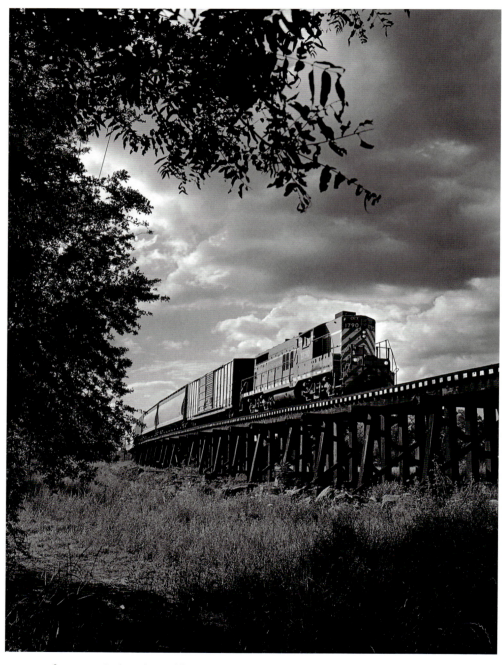

Sacramento Local southbound on Bridge 34-B—Wilton, California 5/26/98

Trolley bond, Blackland station. 11/13/98

A bridge route facing an uncertain future with bonds to a vibrant past, CCT presented a remarkable picture of California's interurban era in the closing decades of the 20th century. The "traction" in Traction Company could be found in details such as a trolley bond on 75-pound mainline steel at Blackland station, where 1,200 DC volts of third rail powered the line's electric years, and in the sight of former Nevada Copper Belt gas motor No. 21 traversing the gentle arc of Bridge 34-B between Shelton and Wilton on a 1978 fan trip in the charge of conductor Sherrick. Encountering no more than half a dozen curves of consequence on 44 miles of mainline, CCT found its most scenic variation on the linear on the floodplain of Deer Creek and the Cosumnes River, where GP18 No. 1790 rolled home to Stockton under an ominous sky in May 1998.

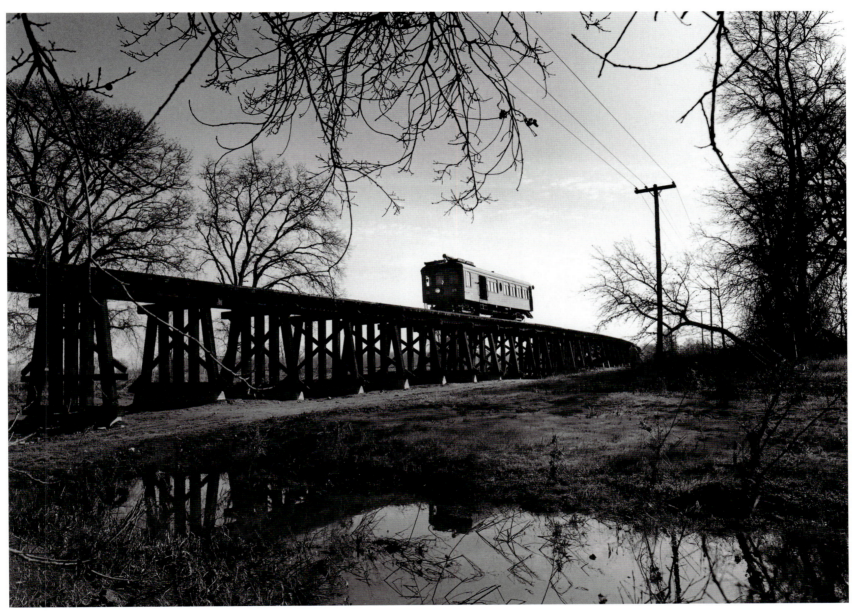

Nevada Copper Belt car 21 northbound on Bridge 34-B—1/21/78

Odors of stove oil and Number 2 Diesel—Lodi, California. 5/14/98

Herman Owens cuts in the air—Lodi Junction.
5/4/98

Six days a week, year after year, the Traction Company moved through three decades of railroading with the practiced routine of a tightly knit family in a comfortable home. Familiar odors of stove oil and Number 2 Diesel wafted through the caboose doors framing switching actitivity at Lodi, where brakeman Herman Owens cut in the air brakes on the Sacramento Local in 1998. Working his way up the seniority roster, a promoted conductor and licensed locomotive engineer, Owens was a model of stability on a railroad once considered the last resort for employees with a murky past.

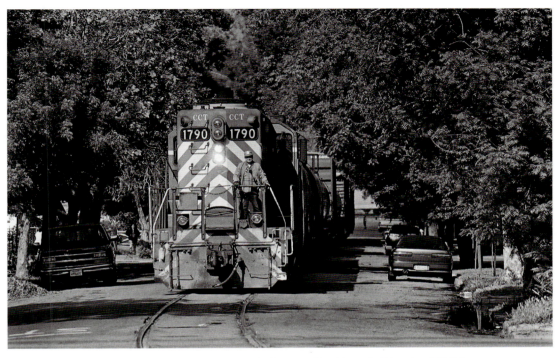

Sacramento Local on Roosevelt Street—Stockton, California. 5/4/98

The trees on Stockton's Roosevelt Street brought a leafy canopy down to car-top level as conductor Norman Auberg's crew departed the old Western Pacific interchange over rail owned by the Stockton Terminal & Eastern. Dusk on Waterloo Road found caboose 24 silhouetted in the headlight's glow as engine 1790 returned from the Santa Fe transfer. Another day's work was minutes away from completion on this balmy May evening in 1998.

Dusk on Waterloo Road—Stockton, California. 5/26/98

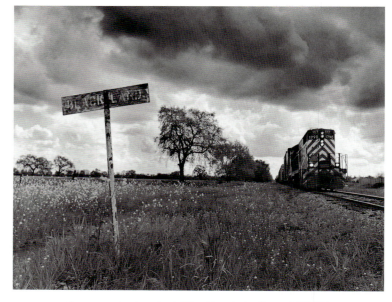

Sacramento Local at Blackland station—3/25/98

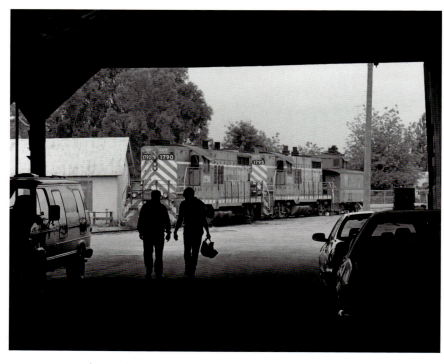

Answering the call at the Stockton shops—6/11/98

It all came down to one final spring, storm clouds swirling across the sky in a land so rich that the soil turned black. With rumors of closure surfacing in late April 1998, the faithful stepped into the cool shade of the Stockton shops with increasing regularity, filling the moments with photographic memories no act of commerce could erase. No longer would the sight of crewmen going to work outside the old carbarn be taken for granted. As the date of Charlie Sherrick's retirement drew closer, the import of the second Friday in June grew increasingly ominous. Only Hollywood could script a story that would find the conductor's last day coinciding with the last run to Sacramento. The closest CCT got to "Tinseltown" was lunch at Lodi's Hollywood Cafe.

On June 12, 1998, it was close enough.

Six hours after Sherrick's retirement reception in the Stockton crewroom, an angry sky framed the southbound passage of No. 1795 at Centralia, heavenly confirmation of the news that arrived on the run to Sacramento. UP would assume switching at Polk the following Monday. A family production to the end, the Traction Company had beaten the dramatists at their own game.

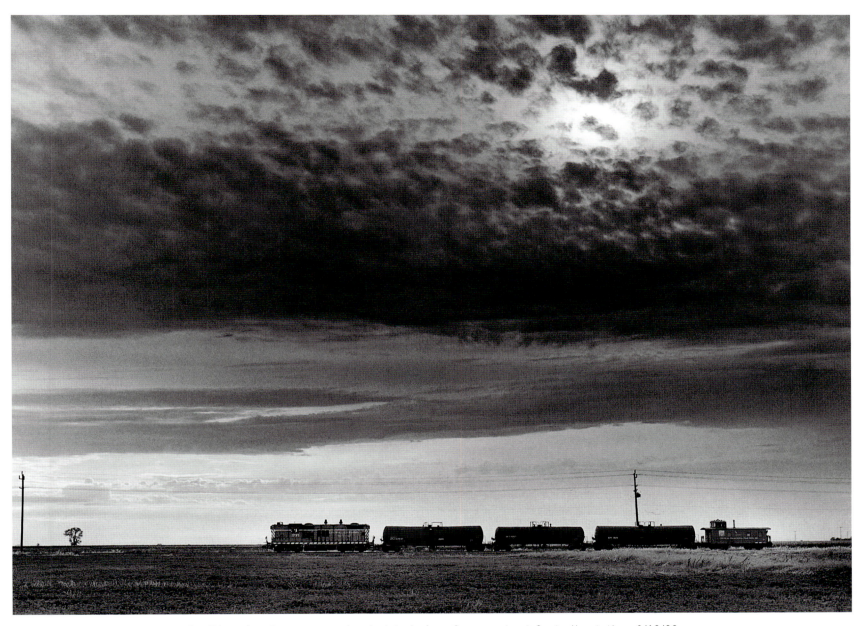

Southbound under an angry sky—last train from Sacramento at Centralia station. 6/12/98

"YOUR FRIENDLY RAILROAD"

Mere adjectives fail to define the Southern Pacific Company. All-encompassing, heroic, monolithic—a colossus of roads in the American rail industry—Southern Pacific's steel trail defined the map of far western commerce for the better part of 13 decades. No wonder the first two letters in "spectacular" were "SP."

Superlatives for Southern Pacific were hard-earned. One need look no further than predecessor Central Pacific's ascent of California's Sierra Nevada to ascertain the human cost of a transcontinental railroad. Chinese laborers perished by the hundreds in the cliff-hanging purchase of a roadbed around Cape Horn and the inches-per-day war with the granite face of Donner's summit tunnel. Construction Superintendent J. H. Strobridge lost an eye while blasting through the cemented boulders of Bloomer Cut near Auburn. General Washington's misery at Valley Forge found a rival in the winter of 1866–67, when 44 separate storms deposited 40 feet of snow on the Sierra crest and the bodies of men swept away in avalanches weren't recovered until summer. And all this just to bring the railroad to California. Rebuilding the system in the aftermath of fire, flood and earthquake

would engage the company with disturbing regularity for the next 130 years.

Shouldering the struggle of man against nature as the cost of doing business, SP set itself on a steady course of developing the "Golden Empire." Colonists attracted by California's temperate climate and homesteading for $2.50 an acre on railroad land rode the "Zulu trains" west. Innovations such as oil-burning cab-forward steam loco-motives and ice-cooled refrigerator cars sent the fruits of their labors back east. Great forests of redwood and pine fed the sawmills of Oregon and northern California, perfuming the freight trains traveling the Shasta, Ogden and Sunset corridors to the nation's heartland. Travelers on "America's most modern trains" had their choice of four scenic routes to the Golden State while dazzling *Daylights* in red, orange and black reflected the setting Pacific sun on their north/south intrastate passage. Commuters riding SP's first 47 miles between San Francisco and San Jose did so on the only suburban operation west of Chicago. Interloping carriers notwithstanding, California at the dawn of the Freeway Age was still very much the feudal domain of the lordly Southern Pacific.

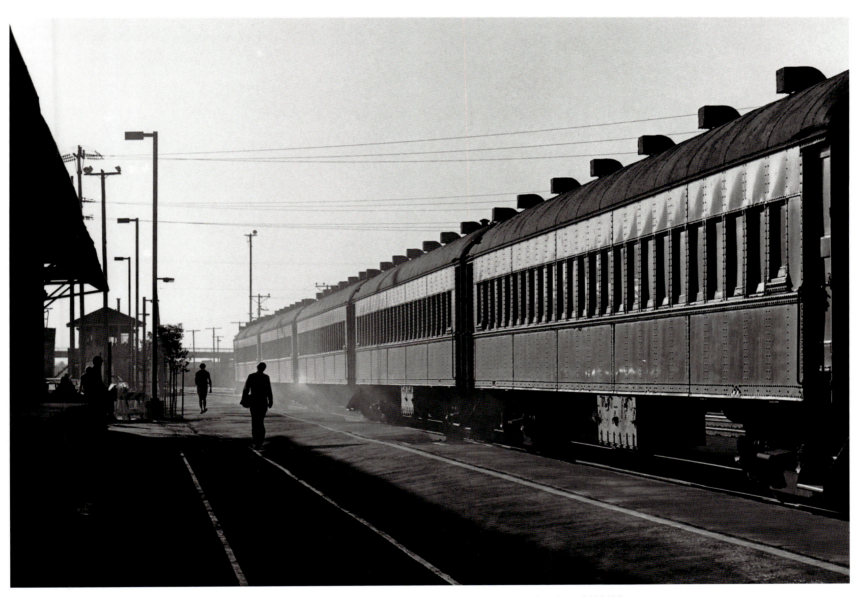

Train time at Santa Clara—SP's last day of Peninsula Service. 6/12/85

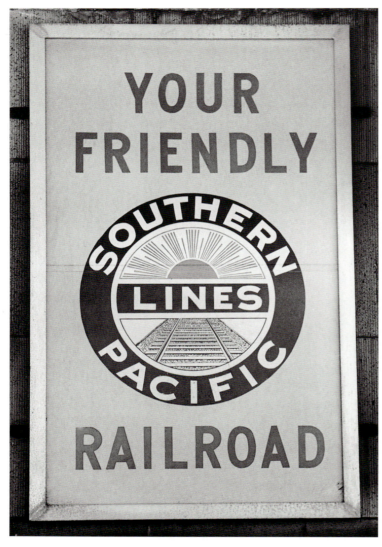

Oakland 16th Street—3/22/69

Growing up with the "Espee" in the 1950s and 1960s, it was impossible to ignore the the sign greeting travelers outside the granite exterior of Oakland's 16th Street Station. "Your Friendly Railroad" read the souvenir from the salad days at Oakland Pier, where San Francisco-bound passengers boarded SP ferryboats for an atmospheric bay crossing in pre-bridge years. By 1969, the irony of the sign was monumental. For if there was one adjective that escaped the SP in all its corporate majesty, the word was "friendly."

In short, SP had an image problem. With size came power and with power came arrogance. As historian Bruce MacGregor noted in *New West* magazine in 1979, "When Southern Pacific walks through the valley of the shadow, it fears no evil. For it is the biggest thing in the valley." Whether foreclosing on settlers at gunpoint or holding political pistols to the heads of state allergic to railroad demands, the Southern Pacific of 1901 was widely reviled as the "Octopus," fair game for muckraking journalists and legislative reformers. Chastened through the Interstate Commerce Commission and statutory limitations inspired by the years of excess, Espee could never shake its negative press. By the late 1960s, when Interstate highways and jet airliners were turning rail passengers into "vanishing Americans," protestors of the unceasing train-off petitions vilified the company as the "fiendly" Southern Pacific.

In truth, the SP that celebrated its gold spike centennial in 1969 was far more personable than its public image implied. Lauded by *Trains* Magazine editor David P. Morgan as the "new standard railroad of the world" in 1965 and heralded by *Forbes* as one of America's best-run railroads, SP continued its innovative ways into the 1970s.

Computerized car distribution, the nation's largest private microwave network, automated Centralized Traffic Control, intermodal freight service and high-horsepower diesel locomotives all pointed to a promising future, with or without inter-city passenger trains.

Despite its curmudgeonly demeanor at 65 Market Street and the paramilitary proficiency of the corporate police force, Southern Pacific often was a friendly railroad. Childhood encounters with local mentors Guy Dunscomb and Ed Tyner went a long way to cultivate a profound respect for their employer. Inspired by "On-Time" Tyner's tales of the rails and Guy's photographic history of an Espee I'd never known, my interest continued to grow. The further one explored the hinterlands of the Golden Empire, the more cordial the reception became. You could spend hours in outlying terminals such as Tracy, learning the intricacies of diesel locomotion from men such as roundhouse foreman Roger Bowman while photographing the increasingly rare Krauss-Maffei hydraulic units parked outside the engine house. It was in Tracy in early 1967 where I first set foot on a K-M, discovering the trepidation crewmen felt for the high-speed drive shaft whirling just under the cab. And it was also in Tracy in 1967 that I learned that SP's multi-million-dollar "hydro" experiment was over—months before San Francisco would publicly confirm what the railroaders knew all along. Over the next 20 years, I would come to know scores of "rails" like Bowman, Dunscomb and Tyner, all proud of their SP heritage and more than willing to share the special place it held in their lives. By 1986, "friendly" was the first adjective I associated with Southern Pacific. The closer I got to the Octopus, the harder it was to let go.

Stranger at the stable door—Tracy, California. 1/2/67

Car inspector Joe Gomes, Third & Townsend station—8/19/74

Monday morning at Third Street—San Francisco, California. 7/30/73

8:10 a.m. Monday, July 30, 1973, at the corner of Third and Townsend Streets in San Francisco. A steady stream of humanity pours off Peninsula Service trains Number 125 and 127 from San Jose. Each weekday, 10 arrivals dock in a 75-minute window, some on 4-minute headways. Each afternoon the process reverses itself. Railroaders such as car inspector Joe Gomes call it "the parade," and it's been a hallmark of SP tradition for the better part of 100 years. The only things that change are the fashions and the rolling stock.

Few other aspects of the Southern Pacific were so untouched in the 1970s. Diesels dressed down in scarlet and gray, and endless requests to discontinue service had defined passenger policy since steam power's retirement in 1957. While many first-class schedules followed the steamers into oblivion, SP was kinder to its patrons on the Monterey Peninsula, where the *Del Monte* provided an upscale commuter service between Atherton, Carmel and San Francisco's financial district. Double-headed on weekdays with additional coaches between "the city" and San Jose, weekend editions of Trains 126 and 139 featured solo passenger GP9's and a minimal consist on the Monterey run. Though no longer prowling Cannery Row and the rocky shoreline to Pacific Grove, the *Del Monte* remained in service until the advent of Amtrak, retiring as the oldest named train in the West in 1971.

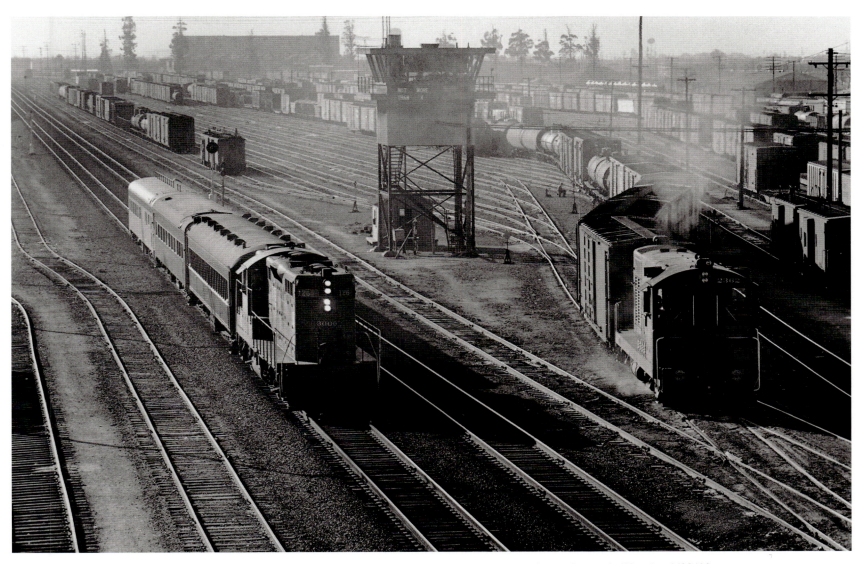

Suburban service for the "feudal aristocracy"—The *Del Monte* passes Santa Clara, California. 4/25/69

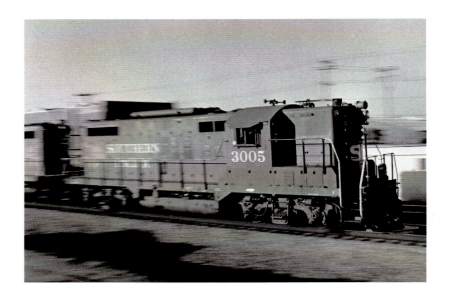

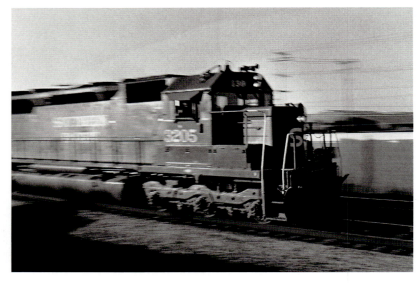

Twenty-one miles south of San Francisco, the afternoon calm of April 2, 1973, is shattered by the unceasing chime of Nathan M-5 airhorns as the evening "parade" storms into Belmont. Beginning with Train 124 at 5:20 p.m., 10 trains will pass through Belmont in the next 66 minutes. Second out in the parade, "torpedo boat" GP9 No. 3005 and a sister Geep storm south on the old *Del Monte* schedule. One train and 11 minutes later, it's SDP45 No. 3205 and engineer Neil Vodden on "the express," Train 130 running nonstop to California Avenue—38 miles in 32 minutes. At 5:39 p.m., the distinctive roar of opposed pistons at full throttle heralds the arrival of Fairbanks-Morse Train Master No. 3020, four miles away from Number 132's first stop in Redwood City with her Barco speedometer still pegged at 70.

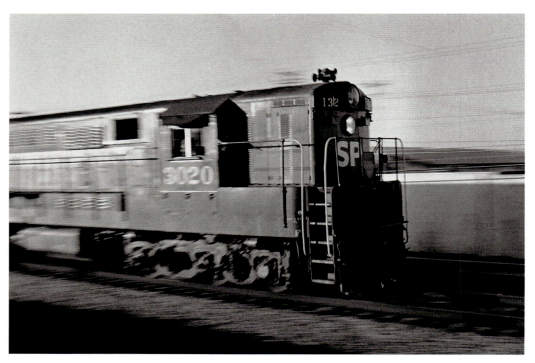

The parade comes to Belmont—4/2/73

Running 10 minutes behind the Portland-bound *Cascade* at Martinez, California, Extra 6347 East assaults the 0.9-percent western approach to the Benicia bridge in the dying light of a March afternoon in 1968. With 123 cars trailing the A-B-A set of F7s and an Alco Century 628 up the grade above Mococo, there's little chance of the Roseville drag even sniffing a yellow block behind Number 12 on the run to Davis. The day is indeed growing short for SP's Electro-Motive F7's. Swept away by a flood of new SD45's, some 158 F-units will leave the roster by the end of the fiscal year. Black Widow 6347 will be among them.

More change lies in store for Southern Pacific passengers on the evening of March 23, 1969. Beckoned eastward by the Style B semaphores protecting Oakland's 16th Street interlocking, EMD SDP45 No. 3202 and an FP7A roll the *Cascade* off to Portland in a move foreshadowing a new era for West Coast rail travelers. By adjusting the *Cascade's* schedule for a later departure, SP has made it possible for *Coast Daylight* passengers to enjoy a direct connection from San Francisco, saving a one-night layover on the Los Angeles–Portland trip and validating the "Friendly Railroad" sign hanging outside the 16th Street station. Two years later, Amtrak's *Coast Starlight* adopts a similar schedule, bypassing San Francisco in favor of a direct rail link between Oakland and San Jose. Three decades down the road, the popularity of the Coast route will turn the *Starlight* into the finest long-distance train in America.

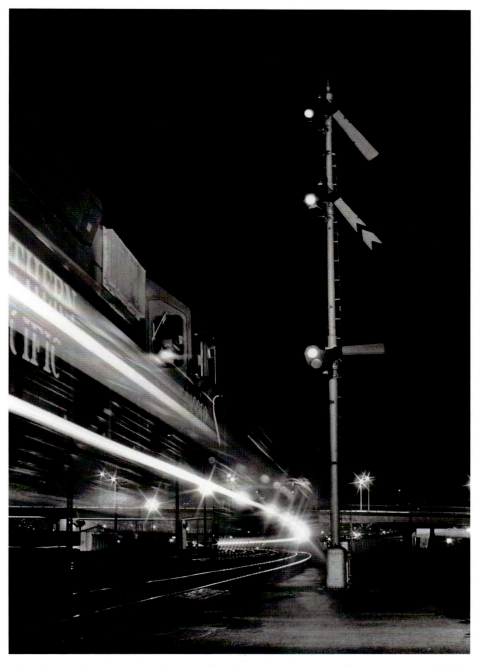

New day for the Cascade—Number 12's first night departure from Oakland. 3/23/69

THE WILLING PEOPLE

"If you build that line, I'll kill you."

Edward Henry Harriman measured each syllable carefully, slicing off his words with razor-edged precision. He'd spent a decade rebuilding the ravaged hulk of the Union Pacific that Jay Gould had left behind. A late arrival in the barony who completed the great American rail systems of the 19th century, Harriman gained control of UP following Collis Huntington's death in 1900. He wasn't about to entertain competition from the son of the scoundrel who'd picked UP's coffers as clean as a Christmas goose.

George Gould welcomed the challenge. Spurned in the quest to maintain a friendly connection for his Denver & Rio Grande at Salt Lake City, Gould dusted off a set of 40-year-old surveys through California's Beckwourth Pass. A railroad to the Pacific? By George, he'd build one himself. Harriman wasn't impressed.

The Western Pacific Railway was the missing link in a decidedly secondary transcontinental system meandering through the nation's midsection. Casting 924 miles of mainline through some of the most desolate reaches of the far west, WP opened in 1910. Remarked for its engineering —a charter-mandated 1-percent maximum mainline gradient—and renowned for its scenic traversal of the Feather River Canyon, WP stumbled in the shadow of Southern Pacific. Derided as "The Wobbly," Western

Pacific adopted the nickname as a matter of pride. Tempered on the anvil of two bankruptcies and a like number of world wars, the WP marked its 40th anniversary in 1949 with a resilience even Southern Pacific had to admire. There was no denying the Wobbly's courageous style. And there was no ignoring WP's bid for the rail travel market in the second half of the 20th century. Nowhere was there a train like the *California Zephyr*.

The dream that became the CZ began with Arthur Curtis James' control of the WP in 1926 and the opening of Rio Grande's Moffat Tunnel transcontinental route in 1934. Preceded by the *Exposition Flyer*, a three-railroad passenger consortium of James-controlled Burlington, Rio Grande and WP, CZ traded speed for scenery, wagering diesels and Vista-Domes against Dodges and DC-6s to create a "365-days-a-year railfan excursion," in the mind of *Trains* editor David P. Morgan. "She was the train that behaved like a Caribbean cruise ship," Morgan wrote in *Portrait of a Silver Lady*, "inviting you to loaf and look, dine and drink, with ultimate destination beside the point."

The *California Zephyr* was the ultimate expression of a Western Pacific whose image far outdistanced its 1,436 route miles in the 1950s and 1960s. "America's most-talked-about train" turned the national spotlight on WP, who proved a small carrier's hospitality was more than mere

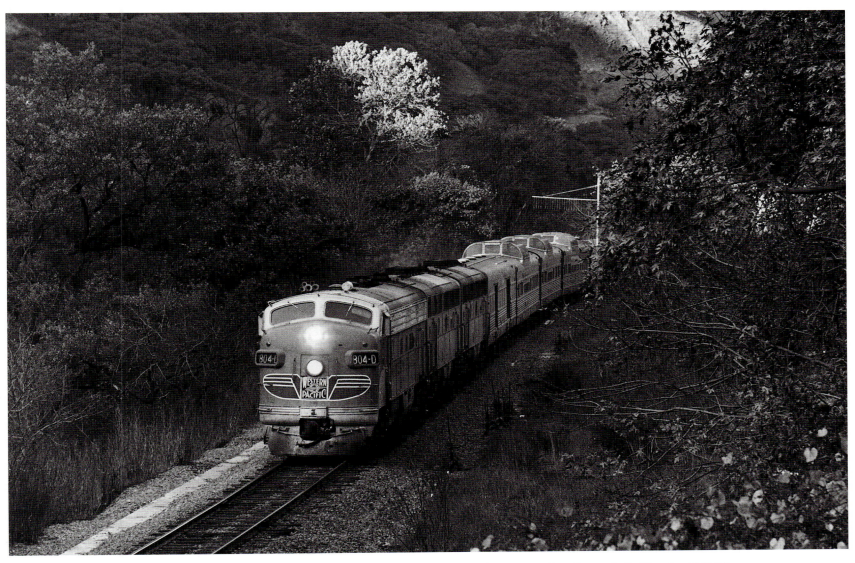

Autumn shadows, Niles Canyon—Western Pacific's *California Zephyr* approaching Fremont, California. 11/7/68

advertising. By the late 1960s, when SP's "friendliness" seemed an ironic joke, WP was billing itself as the railroad of the "Willing People"—a slogan whose reality was understated.

In time, WP's cordial nature would come to haunt the line. The focus of twin merger proposals from SP and Santa Fe in 1960, Western Pacific was released in 1965 to continue as an independent carrier. The ICC acted in the public interest, taking into account WP's image as the "tough-minded little guy," buoyed by the *Zephyr*'s popularity and reputation for excellence. A year later, the ICC began hearings to discontinue the train that had dramatized WP's progressive emergence.

Bankrolling a symbol of public service by undermining the substance of freight revenue was a trade the WP couldn't afford to make, yet every year the verdict rolled in—discontinuance denied. Both sides argued valid points —corporate survival versus a public whose desire to "loaf and look" was steadily co-opted by Interstates and DC-10s. At the end of an exasperating third round of hearings in November 1969, WP's mild-mannered attorney, Walter Treanor, stormed out of a Salt Lake City courtroom, growling "Mr. Nice Guy has gone home!" Three months later, the news came over a darkroom radio at San Jose State College. Western Pacific's famed *California Zephyr*

would be...discontinued! Right on cue, a DJ dropped the needle on Creedence Clearwater's "Who'll Stop the Rain?" It was 4 p.m., Friday, February 13, 1970, when my railroad world ground to a halt. I'd ridden the *Zephyr* but once.

There would be more rides to take, the last one ending in the cab of Train 17 the day before the final run. And there would be a new Western Pacific to fall in love with in the freight-only days ahead. Walt Treanor wasn't serious —Mr. Nice Guy was alive and well and would be for another dozen years.

It wouldn't be the same railroad that captured my imagination one September afternoon in 1966 when a SP policeman threw two aspiring photographers out of West Oakland yard, suggesting we "go bother the WP." It wouldn't be the same railroad that filled my camera one November afternoon in 1968 when a late-running Number 17, like any lady worth the wait, grandly entered Niles Canyon in the last light of day.

In the end, it would be the Willing People—the Jim Boyntons, Nick Labas and Lee Sherwoods—who kept me coming back as long as there was a Western Pacific. The attraction was basic for someone who admired the tough-minded little guys of the world. Sure, Southern Pacific could win your respect...

The WP won your heart.

One week from eternity—Train 17 in Niles Canyon. 3/15/70

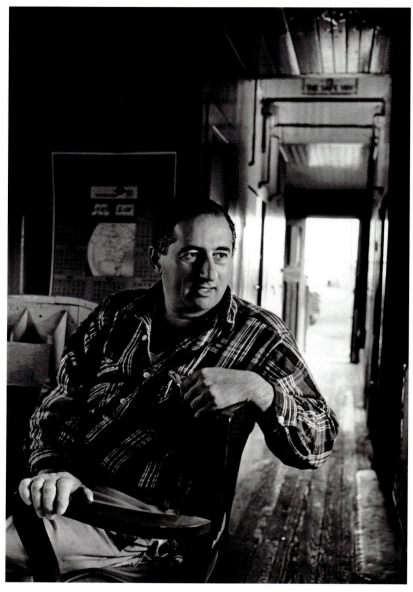

"Tidewater 308"—Conductor John Yonan, Modesto, California. 2/25/73

A Baldwin on the Turlock Local—Tidewater Southern Railway. 4/5/67

With a modest network of erstwhile interurbans providing the bulk of its feeder traffic, Western Pacific found it hard to escape the image of "The Wobbly." In contrast, the men delivering tonnage to the WP were rock-solid railroaders such as Tidewater Southern conductor John Yonan—throwbacks to the days of "wooden cars and iron men." Plying his trade in a caboose built as a boxcar in 1916, coal-heated and kerosene-illuminated into the early 1970s, Yonan followed an engaging collection of motive power across diesel's first generation.

Worn out after 20 years of demanding work, Tidewater's little General Electric units sputtered toward retirement in 1967, prompting frequent relief from WP's Stockton yard. On rare occasion, one of the home road's Baldwin VO1000's would answer the call, as witnessed by 1945-vintage No. 581 departing Modesto on an overcast afternoon.

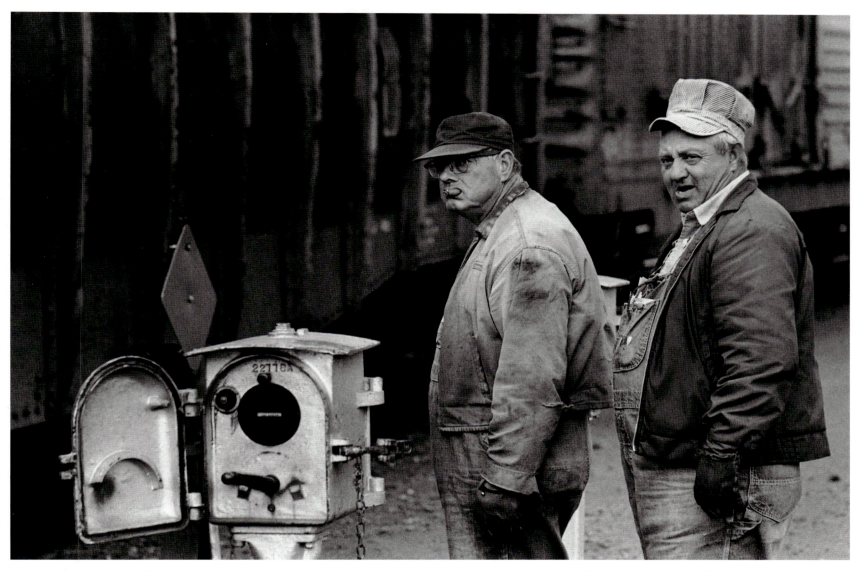

Walt and George on the Yuba City day job—Sacramento Northern Railway, Marysville, California. 10/19/71

An "island of electricity" long after the rest of the railroad succumbed to the diminutive diesel products of GE, Sacramento Northern operations at Marysville and Yuba City, California, kept the catenary energized until 1965. Six years after trading steeple-cab motors for Electro-Motive SW1's, trainmen Walt Kimble and George Matthews recalled the interurban era as they shuffled cars on the Western Pacific interchange at Marysville.

Suspended on spidery steel—Westwood Local outside Keddie, California. 6/17/68

To know the Western Pacific is to know the Feather River Canyon, and it was on a sun-splashed Monday, June 17, 1968, that Tom Taylor and I began a memorable first exploration of the mountains east of Oroville, California. Arriving at Keddie in early evening, we encountered the Westwood Local descending the "High Line" from Crescent Mills, a pair of white-flagged GP7's suspended on the spidery steel of the Clear Creek Bridge an hour before sundown.

Two days later, a note of introduction from longtime WP historian Guy Dunscomb was as good as a company waiver for engineer Jim Boynton, who had "no idea" how a couple of college boys found their way aboard the sole GP9 splicing five F7's on the Bieber run. Five hours and 112 miles of high adventure were just getting underway aboard the *Expediter*, hottest of the hotshots on the Inside Gateway. Clawing out of Keddie on the 2.2 percent to Indian Creek, Boynton's beleaguered power faced a hard pull to Lake Almanor and train orders at Westwood, where relief telegrapher Mary Jo Ledwig was doing the honors in January 1974. Closed since June 1970, the Westwood office had been resurrected as a temporary source of written communication for Southern Pacific traffic detouring around storm damage on SP's Shasta line.

Orders at Westwood—Mary Jo Ledwig, 1/21/74

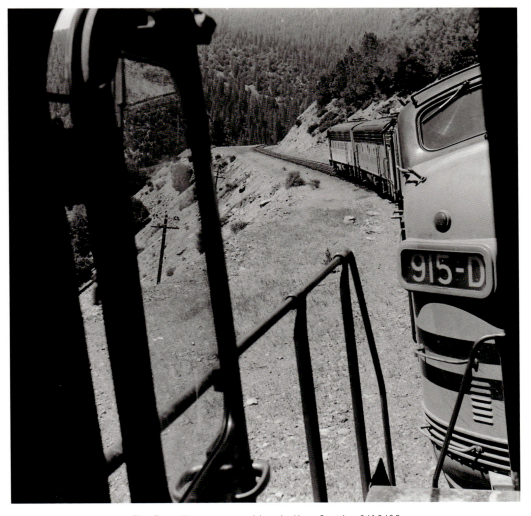

The Expediter *approaching Indian Creek*—6/19/68

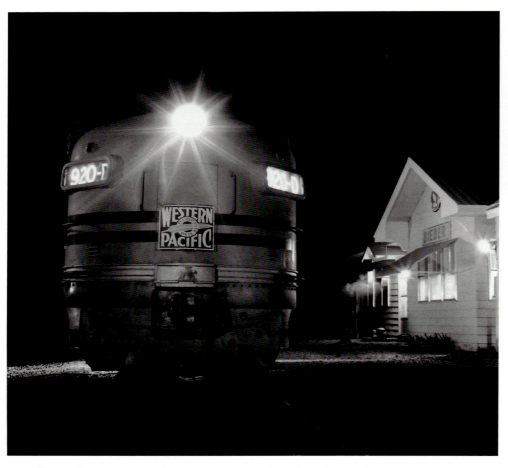

Where the goat meets the feather—WP No. 920-D at Bieber, California. 6/19/68

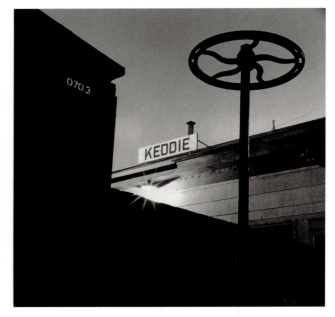

Twilight at Keddie—6/17/68

Nightfall in the Pit River valley found WP F7 No. 920-D idling outside the Great Northern depot at Bieber as the CAL symbol freight changed crews and carriers on its Seattle–Los Angeles run. Tackling Southern Pacific head on in the West Coast tonnage wars, WP joined forces with Santa Fe and GN to provide an invigorating, competitive balance between Southern California and the Pacific Northwest. At the other end of the Northern California Extension, the lights were on all night in the crewroom at Keddie.

Morning in Keddie's mountainside yard saw the main line take center stage. High Line diesels idled in the shadows beneath the trademark twin water towers as the westbound *California Zephyr* eased into town behind 1947-vintage F3 cab unit 803-A. Resplendent in factory-fresh silver and orange, a quartet of General Electric U30Bs rested in the siding with the Ford *Auto Parts*, waiting for signal indication to follow Number 17 "down the slot" to Oroville, Stockton and San Jose.

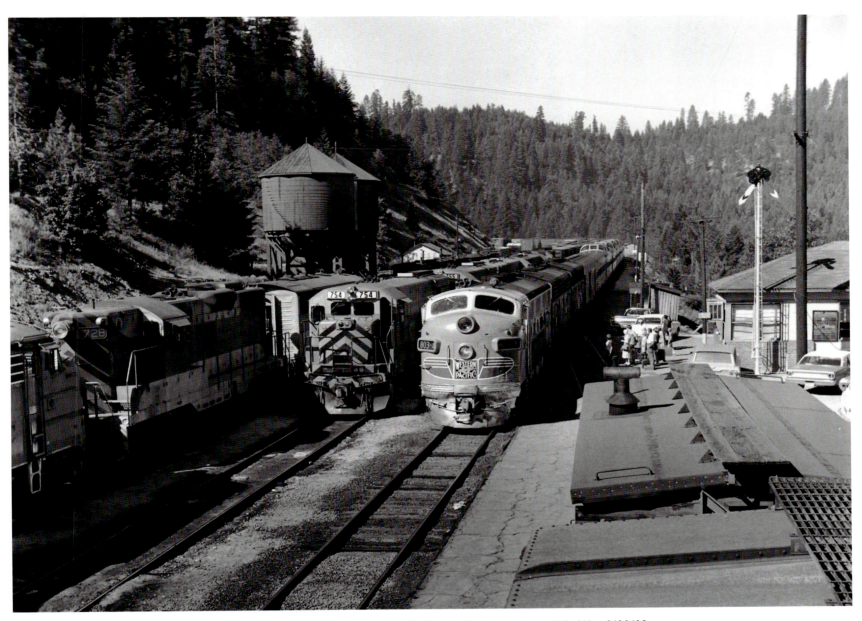

Majesty on a summer's dawn—the *California Zephyr* arrives at Keddie. 6/20/68

Big boost for a little lady—Pleasanton, California. 2/5/70

Conductor Don Downer, smiling all the way—3/21/70

Polished and professional in the darkest of hours, the crews of the *California Zephyr* maintained the tradition of America's "most-talked-about train" to the end of her days. No detail was overlooked; no chance to make a memory ignored. Porter Art Jones and Brakeman Ernie von Ibsch gave each schoolkid a boost and a smile as the Fremont elementary students detrained at Pleasanton following a first-and-last field trip aboard Train 18. Captain of all he surveyed, Conductor Don Downer still carried a smile as the final eastbound *Zephyr* boarded passengers at Oakland on March 21, 1970.

On the business end of Number 17, engineer Gordon Addis had the speedometer dancing on 64 and the whistle valve wide open as engine 804-D closed on the Highway 120 crossing west of Manteca at 88 feet per second.

Forty-five hundred horses take Gordon Addis home—3/21/70

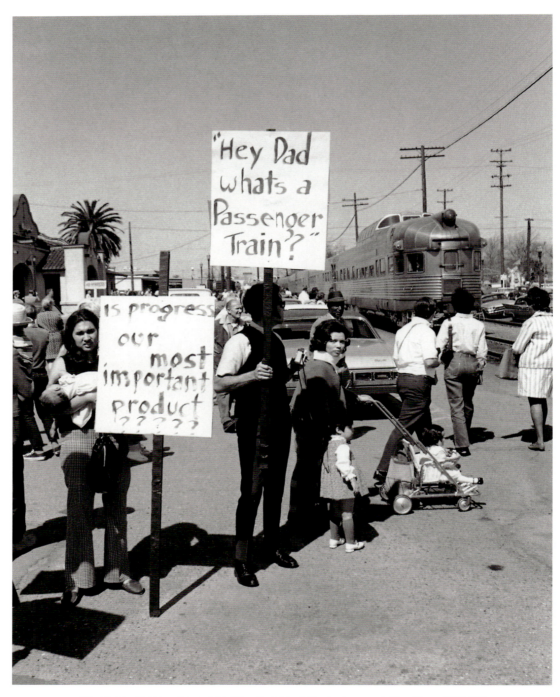

Could any train ever compare?—Number 18's last run at Stockton. 3/21/70

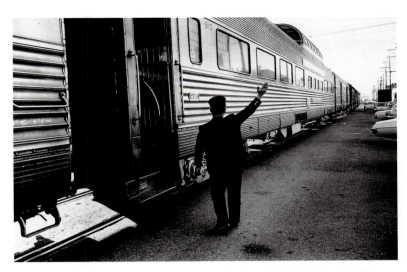

Highball for Middle Harbor Road—Oakland, California. 2/5/70

A mile away from Middle Harbor Road and the bus connection to San Francisco, Number 17 pulled away from Oakland's Third Street station on a February afternoon in 1970. Many farewells would be offered to the *Zephyr* in the weeks ahead, but few as emotional as the exchange at Stockton on March 21, 1970, where a young family bid goodbye to Number 18 with protest signs asking questions that escaped reply. Could there ever be another train to compare with the final Number 17 flying past our cameras on the "speedway" west of Tracy on March 22, bending the signal mast at Valpico through the optical sorcery of a fish-eye lens? Would the fathers of the future share any kind of passenger train with their children?

There were no answers to be found in the gathering gusts sweeping off the Altamont hills that spring Sunday—just a disappearing vision in stainless steel and a ghost of Greek mythology vanishing with the wind.

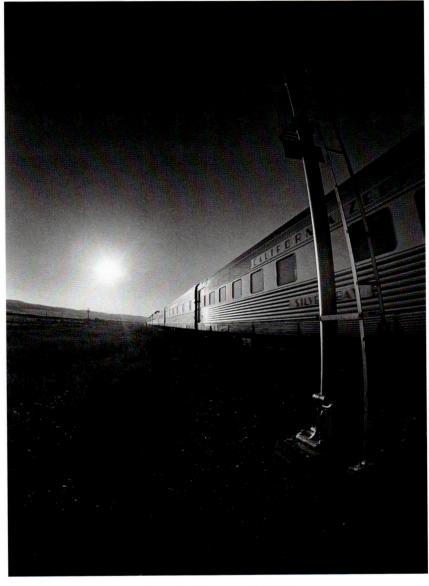

Sunset at Valpico—3/22/70

Eastbound for Martell—Amador Central crossing Highway 88 near Ione, California. 4/1/69

FIELDS OF ASPHODEL

Ninety-seven summers had passed since James Marshall looked into the tailrace at John Sutter's sawmill in Coloma, California, and saw something yellow glittering back at him; 97 years since the American West was thrown open in a national lust for the treasure of the Golden State. Untold riches had poured forth from California's Mother Lode in the nine decades since the rush of 1849. A collective $70 million alone had been extracted by the Argonaut and Kennedy mines 41 miles south of Coloma at the rip-roaring town of Jackson. Ninety-seven summers after the first cries of "gold!" rang out in the streets of San Francisco, Jackson remained the home of "the gaudiest saloons and...the widest-open gambling parlors anywhere in California." The frontier had "never been entirely eliminated in Jackson," much to the delight of Lucius Beebe and Charles Clegg, who spent a spirited evening at the El Encanto Casino in July 1945 before emerging "in J. P. Morgan mood and stimulated with winnings and champagne, to go up the hill and take some pictures of the Amador Central Railroad at Martell."

The story was briefly told in *Mixed Train Daily*, Beebe's classic volume of shortline railroads first published in 1947. The most-beloved of Beebe's books, *Mixed Train Daily* passed over the "thunder and drumbeat of main-line operations" in favor of the little railroads whose rights of

way "skirted the hillsides and courted the level meadows... to go where the main lines and highways do not." They were the independent carriers, "operated with motive power and rolling stock bearing its own name or insigne," the railroads whose officials liked to point out, were "not as long but just as wide" as their connecting trunk roads. "Quaint and querulous...sylvan and serene," they were the railroads plying their trade "in fields of asphodel."

The shortline, Beebe observed, was by and large "a country thing...its operations rural and the vistas from the windows of its cars those of fields and fertile meadows, grazing cattle, tall trees, barns, silos and homesteads." Defining the "essential flavor" of a shortline was elusive. "It must be seen and experienced—almost touched—in order to apprehend and faithfully evaluate," Beebe remarked on page 6 of *Mixed Train Daily*. The mere act of photography was not enough. "It should be ridden, if possible both head-end and in its coaches or caboose, and the truly perceptive reporter will drink whiskey with its crew members and talk crops, if such colloquy is within his gift."

Above all, shortlines were to be savored for their mere presence as "they whistle for grade crossings with the cautious deference of old and very fragile things." For even in 1947, when the index to *Mixed Train Daily* included

"Cornfield meet" at Stone Corral—AC No. 8 and section crew. 4/1/69

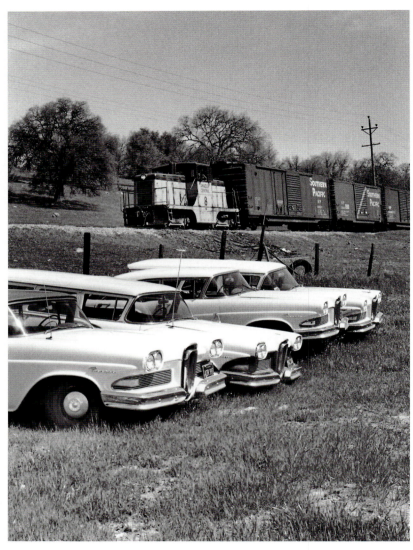

Savored for its mere presence—No. 8 westbound from Martell. 4/1/69

"Iron Ivan" at rest in Ione—4/1/69

294 shortline carriers, 92 were noted as no longer operating or absorbed by another railroad. "All too many short-line railroads are heading into the sunset," Beebe lamented, a condition he equated with "such manifestations of decay as the assembly line, Model T Ford, woman suffrage, game wardens, the income tax and the elm blight."

Amador Central, sixth on the alphabetical index of *Mixed Train Daily*, was very much alive and well in the spring of 1969, a quarter-century after Beebe and Clegg recorded the railroad's passage over the "twelve incredible miles" between the sawmill town of Martell and the SP connection at Ione. Baldwin No. 7, the 2-6-2 so tenderly photographed in 1945, was enshrined in a park adjoining Ione's city hall and police station, memorialized as "Iron Ivan." Sixty-nine curves and 1,244 feet up the hill from the town once known as "Bed Bug," the General Electric 44-ton diesel that was pending delivery in 1945 still rolled out of the Martell enginehouse six days a week, her $50,000 purchase price long since amortized. A Baldwin S12 acquired in 1965 languished at the American Forest Products mill, waiting patiently for the section gang to bring AC's circumspect infrastructure up to standards for the heavier power while little No. 8 continued to perform yeoman service.

Amador's circumstances would change over the next 30 years, perhaps not as dramatically as some Western shortlines, but winding up with the same conclusion faced by most of the railroads shown on the following pages. As a single commodity carrier, the fortune of the AC hinged on the sawmill at Martell. When the second change of ownership in eight years resulted in consolidated lumber production at a different location, Amador Central was left with nothing to haul. On March 27, 1997, AC closed the Martell enginehouse door for what appeared to be the last time. Ironically, the railroad had never been in better condition. Although it was "famed throughout California for the virtuosity of its crews as rerailing artists," as Beebe noted 50 years before, it had become a rare day when Amador rolling stock left the track. The pair of used rails propping up the wooden trestle spanning Highway 88 east of Ione were long gone, along with most of the trestles that remained in 1969. Baldwin diesels had been supplanted by EMDs in 1995. The details had changed, but the Amador Central remained an intriguing example of down-to-earth railroading in 1997.

Indeed, it was the details that endeared the "baby railroads" to several generations of rail enthusiasts. "Shortlines are notoriously different," David P. Morgan wrote in the February 1959 issue of *Trains*, "so much so that a good many eschew the big roads in favor of the Sierras and the Union Transportations."

I couldn't completely concur with that sentiment—the thunder and drumbeat of mainline railroading was too compelling to spend an entire career trying to place nothing but shortlines in the negative file. But there was a substantial part of that file dedicated to the Sierra Railroad. There were a number of envelopes filled with small carriers I had seen but once. And there were many railroads whose total mileage was substantially disproportionate to the number of negative envelopes alloted to trunk line carriers.

I could understand why a Class 1 aficionado like DPM would comment "count me out—I don't like shortlines" in that same issue of *Trains*. I guess I could say the same for myself. But the rationale would be radically different.

Because I don't *like* shortlines—I *love* 'em!

The Annie & Mary at Warren Creek—6/8/78

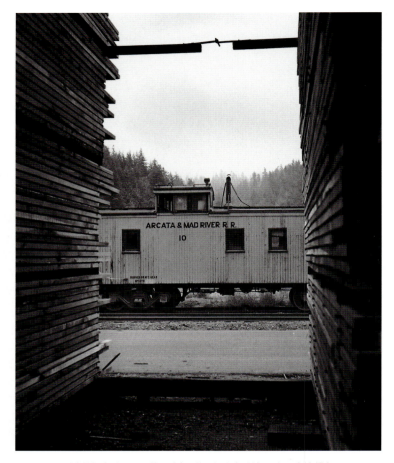

A&MR Caboose No. 10—Korbel,California. 6/8/78

With operations dating to 1854 on its horse-powered predecessor, Union Wharf & Plank Walk, the 7.5-mile Arcata & Mad River claimed the honor of being California's first railroad—a fact often ignored in the light of the plank road's four-legged locomotive. Shivering the timbers of the Warren Creek trestle 15 miles northeast of Eureka, "Annie & Mary" engines 102 and 101 rolled home to Blue Lake, California, with eight empties off the Northwestern Pacific on a foggy June morning in 1978.

Married to the ambiguities of single-commodity carloadings and a single-carrier connection, A&MR's fortunes mirrored those of the Simpson sawmill at Korbel, where a former NWP caboose rested amid drying stacks of dimensional lumber. Frustrated by NWP's oft-interrupted interchange and wrung out by recession, A&MR discontinued service in 1983, receiving permission to abandon in 1985.

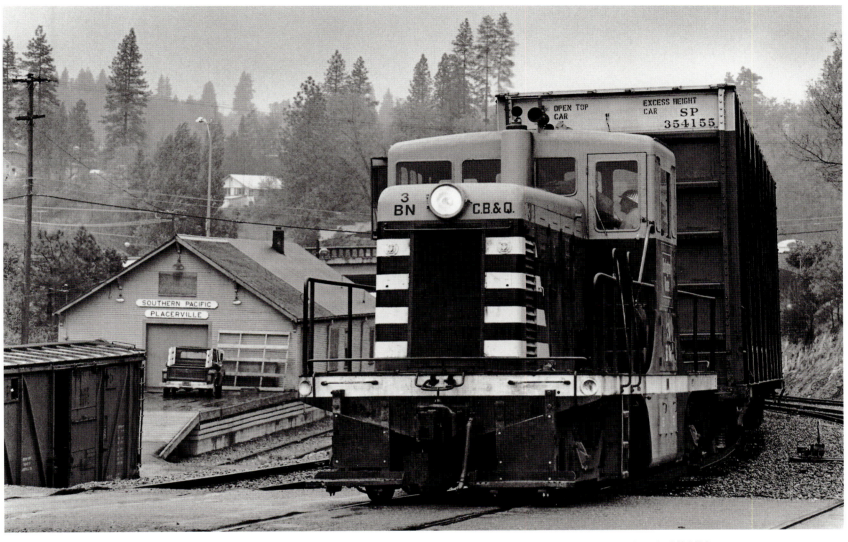

Three hundred eighty horses and a 3-percent grade—Camino, Placerville & Lake Tahoe Railroad. 4/24/72

General Electric diesel salesmen found a number of eager customers on the shortlines of Northern California in the years after the Second World War. Few cared that GE's 44-ton unit packed a paltry 380 horsepower. Light rail and spindly bridgework more than offset foothill grades exceeding 3 percent.

A rainy April Monday in 1972 saw the heroically named Camino, Placerville & Lake Tahoe Railroad pulling the SP interchange at Placerville for the climb back to Camino. Running 8 miles between the first two points and nowhere near the later, CP< was ushering in a second generation of GE power with Burlington Northern No. 3, a CB&Q unit rolled out of Schenectady in February 1941. Plans to abandon the SP line brought the end of CP< operations in 1986.

Descending from Summit—California Western outside Willits, California. 8/14/85

A wet day on the Crowley Loop—4/17/71

Tracing the Noyo River through majestic stands of sequoia and fir before looping over the Coast Range on 3.5-percent grades, the California Western Railroad has enchanted multiple generations of railfans and tourists on its 40 scenic miles between Willits and Fort Bragg on the Mendocino coast.

Faced with a growing demand for seats on the motor cars that began local passenger service in 1925, the Redwood Route made a bold move in 1965, purchasing a second-hand steam locomotive (Baldwin 2-8-2 No. 45) and resuming full train operation. Regally dressed in vermilion and red with accents of gold and black, the "Super Skunk" turned the railroad into a travel agent's dream. Sold-out steam service brought the addition of a second locomotive in 1970 and increased capacity for special excursions. Early in her CWR career, Baldwin 2-6-6-2 No. 46 contributed to the cloud cover on a stormy day at Summit, staging a spectacular run-by for the assembled photographers. Any comfort attached to "working the cushions" was tempered by the conductor's need to inspect the train while descending Crowley Loop in a Mendocino monsoon.

Few railfans complained when the economy of regular diesel operation later forced Cal Western to supplant its roster of Baldwins with a trio of Alco RS11's from the Southern Pacific. One mile below Summit, CWR engine 61 eased toward Willits accompanied by the distinctive whining wheeze of Alco dynamic brakes.

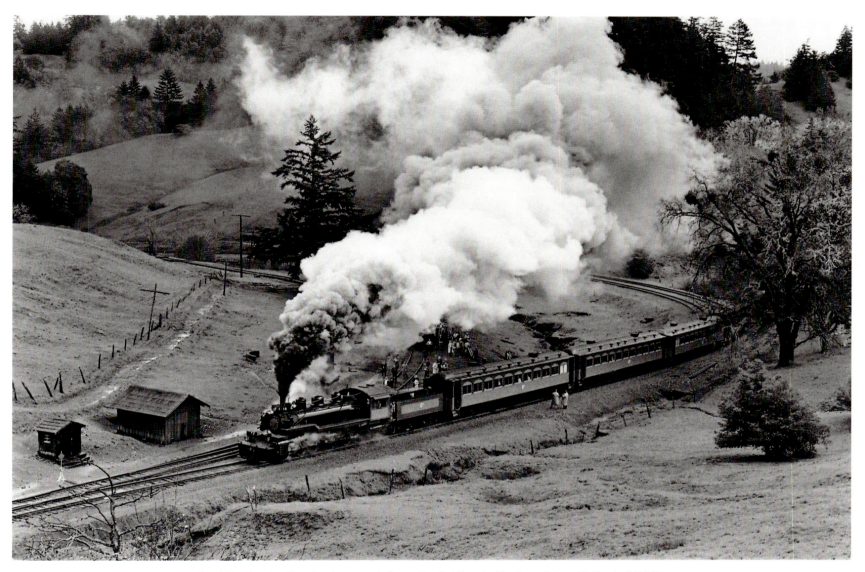

Contributing to the cloud cover at Summit—California Western Extra 46 West. 4/17/71

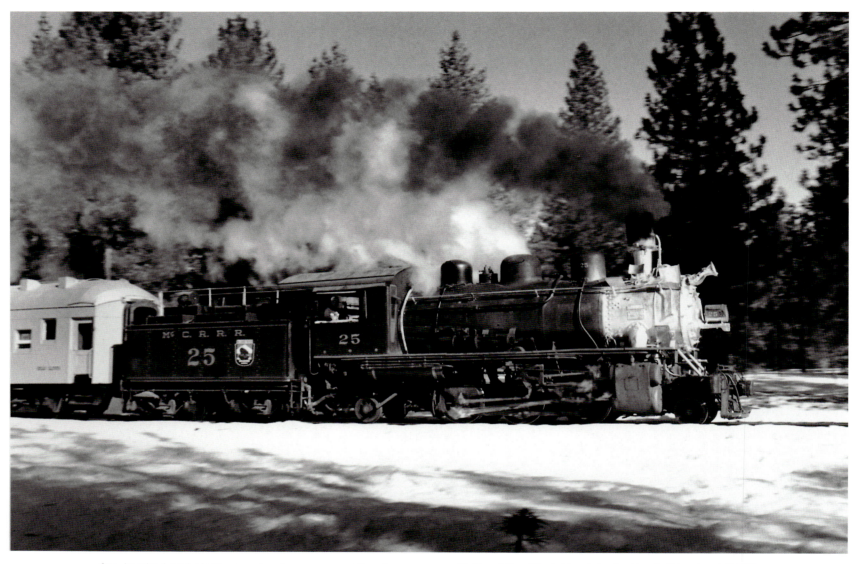

One hundred and eighty pounds of pressure on the steam gauge—McCloud No. 25 strides into Bartle, California. 1/26/75

With 130 miles of mainline in the shadow of majestic Mount Shasta, the McCloud Railroad evokes the image of a classic western log-hauler in 1999, surviving on the interchange of forest products to erstwhile SP and Great Northern lines in Northern California and thriving in the continued operation of steam locomotive No. 25.

Seventy-two tons of perky Alco Prairie, the 1925 Schenectady product still sends her Nathan chime whistle echoing through the woods at Bartle, California, where a January weekend in 1975 found engine 25 cavorting in the sun. "Is there a prettier 2-6-2 than No. 25?" *Trains* Magazine inquired in October 1971. "No way."

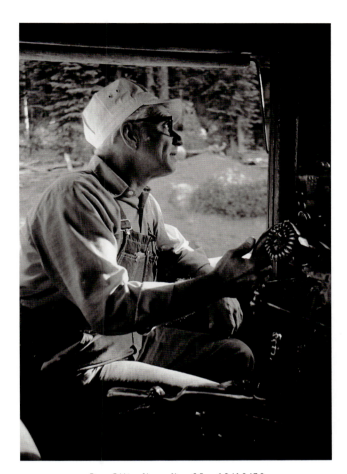

Ray Piltz fires No. 25—10/10/70

Few locomotives had a better friend than engineer Ray Piltz, whose service pre-dated the Second World War, when the line was known as the McCloud River Railroad Company. Equally at home on either side of the cab, Piltz was never happier than the days when No. 25 had 180 pounds of pressure on the steam gauge and a train full of smiling excursionists in the wake of her 46-inch drivers. With hands strong enough to coax the maximum performance out of any McCloud locomotive and a gentle appreciation of his employer's place in history, Ray Piltz was a perfect ambassador for shortline railroading in the 1970s.

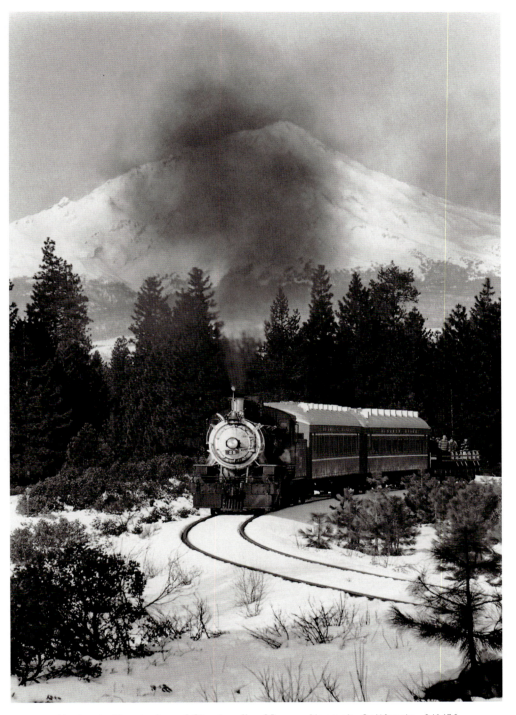

At play in the shadow of Shasta—No. 25 near Algomah, California. 2/1/70

Oregon, California & Eastern Railway—Klamath Falls, Oregon. 6/8/70

"Has Uncle Bob sold us out?" The citizens of Klamath Falls, Oregon, were outraged when promoter Robert Strahorn announced the impending sale of his Oregon, California & Eastern Railway to the Southern Pacific in 1925. Completed into the Sprague River Valley in 1923 to tap the timber reserves east of "K-Falls," the OC&E became a pawn in the chess game between SP and Great Northern's Inside Gateway line building south from Bend, Oregon. In allowing GN access to southern Oregon (and ultimately California through the Bieber extension in 1931) the ICC made the OC&E joint property of SP and GN, who in turn operated the line on a rotating basis.

In June 1970, the ink was barely dry on the Burlington Northern merger agreement and OC&E effectively remained in the hands of the Big G, whose plywood-paneled red cabooses rested outside the battered coach that served as a yard office in Klamath Falls. Morning rain accompanied the assembly of empty logging flats for Bly and Sycan, where Weyerhaeuser Timber's private railroad took over to serve the last great rail logging system in Oregon. The clouds were gone by late afternoon, when the road crew aboard Great Northern SD9 No. 599 and a trailing GP9 rambled though the "parachute" near Olene and negotiated the 2.06 percent over the switchbacks on Bly Mountain. Sold to the timber company in 1975, OC&E hauled its last logs in 1990 and was scrapped in 1993.

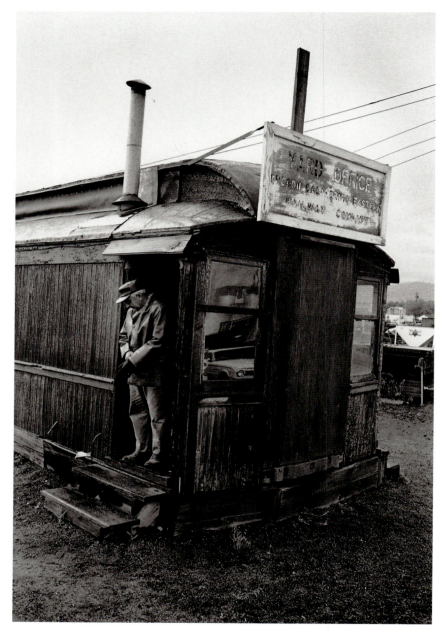

Monday morning in Klamath Falls—6/8/70

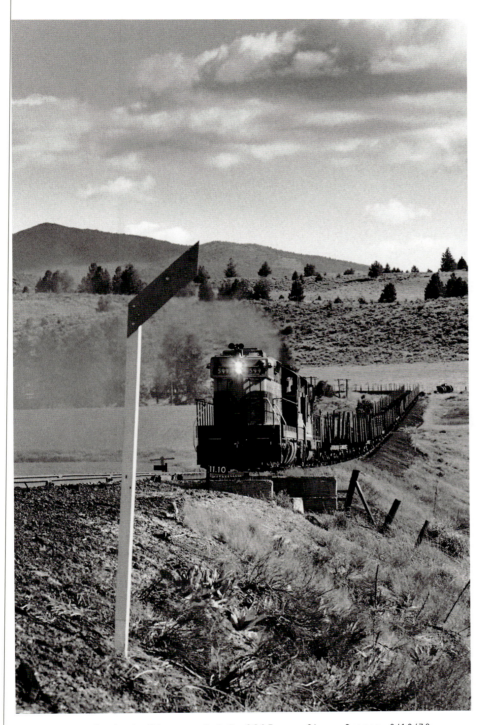

Sycan Hauler in "the parachute"—OC&E near Olene, Oregon. 6/10/70

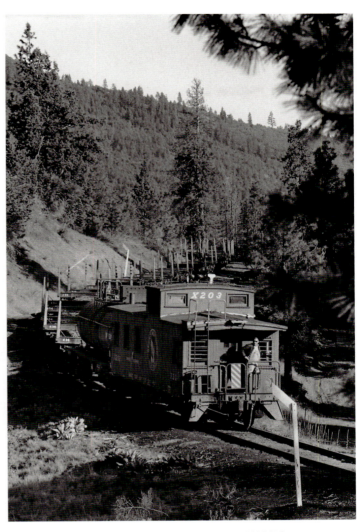

Switchback on Bly Mountain—6/10/70

Milwaukee 873 in search of the great unknown—5/10/74

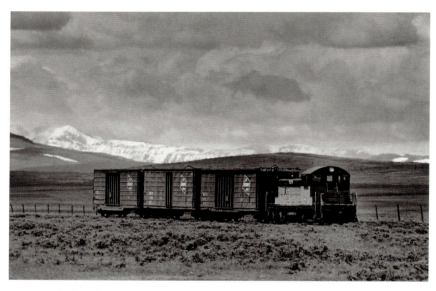

A shortline with an impressive set of initials—WSS&YP near Ringling, Montana. 5/10/74

There was a time in my life when the White Sulphur Springs and Yellowstone Park Railway was no more than an impressive set of initials in a photograph by Richard Steinheimer. Ringling, Montana, was the setting for a Jimmy Buffett song where electric trains ran by "once or twice a month" and White Sulphur Springs, the other end of the 22.8-mile railroad, might as well have been on Mars.

All that changed on the morning of May 10, 1974. Following a pair of Milwaukee Road "Little Joe" electrics west of Harlowton, I crested the Belt Mountains on Montana 294 to discover the rusty rails of the WSS&YP hosting the passage of three empty woodchip cars behind a Milwaukee SW1. What to do? The attraction of the shortline was strong; the thrill of exploring the unknown almost overpowering. But doing so meant giving up the chase of Number 263. With the Milwaukee electrification entering its final month of operation and a day train on Pipestone Pass, I could not let the big railroad go.

WSS&YP became a 15-minute experience—a total of 13 negatives exposed in three views north and south of the 294 crossing. I promised myself to come back in the future and invest the hours I couldn't spare on this dramatic day. The return never happened. In August 1980, the WSS&YP was abandoned following CMSt.P&P's closure west of Miles City.

And Milwaukee Road Train 263? Its pursuit culminated in the image on page 120. The result speaks for itself.

Heading home under a big sky—Fifteen minutes of fame for the White Sulphur Springs & Yellowstone Park Railway. 5/10/74

Where rails roam a raw, rare land—Nevada Northern Railway south of Currie. 9/17/76

OUT WHERE A TRAIN IS A TRAIN

He stood at the crest of the Sierra Nevada on a July afternoon in 1851, scanning the horizon from a dry, treeless mountain saddle, long hair flowing in the wind and a century of experience crammed into 50 years of living. Jim Beckwourth was the last of his kind—"a character straight out of Cervantes," in the estimation of Bruce MacGregor, writing in *Portrait of a Silver Lady*—a mountain man and scout "near the end of more trails than one." This low crossing on the backside of California's mountain wall was his last claim to fame—the place sure to put his name on the map. To the west he saw the headwaters of the Feather River flowing into the verdant canyon of its Middle Fork. To the east lay the "whirlwinds, savages and hell holes" of Utah Territory. Shaking the dust off buckskins stained as black as his face, the mulatto mounted up and rode west.

Jim Beckwourth wasn't alone in his assessment of the land east of the Sierra. Crossing his namesake pass for the first time in 1970, enroute to a rendezvous with Western Pacific's Reno Local, I took one look at the vast bleakness of Nevada and concluded there was nothing there. I'd been here before, on a family vacation to Idaho in 1956,

and despite the haunting refrain of "The Wayward Wind" that flowed out of every radio and jukebox between Modesto and Coeur d'Alene, there was no fascination in Nevada—nothing that could begin to make me a slave to my wandering ways. It was, as history would teach me, the Great American Desert. I was thankful we were making the crossing in a Ford Fairlane. How the emigrants managed in Conestogas was beyond comprehension.

All that changed in June 1973. Enroute to Colorado and a first encounter with a new/old *Zephyr* friend, MacGregor and I found ourselves crossing the wasteland of Nevada one Saturday afternoon, savoring the meteorological display above and the railroad activity the clouds framed below. We left Reno with hearts and steering wheel set on Salt Lake City. We wound up in sleeping bags behind a wooden section shed on the Southern Pacific–Western Pacific "paired track" east of Elko, awakening Sunday morning to find Rio Grande diesels on westbound SP tonnage and determining there was indeed "life after Deeth." Another day passed before we set eyes on Utah. While I enjoyed riding and photographing the wistful maverick known as the *Rio Grande Zephyr*, one indelible

Half a world behind their backs—Union Pacific 6926 East and Amtrak Number 5 West near Green River, Wyoming. 3/25/74

truth remained: I couldn't wait to get back to Nevada and all its glorious nothingness.

The next trip was the charm. It was April 1976, and empowered with a commitment from *Trains* Magazine to publish a photo essay on railroading in Nevada, wife Liz and I set out for Caliente, Ely and Wendover. En route we encountered weather ranging from brilliant sunshine to heavy snow, dispatchers willing to provide lineups to total strangers, a shortline whose hospitality knew no bounds, and an anonymous trucker with a cable winch who saved our shiny new Ford van from an alkali mud-laden grave. One trip begat another, and in January 1978, the resulting photo selection filled an entire issue of *Trains*. As editor Morgan had rightly surmised, all 122 subscribers in Nevada were enthralled. The rest of the readership had mixed emotions. Some found the Silver State "captivating." Others considered 35 pages of sage and sand the biggest editorial mistake the magazine had ever made.

Defining the desert's attraction is not easy to do. No educational discipline can replace the experience of being there. And when it comes to field studies in the Great American Desert, there are many avenues of exploration. Start by throwing your academic arguments through the wind-wing as you drive across Nevada on US 50—the loneliest highway in America—topping one mountain range after another to find nothing but more mountains 50 miles in the distance.

For Nevada is not the classic Sonoran terrain one associates with most desert areas in the Southwest. Nevada, Utah and Wyoming are anything but flat. Seen from the air, the land resembles a gigantic bowl of mashed potatoes. In this regard, commercial flight is another good introduction to the landscape, particularly if you're trying to place the green gash of the Humboldt River in proper perspective against the unrelenting umber of the rest of the land.

For my dollar, though, take the train. Amtrak Number 5, the westbound *San Francisco Zephyr* on its pre-1983 Union Pacific routing, was always a good choice, particularly in the years when the train had to back in and out of Cheyenne. Departing Denver in mid-morning to march over Sherman Hill at lunchtime, Number 5 spent the long afternoon skimming across southern Wyoming on UP's glass-smooth doubletrack, holding to a rulebook 79 most of the way. Laramie, Rawlins, Green River—all stood out in their isolation, a string of oases along a steel highway with nothing but nothing for a hundred miles in any direction. West of Green River it was a special delight to take a vestibule for the last minutes of daylight, hoping to photograph at least one eastbound freight before a brakeman escorted you back to your seat.

For it was here, in the great American desert, that one could fully comprehend what David P. Morgan described in the March 1966 *Trains* as "the pilot-to-caboose miracle of the freight train." It was here, on twin strands of steel less than five feet apart, that one could understand "why the railroader and the gallon of locomotive fuel oil produce up to five times more transportation than their counterparts in trucking." It was here that one came to learn that the only "nothing" in this vast bleakness existed in the minds of those who thought it so.

This is the West our forefathers knew—a raw, rare land; the stuff of legend, the myth of the last frontier. This is Nevada and points east—out where a train is a train—and photographers become slaves to their wandering ways.

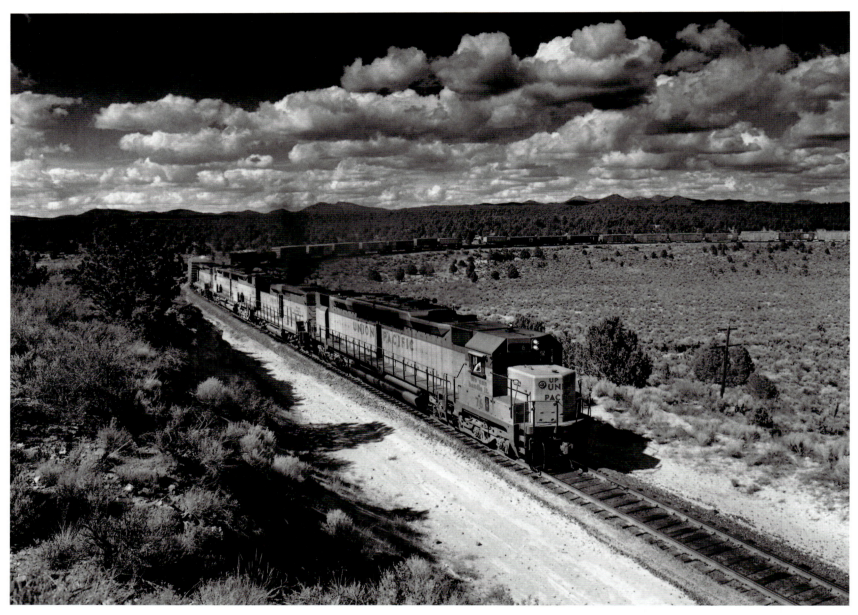

"Unlimited Power" on Crestline Curve—UP Extra 76 West, Crestline, Nevada. 9/14/76

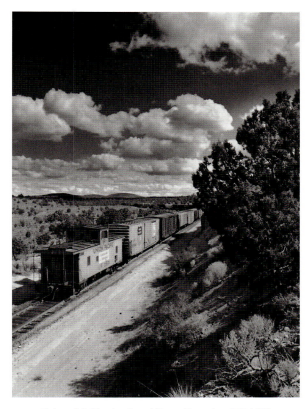

Extra 76 West—Crestline, Nevada. 9/14/76

With the wind at his shoulder, 91 cars on the drawbar and 14,450 horses in his left hand, the engineer on Union Pacific No. 76 tackles two 10-degree curves and a 1.03-percent ruling grade around the horseshoe curve at Crestline, Nevada, 4 miles west of the Utah line. UP lives up to its "Unlimited Power" billing on this September afternoon in 1976, sending westbound merchandise across the pinon-studded upland behind DD35's in cab and booster configuration, spliced by a pair of GP30B's.

Thirteen miles down the hill from Crestline, the empty coal hoppers of Extra 3719 East shatter the Sabbath stillness of Modena, Utah, roaring wheels echoing off the weathered wood of a general store bearing witness to a boisterous past. Two states to the north on this portentous May 18, 1980, the volcanic wrath of Mount St. Helens sweeps across southern Washington.

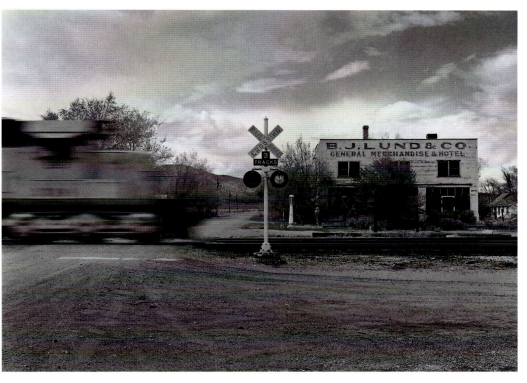

Eastbound with a vengeance—Modena, Utah. 5/18/80

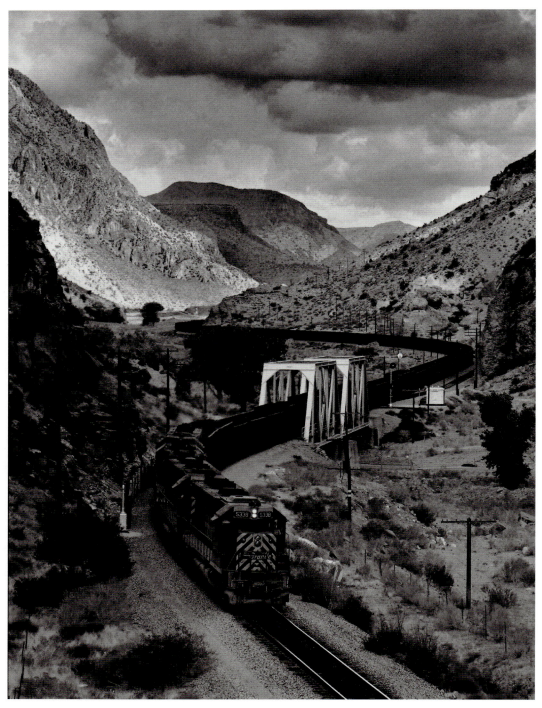

Kaiser coal in Rainbow Canyon—Boyd, Nevada. 9/15/76

Meadow Valley Wash south of Caliente, Nevada, defines Union Pacific's Salt Lake Route. Docile when dry and deadly when wet, Meadow Valley offers a near-water-level passage to Las Vegas in exchange for eternal vigilance. Bathed by the interplay of sunlight and cloud on a storm-clearing summer day, the *Kaiser Unit West* glides past Boyd siding and the spectacular sandstone of Rainbow Canyon. Shuttling coal between Utah mines and the steel mill west of San Bernardino, the Kaiser trains feature a power pool of Rio Grande and Union Pacific SD45's in the late 1970s. D&RGW 5338 does the honors on this edition of the California-bound loads.

Shorn of first-class service at Amtrak's inception in 1971, America's first 24-hour city brought passenger trains back to the Salt Lake Route in 1979 through persistent lobbying. Minutes away from the casinos of Las Vegas in May 1980, sundown finds the *Desert Wind* threading the hills east of Sloan.

Far from the bright lights of the "Entertainment Capital of the World," the steam-era division point of Caliente holds a few reminders of the glory years. Offering "Eats, Drinks, Beer and Slot Machines," the Train Service Store could fulfill almost every conceivable desire for the discerning desert devotee.

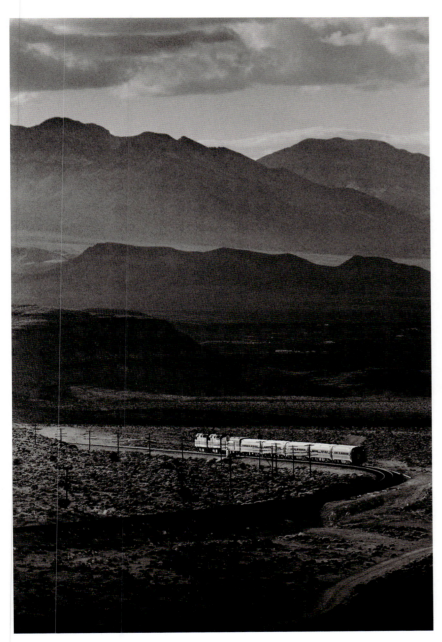

Sunset on the Desert Wind—Sloan, Nevada. 5/15/80

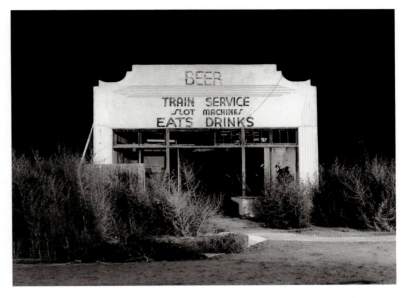

A ghost from a simpler time—Caliente, Nevada. 9/14/76

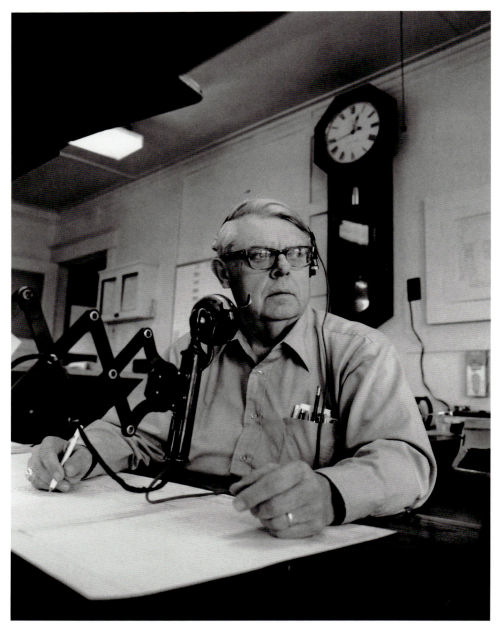

Chief Dispatcher Jack Whitehurst—East Ely, Nevada. 9/16/76

Nevada Northern No. 40—East Ely. 4/13/76

There's a railroad out there in the sagebrush a few miles south of Currie, Nevada, off US Highway 93, but you'd be hard pressed to find it if it weren't for the morning meandering of the Nevada Northern Railway. Subtract the brief intrusion of Kennecott Copper No. 101 with the southbound freight and little evidence of civilization remains in the shadow of the Cherry Creek Range.

Connecting the copper mines of Ely with the Southern Pacific and Western Pacific mainlines in the northeast corner of the state, the Nevada Northern Railway traversed 139 of the loneliest rail miles in American and did so without a single mainline bridge or tunnel. Marshalling a fleet of Alco RS2's on KCC's Nevada Mines Division and a sole SD7 for the mainline run, Chief Dispatcher Jack Whitehurst's East Ely office once bustled with activity. Battling recession and environmental concerns in the late 1970s, the ebb and flow of Ely's mining fortune brought many a long afternoon for NN. It would be years before a new lode, tourism, put a fire back in Ten-Wheeler No. 40 and a fresh glow on the copper-trimmed herald adorning her tender. Until then, Whitehurst had to content himself with sporadic bursts of production from the Kennecott smelter and occasional rambles by the prettiest "Cadillac" in the Silver State (page 63).

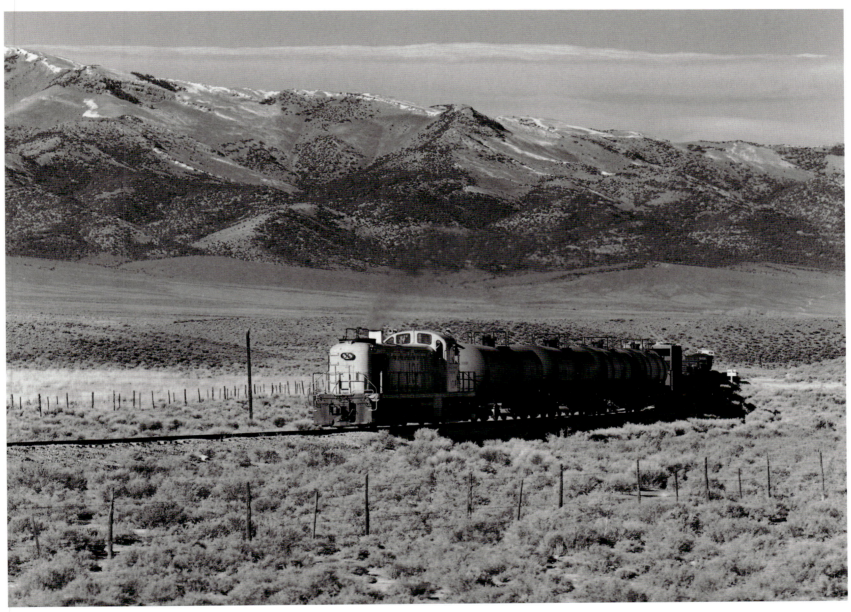

Stepping out in the Steptoe Valley—Kennecott Copper No. 101 near Goshute, Nevada. 11/15/77

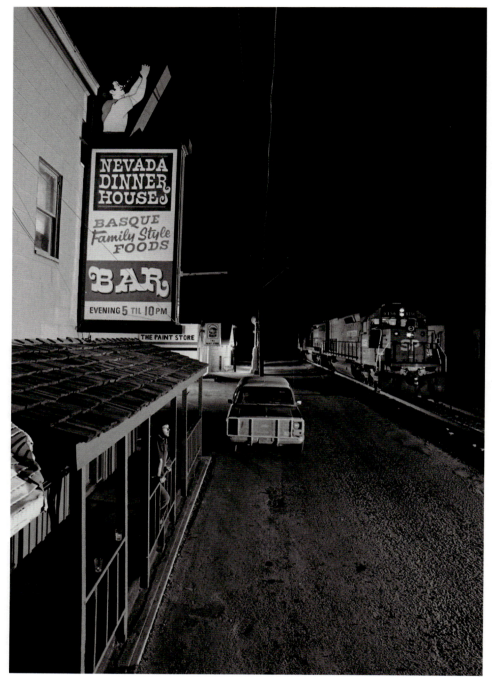

Center stage on Silver Street—Elko, Nevada. 8/5/82

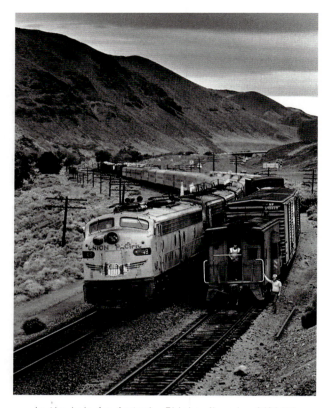

In the hole for Amtrak—Thisbe, Nevada. 6/23/73

It's 9 o'clock on a hot August night in Elko when Nevada Dinner House owner John Aguirre takes advantage of a late evening lull to step outside for some fresh air—just as the Southern Pacific claims center stage on Silver Street. With a fresh crew out of Carlin and a long haul to Ogden, Extra 9356 East fills the darkness with a throbbing urgency, eager to be free of the city limits and making track speed for Wells.

Two hundred and ninety miles west of Elko, a cloudy June Saturday in 1973 finds SP's Mina Local tucked into Thisbe siding for a meet with Amtrak Number 6. Elegant in spite of her battered yellow paint, Union Pacific E9 No. 948 leads a trio of SP FP7's and 12 cars of the *San Francisco Zephyr* into the desert east of Reno at the height of Amtrak's "rainbow" era.

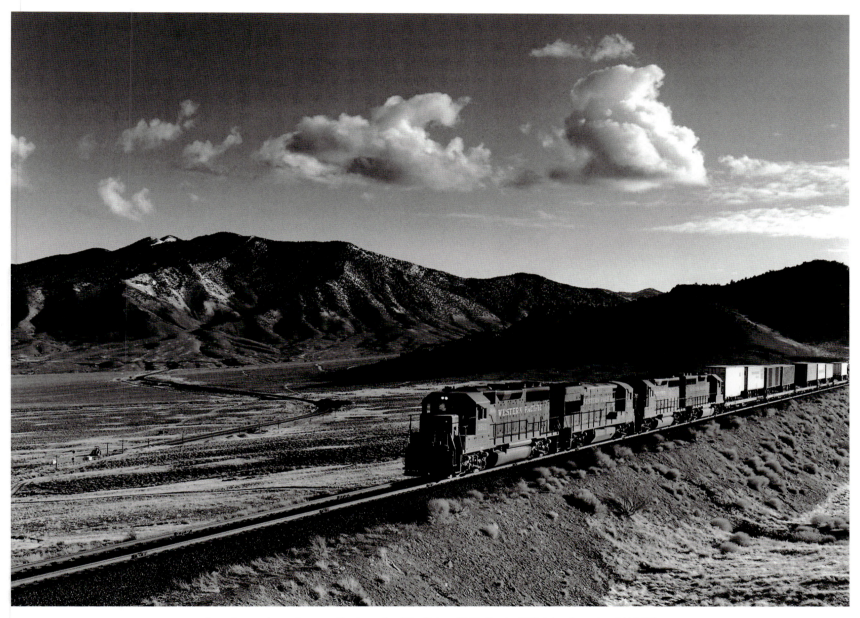

Four hours from Roper—Western Pacific Extra 3511 East. Clifside, Nevada. 4/14/76

A dozen air miles from the Utah line, Western Pacific's eastbound *Golden Gate Merchandise* descends Silver Zone Pass on an April afternoon in 1976, approaching Clifside and Arnold Loop behind a quartet of green hood units. Given a good turn into Salt Lake City by WP's Seventh Subdivision dispatcher, the crew of the "G" is four hours away from dinner at the Roper Yard Cafe.

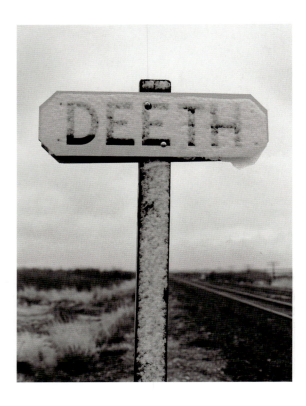

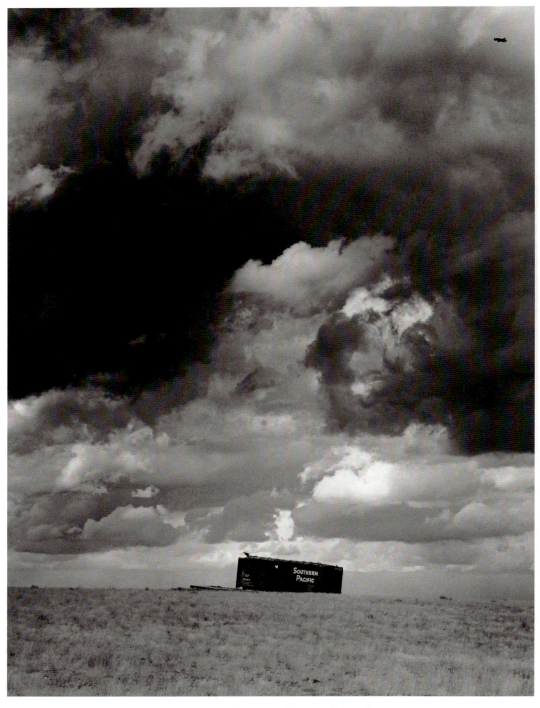

Judgement Day near Alazon—4/15/76

Montana prides itself on a big sky, but when it comes to meteorological majesty, the Great Basin is hard to beat. Here the Pacific storms pause to regroup, building energy for a run at the Rockies after dropping their first salvos on the Sierra. As a result, while Nevada and Utah see relatively little precipitation, the skies are not boring all day.

Case in point: April 15, 1976. Clouds building over the Ruby Mountains south of Halleck frame eastbound Southern Pacific tonnage behind four mileage-equalizing Rio Grande units. Ten miles to the east, fast-moving snow showers leave the station sign at Deeth with a frosty reminder that winter's not over, despite the date on the calendar. Twenty minutes later, the storm rolls over Alazon, leaving an abandoned boxcar beneath a heavenly harbinger of dark days to come in SP's Golden Empire.

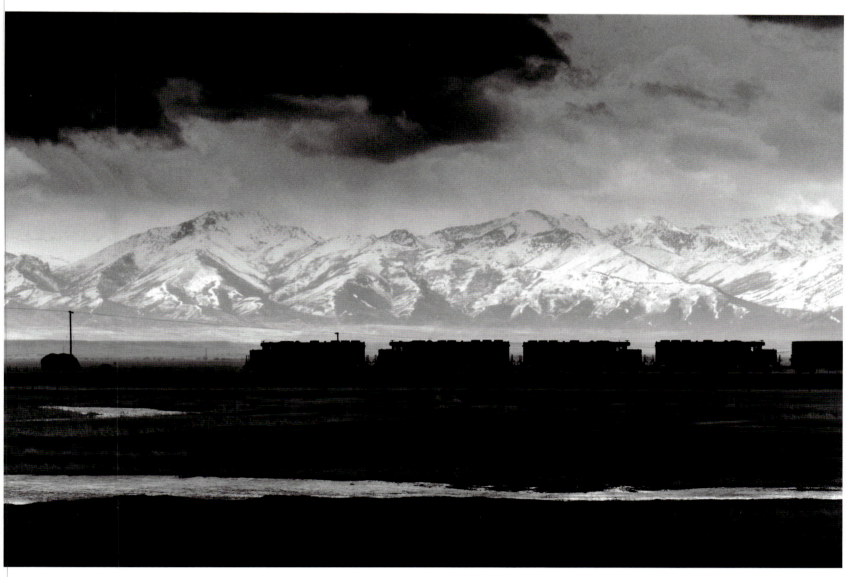

The stuff of legend, the myth of the last frontier—Southern Pacific west of Deeth, Nevada. 4/15/76

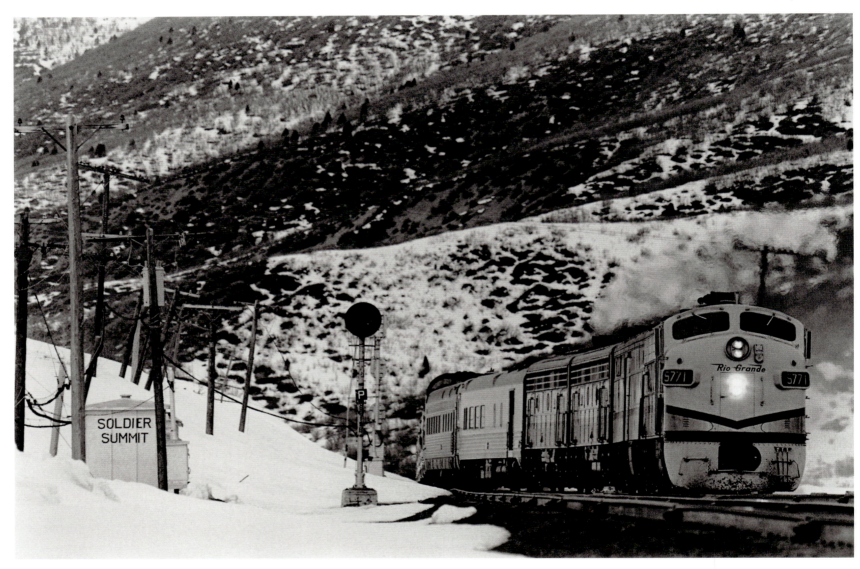

One with the gentle wind—Rio Grande Zephyr Number 18 approaching Soldier Summit, Utah. 4/10/83

HER SPIRIT WILL NEVER DIE

"'She's gone! It's all you can say; she's gone and there's nothing else we can do.'

"Don Drimmin, 18, of Oswego, Ill., was not talking about the girl friend who jilted him, nor the death of his grandmother," editor Richard Rodda wrote in the March 23, 1970, editions of the Fresno, Modesto and Sacramento *Bee* newspapers. "He was expressing the feeling of 300 *California Zephyr* passengers when the train pulled into Oakland last night on its final run over Western Pacific's famed Feather River Route."

The young man from Illinois spoke for everyone at trackside that warm spring afternoon, exhilarating in Number 17's last romp into the Altamont sunset (page 47) and filled with unspeakable sadness as the vernal moon glistened off emptying Vista-Domes in the Oakland yard. Charlie Hopkins and I wore black armbands to dinner that night, drawing sympathy from our waitress when she learned the big silver train that filled the windows at Sambo's would roll down Third Street no more. Who could forget March 22, 1970? Would anyone remember March 23rd?

Number 18's final run hadn't reached Union Station when Burlington Northern's tri-weekly "California Service" departed Chicago on that hazy fourth Monday in March. It was hard enough to imagine the *California Zephyr* on a BN timetable. Three weeks after the merger, it was more

difficult to picture the California connection including Southern Pacific's *City of San Francisco* and a *Rio Grande Zephyr*. The CZ had died, but not in vain. Her loss, more than any other, had inspired the creation of a national railroad passenger corporation that became Amtrak on May 1, 1971.

Simultaneously blessed and cursed, Amtrak made America's trains "worth riding again" by taking the national passenger service map and turning it into something resembling the "after" photo of cosmetic surgery for spider-web veins. The day before Amtrak, 259 "train pairs" filled the public timetables of America's private carriers; 122 remained on May 1. "California Service" was not included. There *was* a "California Zephyr"—daily from Chicago to Denver on BN and thrice-weekly to Oakland via SP-UP-D&RGW—but Amtrak's presumption of the Rocky Mountain route was unsupported by reality. On April 26, 1971, Rio Grande declined the offer.

"Through the Rockies—not around them."

When it came to running a mountain railroad, no one did it better than Denver & Rio Grande Western. The "Grande" didn't seek opinions on the subject—it provided them. Pioneering the "short, fast" concept of freight train operation, the "Action Road" maximized the capacity of a single-track main line where flat tangents were in short

supply. With one passenger train running one way six days a week (and never on Wednesday), Rio Grande wasn't about to cede control of the railroad to an outside carrier, much less pay $1.6 million to release its first line of public contact to an unproven government entity. On May 1, 1971, the D&RGW became one of six railroads operating passenger trains outside Amtrak's fold.

Rio Grande Zephyr—it's funny how fast your opinion of a name can change. In the summer of 1970—when Union Pacific's "City of Everywhere" ran 27 cars out of Cheyenne behind a half-dozen E units and Santa Fe unfurled green flags for separate sections of the *Super Chief* and *El Capitan*—it was hard to get excited about a train whose rolling stock rubbed salt in the wounds of the faithful. *RGZ*'s cars still carried *California Zephyr* lettering, for crying out loud!

By the summer of 1973, the only aspect of the *Rio Grande Zephyr* that *didn't* recall the CZ was the now-departed letterboards. My first *RGZ* miles came that June, one month before the Grande had its first opportunity to reconsider joining Amtrak. The faithful had no cause for worry. Scenery alone made the *RGZ* a popular run. There was rarely a dull mile in the 570 between Denver and Salt Lake City, though most patrons preferred to doze through much of the Utah desert. But scenery was only half of the experience.

A step into the *Zephyr*'s lounge and dining areas was a step back to the great streamliners of the 1940s and 1950s. Little had changed on a train that prided itself for the quality of its meals. All the old favorites remained on the menu. Such attention to detail made sense—many familiar faces remained on the service staff. Gilbert Espinoza was right at home in the same *Silver Banquet* galley he directed in CZ days. A faded Zephyrus still flew across his chef's

hat. Steward Mil Lundquist kept a gentle hand on the waiters and busboys, choreographing each sitting like a ballet on flanged wheels. Lounge areas in the *Silver Shop* and *Silver Sky* carried the same relaxed ambience that highlighted Feather River afternoons in the years before.

Quiet pride flowed at every turn. This was the passenger railroading we had grown up with—the passenger train experience we wanted to share with our children. For 13 years, one month and one day, the *Rio Grande Zephyr* made it possible, providing one extra season for traditional streamliner service in America. Just one of 259 privately operated intercity passenger trains on April 30, 1971, ten years later the *Rio Grande Zephyr* stood alone, the epitome of long-haul varnish in the CZ era and a safe bet to still be America's best.

Rio Grande tried to curtail the service just once, proposing a Denver–Grand Junction turn with buses to Salt Lake and Ogden in 1979. It would take four years to unintentionally implement the plan after a devastating mud slide at Thistle, Utah. By then, the *RGZ* had added connections with two new Amtrak schedules in Salt Lake and was running sold-out on an increasing number of occasions. In the end, the train would succumb to most of the same ills that claimed her predecessor. Shop forces had coaxed all they could out of the *Zephyr*'s 40-year-old rolling stock. Popularity alone couldn't stop losses of $3 million a year. Discontinuance wasn't an option and Rio Grande refused to run a train that was less than its best. Suddenly, Amtrak wasn't that bad an idea.

Amtrak welcomed the opportunity to reroute the Superliner *San Francisco Zephyr* over the "Scenic Line of the World." A proven operator and a good one at that, Amtrak had come a long way in 12 years. Now, Amtrak schedules moved across their contract carriers like any

"She's gone and there's nothing we can do"—Salt Lake City station. 6/22/73

other unit train, generating revenue *and* profits for many roads. When the new national timetable was issued on April 24, 1983, Amtrak finally had a *California Zephyr* and Rio Grande had a new customer.

Trains 17 and 18 went out with a flourish that final spring, ten cars, six domes, and a timeless blend of aesthetics from Budd, Pullman, Alco and EMD. For one last time on an incomparable stage, the *Zephyr* carried the style and substance of the steamlined era into the national spotlight. Graceful to the closing curtain, her spirit was one with the gentle wind.

Her spirit will never die.

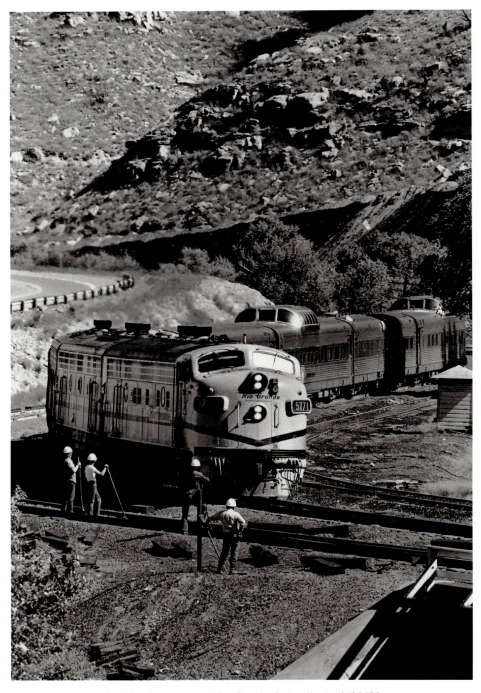

Roll-by for Number 18—Castle Gate, Utah. 6/22/73

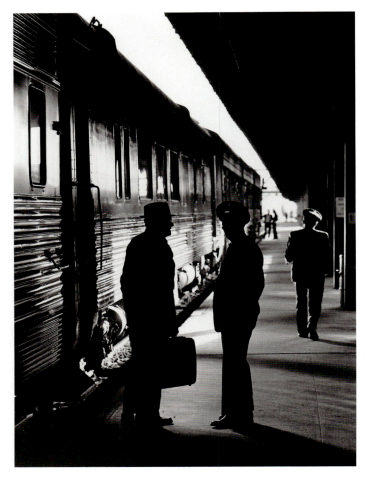

Denver Union Station. 6/21/73

Celebrated by *Trains* Magazine editor David P. Morgan as "God's gift to people who like railroading," Denver Union Station was a fitting home for the train that provided one extra season of traditional streamliner service in the 1970s and 1980s. Two major mountain crossings confronted the *Rio Grande Zephyr* on her 14-hour, 10-minute run—the Front Range of the Rockies on the climb to Moffat Tunnel and Utah's Soldier Summit, 450 miles west of Denver on the last lap to Salt Lake City. Dynamic brakes whining on the 2.4-percent descent from Kyune, eastbound Number 18 slides past a tie gang at Castle Gate, Utah, minutes away from the crew change at Helper and another successful crossing of the Wasatch Range.

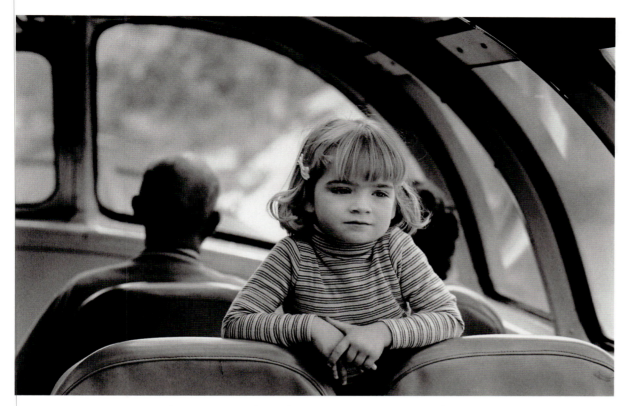

A passenger train to share with our children—4/12/83

It made no difference if the trip was your first or your fiftieth, Soldier Summit in a Budd Vista-Dome was an unparalleled location to experience the *Zephyr*. Eastbound near Gilluly on April 12, 1983, Jessica Benson's introduction to the "Silver Lady" was both a beginning and an end. Two days later, a massive mud slide near Thistle, Utah, forced the *RGZ* to turn at Grand Junction for the last four trips of the train's career. Nine years before, a perfect double-track meet at Gilluly was one of many highlights on a weekend celebrating a quarter century of *Zephyrs* on the Rio Grande. Freight power up front attests to a full passenger load behind as Number 18 assaults the 2-percent ruling grade on the march toward Soldier Summit.

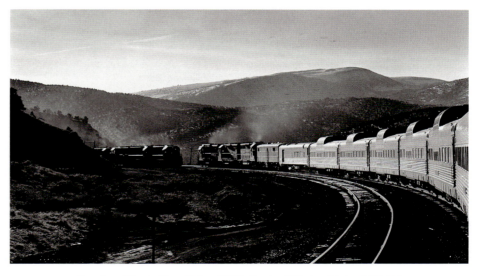

Number 18 meeting Extra 3091 West—Gilluly, Utah. 3/24/74

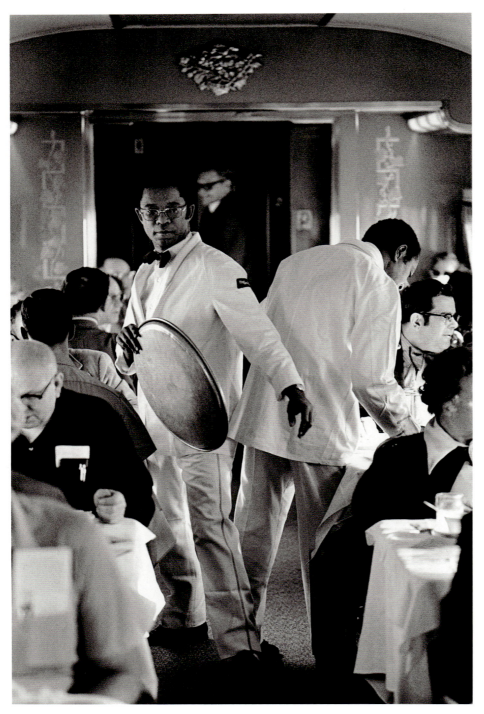

A ballet on flanged wheels—Lunch on the *Silver Banquet*. 3/23/74

They made it look so easy.

Occupying one of the 48 seats in a restaurant racing over the badlands of eastern Utah at 70 miles per hour, you'd look across tables set with with crisp linen and heavy silver and marvel at the economy of movement displayed by the service staff of the *RGZ*'s *Silver Banquet*. Waiters Robert Mays and Leon Smith moved gracefully through the crowded dining room, each step choreographed by years of teamwork and pure instinct; waiter's waiters—with all the pretty, fine moves the Pullman manual never taught. Thirty miles per hour around the curves west of Kremmling; you couldn't hold your camera straight—Irving Faison served the coffee and never spilled a drop. Eighteen hours a day, six days a week—half a life on the railroad away from home. You never saw Irving without a smile.

Step into the galley at the other end of the diner and it felt like a steel mill on wheels. Relentless smoke and heat and Chef Gil Espinoza with his Number Two and Three cooks turning out four-star fare from a steamy, stainless cubicle 6 feet wide and 20 feet long. From the first call to breakfast to the last seating for dinner—from griddle cakes with link sausage and Rio Grande Special French Toast to boneless Rocky Mountain Trout, London Broil, the Rio Grande Chef's Salad Bowl and spinach, German style—the visual feast outside the diner window was matched by the treats within.

And it would be a pleasure to serve any item not listed on the menu if it were available. You had passenger and dining car service director Leonard J. Bernstein's word on it.

They made it look so easy.

You knew it wasn't the truth.

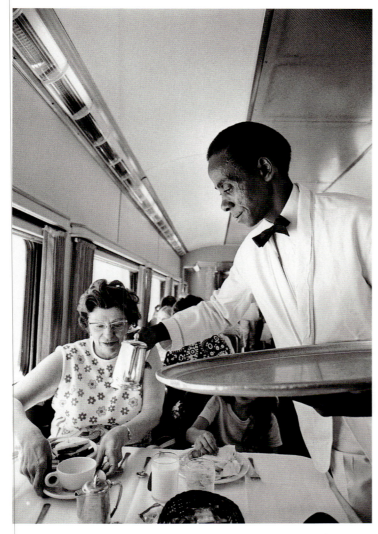

Coffee and a smile—Waiter Irving Faison. 6/21/73

Four-star meals at 70 miles per hour—Chef Gilbert Espinoza. 3/23/74

*As you travel over this bountiful land of ours,
may you ever be reminded of the grace Almighty God
has bestowed upon us. Let us acknowledge our debt to Him
with prayers of thanksgiving.*

Blessing on the *Zephyr* menu, 1949–1983

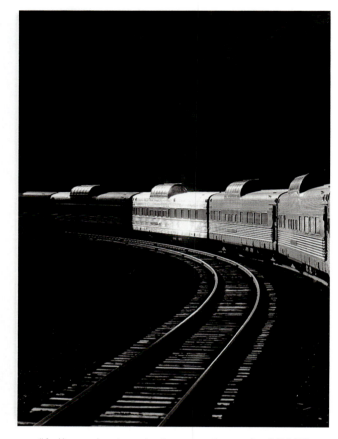

"A diamond set against gray and green"—3/24/74

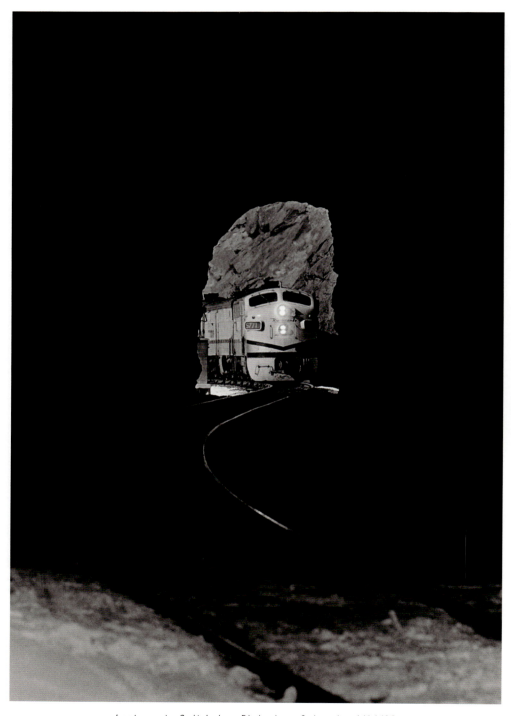

Last run to Salt Lake—Plainview, Colorado. 4/14/83

Thursday April 14, 1983. No one knows it as Number 17 whistles into Tunnel Three, the second of 26 tunnels between Pinecliffe and Plainview, Colorado, but this is the last train to Utah. Tonight, half a hillside will fall into Spanish Fork Canyon; tomorrow's *Rio Grande Zephyr* returns via Wyoming and the Union Pacific. No longer will Number 18 mirror the Wasatch morning sun above Thistle, "a silvery diamond set against gray and green mountains...the brightest object in sight, no matter what the distance," in the words of writer Don Phillips. No longer will Number 18 balance atop Soldier Summit, her engineer mixing throttle and air for the smooth descent into Helper. Ten days from eternity, *Zephyr* stands at the mountaintop, contemplating the fields of Jordan.

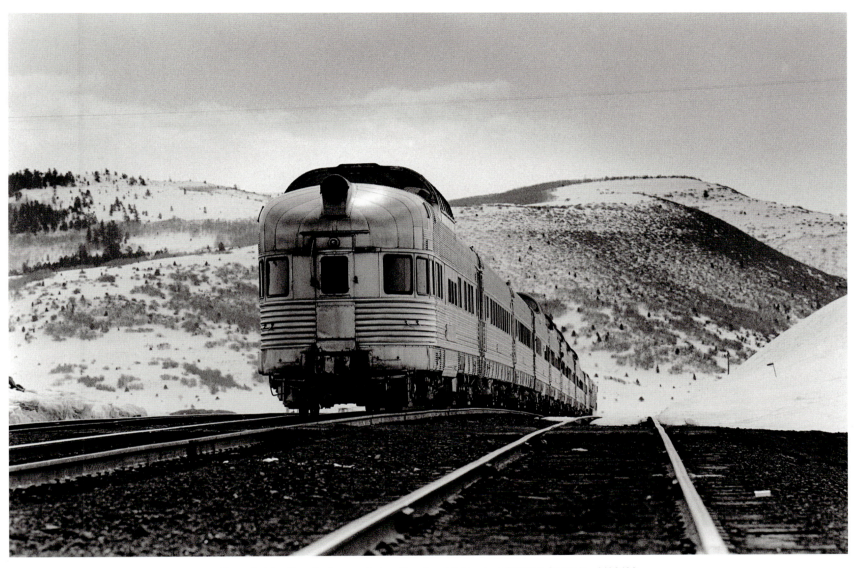

Graceful to the closing curtain—Number 18 leaving Soldier Summit. 4/10/83

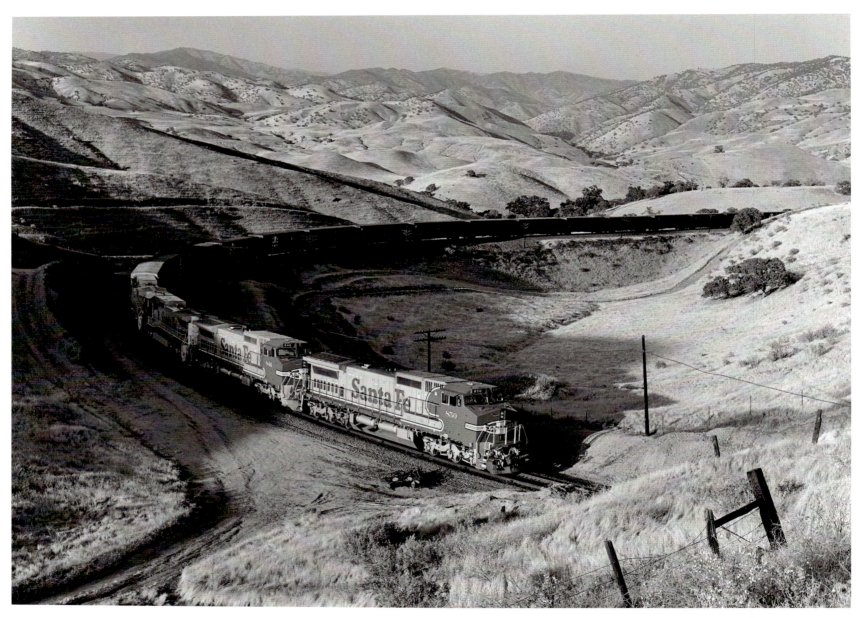

Warbonnets on Tehachapi—Extra 850 East at Tunnel Two. Caliente, California. 6/16/92

CHAPTER SEVEN

SOMETHING ABOUT THE SANTA FE

"Atchison. Topeka. Santa Fe."

One look at the street names on a city map is all you need to know about the genesis of Riverbank, California. Situated on the south bank of the Stanislaus River, 100 miles northwest of Fresno and 94 miles southeast of Richmond, Riverbank owes its existence to a populist monopolist, a Free Soil Abolitionist and their mutual love of a crusade. Given the political climate of California in the 1890s, it required no less than the messianic determination of Claus Spreckels and Colonel Cyrus Holliday to wrest the state from Southern Pacific's oppressive grip— that and the mystical attraction of the unholiest of holy cities: a place called Santa Fe.

Located in 1897 and renamed by the post office in 1898, Riverbank was founded to honor an official of the San Francisco & San Joaquin Valley Railway, the "people's road" built to break SP's monopoly in central California. Established on the $5 subscriptions of local farmers and succeeding on the $50,000 ante of sugar magnate Claus Spreckels, whose support opened the bankbooks of San Francisco's anti-monoply clubs, the SF&SJV was completed between Stockton and Bakersfield in the summer

of 1898. Sold to the Santa Fe that December, the "Valley Road" completed the chain connecting America's heartland with the Golden Gate. Established as a division point in 1912, Riverbank was the final link.

Cyrus K. Holliday wasn't thinking of places like Riverbank when he stood in a shady grove at Wakarusa, Kansas, on April 26, 1869, and told the gathered multitude of his dream for a railroad stretching far beyond the 7 miles back to Topeka—a railroad reaching to Chicago, St. Louis, Galveston and San Francisco—and yea, unto Mexico City. Like most Kansans, Holliday came from somewhere else—in his case, Pennsylvania—and he arrived in 1854 with a briefcase full of dreams and a zest for life. He was a lawyer, legislator and an officer in the militia, battling on both fronts to keep slavery out of Kansas. Once the Civil War was over, Holliday decided to make some money in the business he knew best. Having drawn one charter for a railroad in Pennsylvania, he laid the legal foundation for a road to Santa Fe.

Seven hundred and eighty empty miles separated Waukarusa and the legendary trading post that defined the exchange between the United States and Mexico

13 decades before NAFTA—780 miles less the 7 back to Topeka. On April 26, 1869, the Central and Union Pacific line was two weeks away from uniting the nation and sparking a wave of transcontinental railroad-building. Holliday's battles with the forces of human slavery were a perfect warm-up for the war he faced with the robber barons, tackling the economic peonage of California with the same zeal he employed on the Border Ruffians. It took 25 years for the Atchison, Topeka & Santa Fe to reach the Golden State.

Once it did, it never let go.

Collis P. Huntington joked that there was plenty of room for a second railroad in California—the track centers need only be 13 feet apart. In truth, SP did all it could to keep the SF&SJV well beyond arm's length. In the larger communities, SP's land holdings drove the line away from civic centers. Smaller cities were often bypassed. In the country, the railroad disappeared altogether. The Santa Fe ran 5 miles east of Modesto and I was nine years old before I knew it was there.

Fortunately, AT&SF wasn't a secret to local passengers and shippers. Serious rail competition came to town in 1911 with the building of the Modesto & Empire Traction Company, whose "traction" never came from electric locomotives. Starting with 5 miles of main line and adding 35 miles of side track, M&ET became a model of family-owned industrial development, a sparkling example of shortline railroading with an operating ratio so low company officials wouldn't discuss the issue. Following Santa Fe's lead, M&ET embraced diesel power and piggy-back freight early in the game. By the 1990s, up to three daily intermodal trains originated at Empire along with the last solid boxcar train in the valley—Santa Fe 952 carrying a full lading of eastbound Gallo wine (page 86).

Growing up in the heart of SP's Golden Empire, there was always something about the Santa Fe, something foreign and out of place. Take Riverbank, for instance. My first visit came in the spring of 1958 when we drove over to meet Dad's boss returning from a business trip on the *San Francisco Chief*. Before this bright Sunday, I'd only seen pictures of Santa Fe trains. I was eager to see those red and silver F units in real life.

I'm not sure why we went to Riverbank. The regular Modesto stop was 6 miles south at the M&ET connection in Empire. Riverbank's division terminal was flag-only, but we didn't know it then. Not long before Number 1's scheduled arrival, an operator stepped out of the depot to post train orders. That was odd—I'd never seen SP's *San Joaquin Daylight* take orders off the stand in Modesto. Of course, I'd never seen the *Daylight* go through at 70 miles per hour the way Number 1 did a few minutes later. Add "terrifying" to "foreign and out of place."

Entering my teens, "mystery" was another adjective attached to the Santa Fe. Why was a railroad so imposing in print so dead in real life? You could spend hours at Riverbank and see the *Chief*, a *Golden Gate* and maybe one freight—provided the agent let you hang around that long. Other local roads tried to be friendly to their youthful admirers. Most Santa Fe people I met couldn't wait to show me the door.

Years later, AT&SF became the most accomodating railroad around. Newspaper stories on changes in *San Francisco Chief* operations gave a young photojournalist the professional entrée denied a teenager. Happily, I did get to ride a John Reed-era Santa Fe passenger train, discovering service every bit the equal of my beloved *California Zephyr*. Unhappily, that ride came 12 days before Amtrak sent the *Chief* to the happy hunting ground. The pain only grew when I learned how close AT&SF came to staying out of Amtrak. Santa Fe was a revelation in the early 1970s.

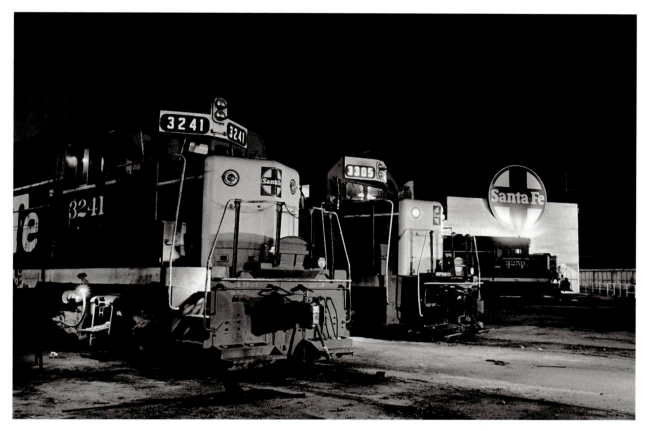

Unashamed to be a railroad—Bakersfield roundhouse. 3/10/73

I admit it—Santa Fe wasn't my favorite line. But I'd be a hypocrite not to confess a deep and abiding sense of loss at the company's merger with Burlington Northern in 1995. Few American industries had such immediate and positive name recognition. No other American carrier was so unashamed to be a railroad.

Case in point: September 1985. In the process of assembling a newspaper feature on the ill-fated SP merger, arrangements were made to ride the cab of Santa Fe's hottest freight, westbound intermodal train 199. How far would we like to go? The length of the Valley Division, 441 miles from Barstow to Richmond? No problem. Any

preference for power? How about one of the newly rebuilt ex-Amtrak SDP40F units?

Public relations man Mike Martin was apologetic about the trio of F45's following Santa Fe 5254 out of Barstow in the pre-dawn glow of September 11, 1985. Barstow's washing facilities were out of order and the trailing units carried a light film of road grime. The company preferred any equipment appearing in the media to be sparkling. But no apologies were required for engine 5254.

Her gleaming exterior was a tribute to the ineffable pride of the Atchison, Topeka & Santa Fe. Barstow's maintenance crew had polished the unit by hand.

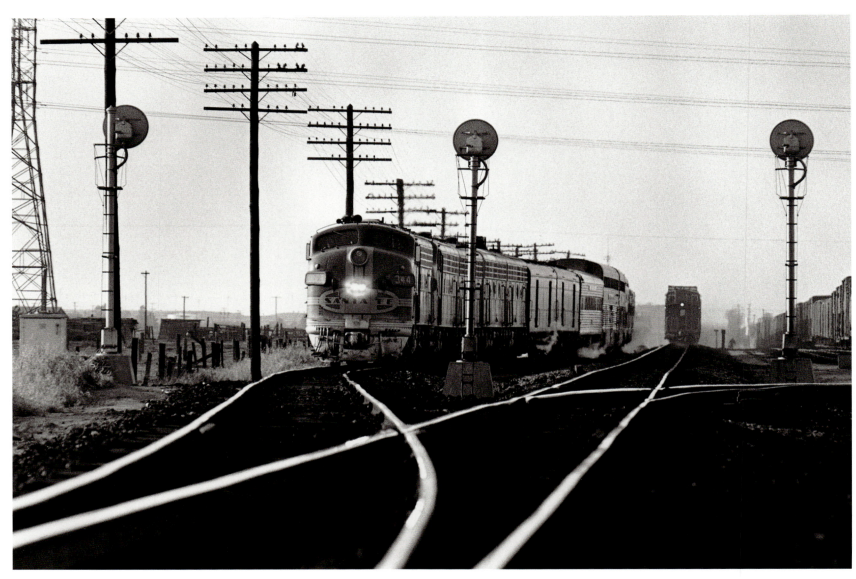

Two minutes off the advertised—Number 2 at Riverbank, California. 4/27/71

Fresh linen in Bedroom B—4/20/71

A warrior in repose—Richmond, California. 3/2/68

"Super Railroad!" *Trains* Magazine didn't spare the superlatives in its January 1954 cover feature on the Santa Fe. "Probably the best-managed, most efficiently operated railroad system in the country," remarked author Wallace Abbey, barely qualifying his praise. As a former employee, Abbey's enthusiasm could be questioned, but not his conclusion: "There has never been such a railroad!"

The *San Francisco Chief* entered service that same year, the last transcontinental streamliner launched before Amtrak, and the first Vista-Dome on Tehachapi. Half a century after Santa Fe passengers first arrived in San Francisco, the Valley Road became a "*Chief* way." Trains 1 and 2 weren't spectacular—beyond the Big Domes, most of the coaches, diners and sleepers were already on the roster. The route east was equally ordinary—three days and two nights across the Southern District with a full 24 hours to savor the scenery between Winslow, Arizona, and Amarillo, Texas, including 30 minutes to stretch your legs at Clovis, New Mexico. Up front, the *San Francisco Chief* played no favorites, alternating power between EMD F-series diesels and sleek Alco PA's. Take away the domes and Numbers 1 and 2 were pretty typical trains.

Which is to presume *any* Santa Fe passenger train could be called "typical" during the lifespan of the *San Francisco Chief.* Start with her inaugural in 1954, the year Boeing intro-

duced the 707 jet airliner and two years before the establishment of the Interstate highway system. The *San Francisco Chief* added Hi-Level coaches in 1964, a year before rival SP declared rail passengers "vanishing Americans." While AT&SF sold its last Alco PA in 1968, F7's remained on the train to the final week. Given more operating latitude, Santa Fe wouldn't have joined Amtrak.

So take another look—at Number 2 getting out of Riverbank two minutes off the advertised after meeting the hot NCX symbol freight; at Pullman porter Frank Peppers making up a berth on Number 1; at Alco 58 resting at Richmond before a last passenger assignment. This is the Super Railroad we lost forever on May 1, 1971. Long may her memory run.

"Dress Blues" at Walong—3/24/72

Warbonnet helper at Tunnel Two—12/28/91

William Hood never drew a paycheck from the Santa Fe, but that didn't stop the civil engineer from standing forever in the company's debt. The expressions of gratitude rarely fade from the Tehachapi Mountains where diesels dressed in the Holy Cross thunder their thanks over 67.28 miles of some of the most spectacular railroad in the world. While Hood's survey around Tehachapi Loop was a matter of expedience and common sense, the result of his vision was anything but common. One century after hosting its first Santa Fe trains, Tehachapi remains a dramatic stage for mainline mountain railroading.

Considering the economic forces at play in the 1890s, it's surprising how fast Southern Pacific invited California's second transcontinental railroad to share the line between Bakersfield and Mojave. Santa Fe had plans for an alternate route when the agreement to share Tehachapi was inked in January 1898. Seven decades later, the matter of which player blinked first was irrelevant to the photographer standing outside Tunnel Nine at the Walong loop, listening to the gathering roar of eastbound Santa Fe tonnage. What mattered was the fresh paint on FP45 No. 5946, passenger power a year earlier that had just swapped red and silver for Santa Fe "dress blue." No one could have predicted the scene at Tunnel Two two decades later, where FP45 No. 98 worked as a mid-train helper in the classic Warbonnet colors restored to Santa Fe's premium power by image-conscious president Mike Haverty.

April 1998 found an eastbound intermodal at Tunnel Ten bringing the future into focus while recalling the past behind a General Electric DASH 9-44CW wearing the Great Northern-inspired merger livery of the Burlington Northern & Santa Fe Railway. Colonel Holliday's road would never be the same, but there would always be something about the Santa Fe.

Where the future becomes the past—Eastbound near Marcel, California. 4/17/98

Mainline meet on the freeway for freight—Maine, Arizona. 7/31/91

Anything but grand—7/16/87

For years it was "The Grand Canyon Line" with Santa Fe trains running right to the rim. By 1987, the line to the canyon was anything but grand, out of service since 1974, with pine trees growing between the rails at Grand Canyon station. Happily, that image would change in 1989 with the establishment of the Grand Canyon Railway and tourist service out of Williams. Resurrection seemed only right. If there's one railroad *never* associated with overgrown and out of service, it's the Santa Fe in Northern Arizona.

This is America's freeway for freight, paired mainlines from Barstow to Belen, where 70 m.p.h. at 7,000 feet is standard operating procedure. Case in point: Maine, Arizona, where passenger trains back off to 79 from the 90 boards out of Kingman and intermodal freights meet at a closing clip in excess of 100 m.p.h. Topping the Arizona Divide at Riordan, the power on Extra 5978 East slides into full dynamic brake for the 1.42-percent descent to Flagstaff, running left-handed in deference to the track crews who keep the Seligman Subdivison an engineer's dream come true.

Coming down from the Divide—Riordan, Arizona. 7/31/91

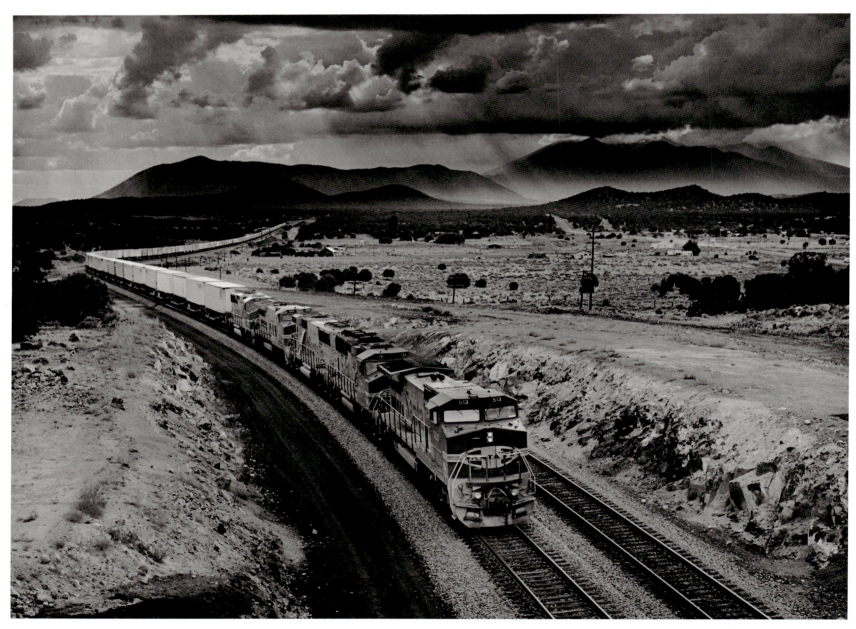

Afternoon monsoon and the 991—Darling, Arizona. 7/31/91

East of Flagstaff the Mother Road rolls gently down the Arizona Divide, abandoning piney uplands for the desert and New Mexico. Old Highway 66 is there for the finding, lurking in the shadows of the Interstate, conjuring up ghosts six decades old. Angell, Two Guns, Winona: the roadmap reads like chapter 15 of *The Grapes of Wrath*, particularly Winona, where a cinder-block service station and delicatessan recalls a weary waitress, two truck-driving saints and nickel candies sold two for a penny to some tractored-out Okie kids.

Northwest of Winona, the San Francisco Peaks dominate the horizon, their 12,000-foot spires defining the lower left corner of the Navajo holy land. Forty-five miles to the west, Bill Williams Mountain marks the turnoff to the Grand Canyon's south rim. The gods of storm inhabit these high places—beacons for blizzards and magnets for monsoons. The land is a photographer's paradise. If you don't like the sky, wait five minutes. You'll see a year's worth of weather in one day at Winona.

The same is true for trains. Santa Fe was here long before Highway 66. Established as Walnut in 1882, Winona became Darling in 1959—an overpass, on the Winona-Townsend Road, two main lines, sidings and a spur. It's a place to exchange blocks of freight, pull ballast hoppers out of the cinder pit, and stay clear of the 40-odd trains that pass every day. It's a great place for pictures.

The view of an eastbound train approaching Darling is a familiar one. The place has been a staple of AT&SF advertising imagery since Dust Bowl days. Be it the heavyweight *Super Chief* behind boxcab diesels or Warbonnet hoods on intermodal freight, no place defines the railroad so well.

One could call Darling a cliché. Any number of fine images can be found in the 292 rail miles between Winslow and Needles. Some days you'd be happier if Darling *was* just a postcard, purchased off the rack at the Winona Trading Post while you put down a pastrami and a pale ale and waited for the summer storm to abate.

For those days—when the only colors are black and white and every conceivable shade of gray—are the days you can't stay inside.

Because on the right day, with the right light, Darling transcends time.

If you don't like the sky, wait five minutes—7/17/87

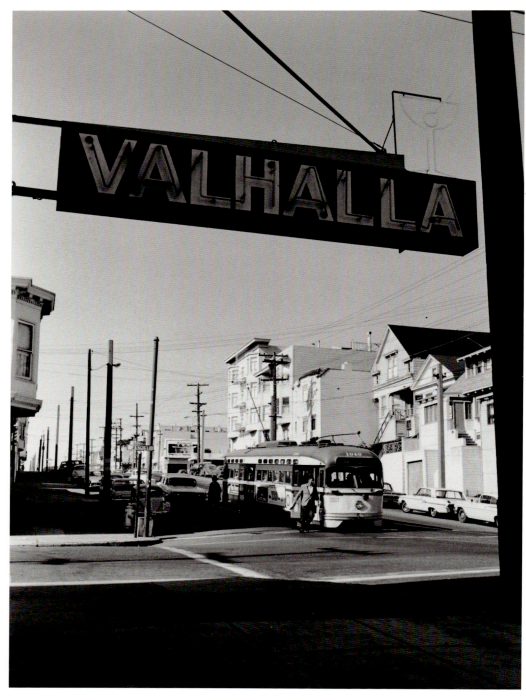

A streetcar to Valhalla—San Francisco Municipal Railway J-Church line. 4/11/70

BENEATH
THE SINGING WIRE

In the pre-central-air-conditioning 1950s, an open window on a summer night was a living timetable for railroading in Modesto, California. As sure as it was 9:30 p.m., the sweet chime of Southern Pacific's *West Coast* would roll in from the west, announcing every grade crossing south of Salida on Train 60's overnight run from Sacramento to Los Angeles. Ten o'clock brought another melodic horn from the north, saluting a dozen side streets before passing five blocks from our home. Once the Tidewater Southern came to town, I could roll over and call it a night.

"Tidewater Southern"—now there was a heroic name for a 50-mile country interurban. TS promoters envisioned a swift, electric alternative to Southern Pacific, running south from "tidewater" at Stockton's waterfront all the way to Fresno. In reality, the Tidewater never got beyond Hilmar, 6 miles south of Turlock, where a handsome stucco depot awaited passenger trains that never came. Electrified to Modesto in 1913, nine daily round-trips were carded over the 33 miles to Stockton in 1916, beating the SP for frequency and speed and doomed from the start by paved parallel roads. Passenger service came to an end in 1932.

Modesto's electrification lasted until 1947 thanks to a city ordinance forbidding steam operation over one mile of 9th Street, where TS parted the traffic lanes of US 99. Controlled by Western Pacific since 1917, the Tidewater Southern Railway was just another dieselized branchline by 1953 (page 38). Trolleys in Modesto? Who would have known?

Which is a pity, for trolley transit defined a city at the turn of the 20th century. By 1913, Frank Sprague's Electric Railway & Motor Company had placed scores of communities on the map. Stockton, Sacramento and Fresno all had city lines running into the 1940s—Modesto did not. Yet what did it matter? By the mid-1950s, America's city and interurban electric lines were all but dead—victims of corporations as singular and collective as General Motors, Standard Oil, and Firestone Rubber. By 1963, San Francisco was home to the last municipal railway on the West Coast. From Portland's pioneer interurban to the Red Cars of Southern California, few forms of rail transportation died faster than electrification. In 1970, "the city" had literally become a Valhalla to the vanquished warriors of a noble cause.

Electric in every way—YVT on Pine Street.
Yakima, Washington. 9/17/74

Electric: the word carries two basic definitions, one scientific, the other emotional. When it comes to railroading beneath the singing wire, both definitions apply. The scientific benefits of electricity are beyond reproach. Connect the power supply to the vehicle, charge the brake line and go. No boilers to fire, no diesel fuel to idle away and no solid particulates to foul the atmosphere. Whether 150 horsepower or 5,000—it's there for the opening of a breaker and the raising of a pole or pantograph.

Emotionally, electric railroading grows on the aficionado like no other means of propulsion. It's raw power arriving with a whisper, allowing one to savor the subtleties lost in the din of conventional locomotion—the whine of traction motors, the woosh of their blowers, the chug of air compressors and the hissing twang of the catenary as a train approaches the observer. Majestic and mysterious, disarming in its simplicity and terrifying in its potential, railroading by the kilowatt hour was summed up by a sign in the Milwaukee Road shop at Deer Lodge, Montana in the early 1970s: "Men who know electricity best respect it."

There was the rub—to respect electricity you had to know it—and the only electric railroading I knew was the San Francisco Municipal Railway. Not that the "Muni" wasn't fun to ride in the days when 70 cents and two transfers took you all over town, but there was something unfulfilling about the experience. The PCC cars weren't much more than trolley buses on rails. Like a Cantonese dinner, they left you hungry for something more.

"Something more" arrived on August 31, 1966, with the purchase of Richard Steinheimer's *Backwoods Railroads of the West.* While tormenting me with the lost glories of the Pacific Electric and Sacramento Northern, "Stein" also

shared the knowledge that an honest-to-goodness interurban still rumbled down the streets of Yakima, Washington. Why there was even a narrow-gauge electric line as close as Davenport, California! Beyond *Backwoods*, a growing number of Steinheimer's photographs in *Trains* Magazine depicted the astonishing electrification of the Milwaukee Road in Washington, Idaho and Montana. It took more than 70 cents and two transfers to get there, but electric railroading in the West was still available for those with a desire to explore.

My wife, Liz, and I began our voyage of discovery in July 1972. Road maps of Idaho and Montana wore circles around the communities of Avery and Deer Lodge while the State of Washington had arrows pointing to Othello, Tacoma and Yakima. There was no denying the powerful image of the Milwaukee Road under wire. Avery and Deer Lodge more than lived up to the brag. The real sleeper, though, was Yakima.

The instant we set foot inside the blackened brick carbarn of the Yakima Valley Transportation Company, 50 years fell off the calendar. Shopmen welcomed us into their midst, offering ample information on operations and setting the stage for an equally gracious reception from the train crew. No courtesy went ignored. We rode the train as much as we pursued it for pictures. My initial impression of the YVT was one of "Sacramento Northern reborn." I was wrong. It dawned on me years later that, with its oasis of irrigated farmland and economy keyed to agriculture, Yakima was another Modesto. True, YVT had SN's hills, but the street running, refrigerator cars and friendly crew could only mean one thing: I'd found another Tidewater Southern, electric in every way.

Disarming in its simplicity—Motorman Mel Lucas, YVT. 7/21/72

The "Davenport Electric" was no secret to California railfans in the late 1960s. Making photographs of the operation was another matter. Tucked into the hills behind the Pacific Cement & Aggregates factory 11 miles north of Santa Cruz, the 3-mile narrow gauge shuttled limestone out of the quarry on San Vicinte Creek in total obscurity. Requests to enter the property for photographs were routinely denied, even to members of the press. Built to standard gauge by the Santa Cruz & Portland Cement Company in 1906 and electrified to 3-foot gauge in 1922, Davenport's mining road was determined to spend its life away from public view. By the winter of 1969–70, with the original quarry playing out and a conveyor belt being built to limestone deposits farther up the canyon, documenting the line seemed a lost cause.

So it came as a pleasant surprise in late 1969 to meet railfan friend Charlie Hopkins in San Jose and see his latest photographic effort—the Davenport Electric! "How'd you get these?" I asked. It was easy, Charlie replied, detailing directions for a surreptitious walking tour of the railroad. Security? "The crews don't care as long as you stay out of the way."

Hopkin's advice came to fruition on a rain-filled Monday, January 19, 1970. Davenport's diminutive juice jacks were more charming than ever imagined. The red Baldwin boxcabs from 1914 had changed nothing but their Golden Glow headlights in the decade since Dick Steinheimer had photographed them for *Backwoods*. The four-wheel hoppers trailing the 18-ton, 180-horsepower motors up and down San Vicinte Creek looked like European refugees. Coming out with the loads, some places had an aura of the Milwaukee Road hauling limestone. Running in reverse with the empties, other locations could have been Switzerland.

The rain rolled off the ocean all afternoon and by the time I got back to Davenport for a hot bowl of clam chowder, the zipper on my camera bag held a light film of rust. By the time PCA closed the mining railroad on August 27, 1970, the film in the bag had turned to gold.

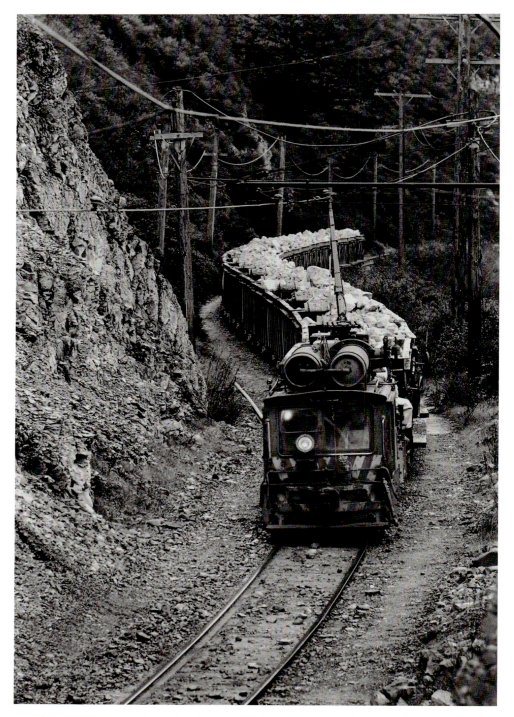

The Milwaukee Road hauling limestone—Pacific Cement & Aggregates. 1/19/70

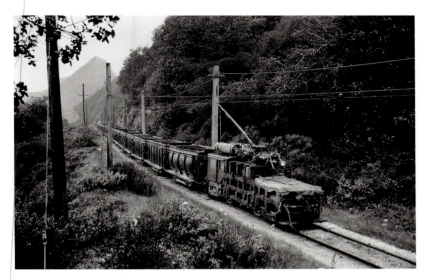

"It could have been Switzerland"—1/19/70

Davenport, California. 1971

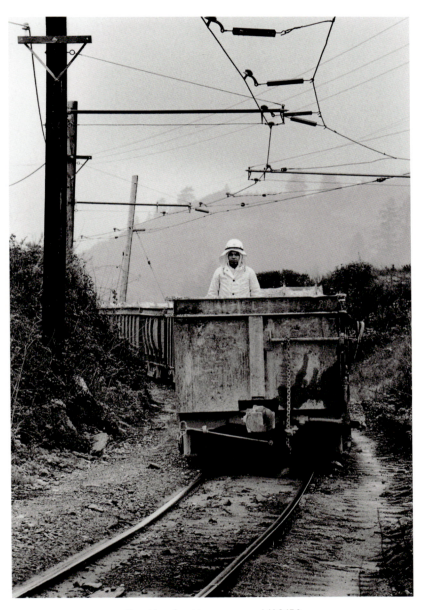

Empties for the quarry—1/19/70

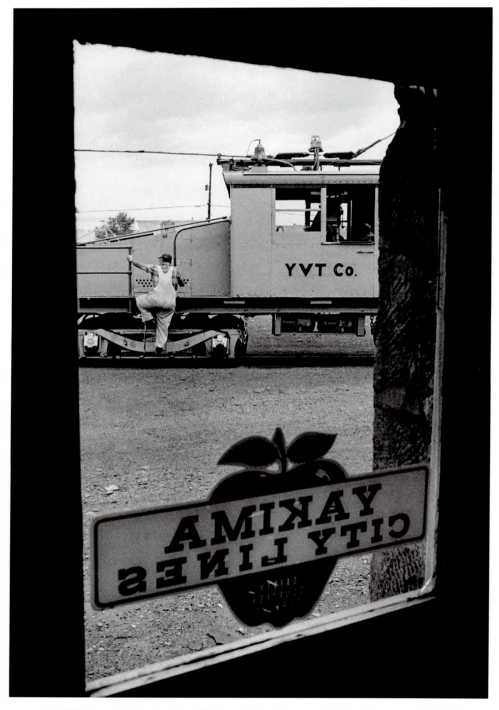

Union Pacific's last interurban, Yakima Valley Transportation was a vision of functional antiquity in the early 1970s. A time capsule of tradition from 1907, YVT spread 20 miles of light steel across its namesake valley, tapping sawmills and packing sheds to forward a steady stream of apples, peaches, pears and pine to the old Oregon Railway & Navigation interchange in Yakima, Washington. Close to 3,000 cars a year were exchanged in 1974, a good half of UP's total carloadings in the valley, and the most romantic waybills originating on America's "automated <u>rail</u> way."

A pair of 50-ton freight motors handled YVT tonnage, with General Electric steeplecab No. 298 doing the bulk of the work. Built new for Yakima in 1922, the 298's design harked back to the origins of electric railroading in the 1890s and predated the visibility of low-nose diesel hood units by six decades.

Going to work outside the carbarn office of Yakima City Lines, whose buses assumed YVT's last passenger service in 1947, motorman John Kilsiemer climbed aboard No. 298 to head for the UP interchange, where a venerable Electro-Motive NW2 cleared the lead in deference to the GE product 20 years her senior. The durability of electric locomotives was borne out by YVT 298, whose revenue service ultimately spanned 63 years. Union Pacific 1034, a member of the railroad's first class of EMD switchers, left the Overland Route in 1977 after 35 years of work—a remarkable total for internal combustion power.

John Kilsiemer's day begins—Yakima Valley Transportation Company. 7/20/72

Two definitions of durability—UP No. 1034 and YVT No. 298 on the interchange at Yakima, Washington. 7/20/72

Shades of the Sacramento Northern—YVT outside Selah, Washington. 9/16/74

Line Car A to the rescue—9/17/74

Northbound for the packing houses at Selah, YVT 298 traversed the Yakima River Canyon in a scene reminiscent of Sacramento Northern in the Oakland hills. West of Yakima, motor 298 eased up behind Line Car A as linemen Bob Jones and Ray Villarreal attend to the collateral damage caused by an errant motorist. With the trolley support pole mended, No. 298 moved on to Ahtanum, exchanging one empty reefer for a load of apples before heading home at sunset.

Ten years would pass before YVT filed for abandonment, its freight revenues devastated by deregulation. Meanwhile, the revival of excursion trolley service in 1974 spurred preservation interests that kept the Selah line intact after freight service ended in September 1985. Fifteen years later, the wires still sing over Yakima—not as often, but just as sweet.

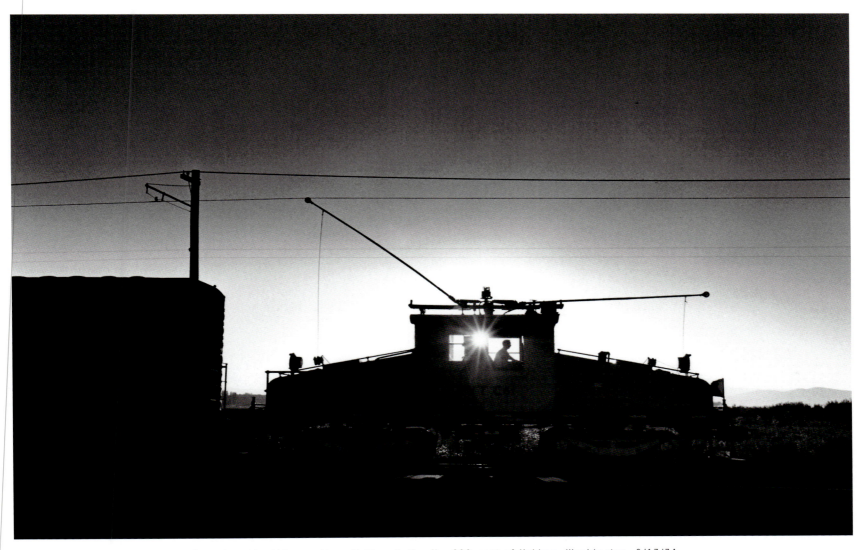

Sunset on the Ahtanum line—Yakima Valley No. 298 west of Yakima, Washington. 9/17/74

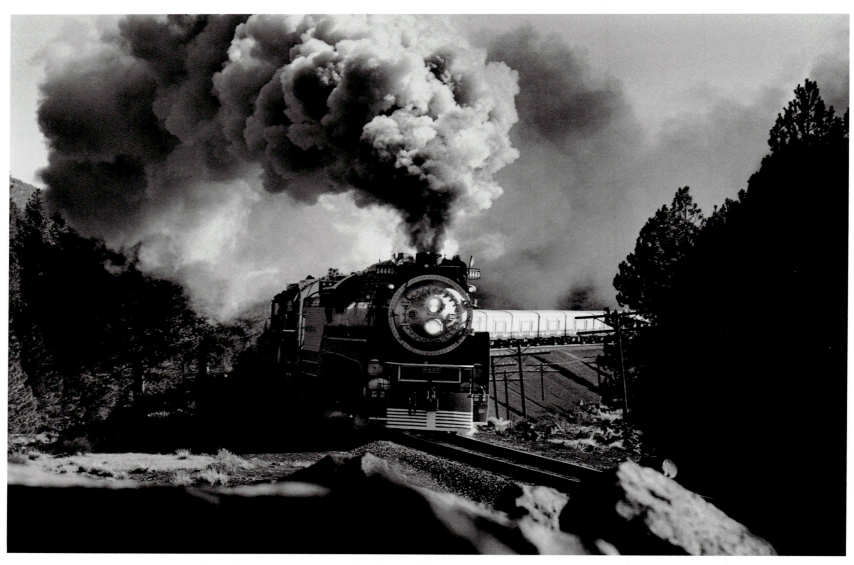

Assault on Grass Lake Summit—Extra 4449 West near Penoyar, California. 11/23/75

PORTLAND'S ROSE

Ding…ka-ding…Ding…ka-ding…

The arm of the Magnetic Flagman swung in mesmeric evenness, lulling the occupants of a 1955 Ford Victoria into the semi-somnolence of a 90-degree July morning in Modesto, California. Sharp notes from a single bell airhorn and the open-roll drum of a steam engine at 60 miles per hour shattered the interlude as Southern Pacific's Los Angeles-bound *San Joaquin Daylight* strode past Kansas Avenue in a red-orange-silver-black blur. Summer, 1956: SP Trains 51 and 52 were rolling into their final weeks behind the 80-inch drivers of locomotives born to run. Less than a mile from his stop, the engineer of Number 52 had just closed the throttle of the jet black GS-4 to "parachute" into Modesto, riding a full set on the electro-pneumatic brake to a perfect landing beside the station platform. Silver snout sniffing I. Street beneath a steel arch proclaiming "Water Wealth, Contentment, Health," the *Daylight* took a long drink from the east water column, her hogger laying a thin stream of lube oil on the valve motion as he planned his attack on the last lap to Fresno.

Two hundred miles to the south through a land once dismissed as "the long, lonely valley of dust and wheat," the world belonged to EMD FP7's, Black Widows supplanting the long-limbed Limas on the Bakersfield–Los Angeles run. Summer, 1956: Elvis filled the airwaves, but steam was still the king on the last long-haul, high-speed passenger service in the West. Modesto, California, six years before *American Grafitti's* summer of '62: you couldn't pick a better place to grow up with trains.

I'll never forget that final steam season for the *Daylight*. The conclusion of worship at First Presbyterian Church often coincided with Number 52's arrival, and many Sundays we'd dismiss just as the steam engine nosed under the I. Street arch, with my father driving down to the depot in time for the *Daylight's* departure. Dad was the voice of experience, telling me all he could about a train he knew little about. He was the business manager for the local Ford dealer and his railroad awareness belonged to more innocent times on the Milwaukee Road in northern Idaho. California was his adopted home; SP his adopted railroad. Whenever I'd ask for a train story, the subject always rolled around to the Chicago, Milwaukee, St. Paul & Pacific. By the time I began reading my own bedtime stories from a magazine published in Milwaukee, SP GS-4's were mere images on a printed page.

Five-hundred-odd miles north of Modesto, another young man had a far more tangible impression of Espee's elegant *Daylight* engines. Old enough to have fallen under steam's spell, but too young to have witnessed the glory days, Jack M. Holst and the chapter members of the local

National Railway Historical Society had assumed responsibility for the maintenance of three steam locomotives displayed in a park at Portland, Oregon. Two of them were 4-8-4's; one was SP 4449, retired in October 1957 and removed to Portland in April 1958. The years hadn't been kind to 4449. Moss grew under her boiler jacket and vandals had shattered her glass. A practical group of steam fans, Holst and his companions painted the Oaks Park locomotives from time to time while religiously oiling their driver journals, paying close attention to the spring pad lubricators on the SP engine. Holst knew that moss and broken glass were cosmetic concerns, easily repaired. Rusted, scored driver journals precluded much hope of the locomotives ever running again. Not that there was much hope to begin with—mainline steam was all but dead in the United States. But some day, if you kept the faith and kept them oiled...Jack Holst kept the faith.

"Some day" arrived on December 14, 1974. A nationwide search for a modern oil-burning steam locomotive to pull the *American Freedom Train* on a Bicentennial tour of the 48 contiguous states centered on Portland and 4449. It was love at first sight for AFT's Doyle McCormack and Andy Adams, who convinced their managers, city officials and the SP that an engine sitting outside for 16 years could be brought back to life in short order. Engine 4449 rolled into Burlington Northern's Hoyt Street roundhouse at 3:03 p.m. on December 14, 1974. Restoration commenced at 3:04.

At 7:46 p.m. on April 21, 1975, SP 4449 moved under her own power for the first time in over 17 years. At 8:02 a.m. on June 20, 1975, Extra 4449 West rolled south out of Portland Union Station, bound east to join the *Freedom Train*. With the blessing of SP president Ben Biaggini, Portland to Ogden, Utah, would be run over SP rails—the first steam operation on the railroad since 1958.

Jack Holst never saw the engine move an inch. The Portland planning engineer unexpectedly died following routine surgery in August 1972. But his spirit rode with the 4449 over every mile to follow, her restoration made possible by his oil can and dreams.

Jack was there on a warm June evening in 1975 when 4449 rolled into Klamath Falls, Oregon, to spend her first night on the road in 19 years. Jack was there on a crisp November morning five months later, when the *Freedom Train* stormed out of K-Falls to assault the eastern slope of Grass Lake Summit with the diesel helpers along for the ride and 4449 doing all of the work (page 108.) And Jack was there one week after that when a father and son parked beside California 99 south of Sacramento, waiting for the 4-8-4 to roll down the valley as it had 20 years before.

Now the young man was telling train stories the same way his father had shared so long ago. "She's beautiful, Dad—wait'll you see her!" A steamboat whistle carried out of the trees dotting the Cosumnes River wetlands as 4449 strode onto the stage, a vision in red, white and blue reflecting the soft light of a December morning. Screwed tight to a tripod, my Nikon gobbled frame after frame, Dad murmuring "wonderful, wonderful."

"The *Daylight's* back!" I exulted in a father's voice, turning to gaze into the eyes of a child.

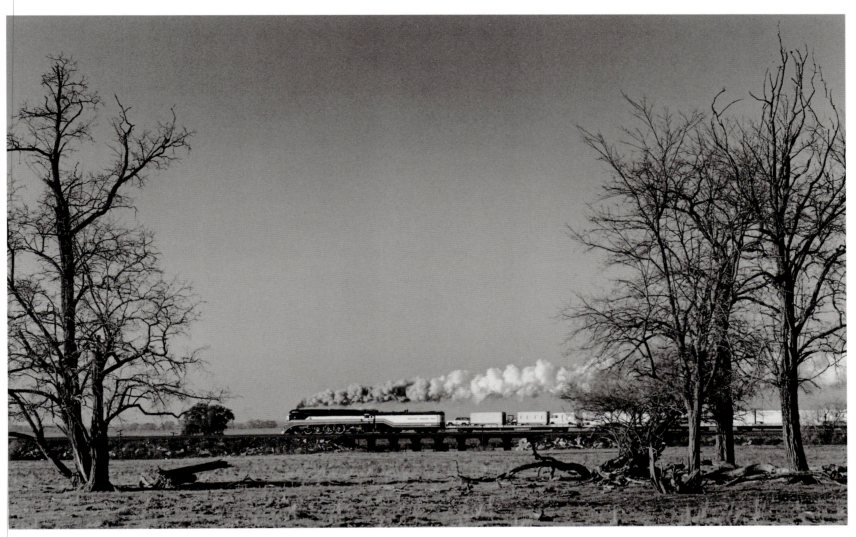

"Wonderful, wonderful"—American Freedom Train south of Elk Grove, California. 12/1/75

Andy Adams, first night on the road—6/20/75

His face bearing witness to the smoky passage through the tunnels of Cascade Summit, fireman Andy Adams pauses for a portrait in Klamath Falls, Oregon. It's Friday, June 20, 1975—the first night on the road for SP 4449 heading east to join the *American Freedom Train* on a two-year bicentennial tour. Wandering through the "Lower 48" in circus train fashion, the *Freedom Train* strides south in late November, en route to display in Reno, Nevada. Home for the holidays, 4449 spent December 1975 in California, alternating between static display and glorious repatriation with most of the engine's operation taking place on SP rails. Under a quintessential pillar of cloud, Extra 4449 East departs Ceres after meeting the *Starpacer's* Portland-bound pigs. Welded rail and CTC came to the "long, lonely valley" six years after steam, but the improvements sat well with the high-stepping Lima.

Memorialized on the backhead of 4449, Jack Holst lives on, his selfless dedication to stream preservation resounding in every revolution of those 80-inch Boxpok drivers.

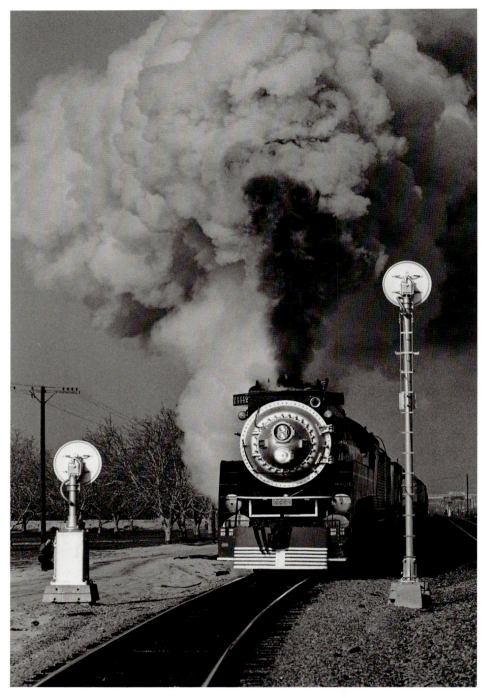

A quintessential pillar of cloud—Eastbound at Ceres, California. 12/18/75

Eugene, Oregon. 1977

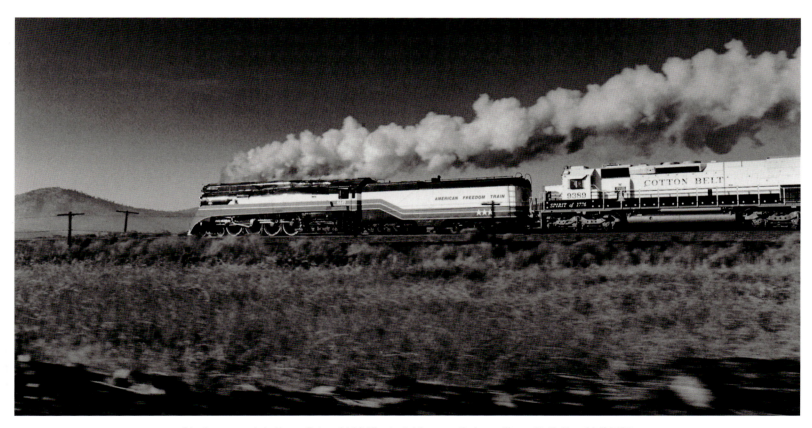

Glorious repatriation—Extra 4449 West strides south from Klamath Falls. 11/23/75

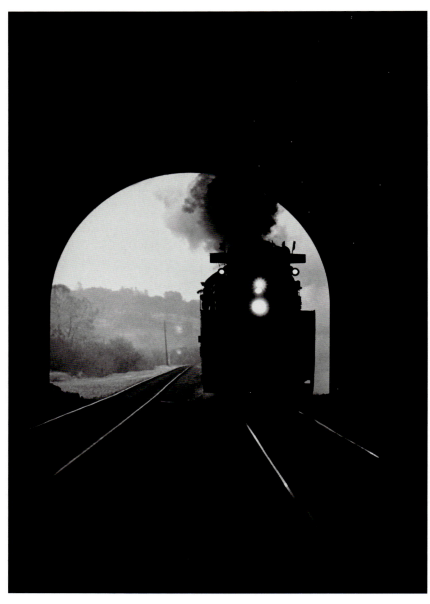

Westbound at Newcastle Tunnel—11/27/75

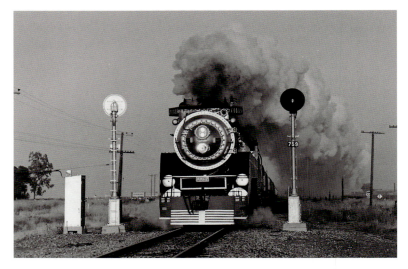

Dancing out of the mist—Bethany, California. 12/18/75

Cresting the Sierra grade on Thanksgiving morning 1975, Extra 4449 West eases down the original Central Pacific alignment through the double-track tunnel at Newcastle. The meandering main-line will return to right-hand running in nearby Rocklin. A festive December awaits the *Freedom Train*, with displays all over the Golden State.

Three weeks later, the tule fog of winter hangs low over the fields outside Tracy. Six miles northwest of town on the line to Martinez, the former station of Bethany slumbers under a blanket of gray, the site of her long-vanished siding framed by the automatic block signals marching into the gloom toward Brentwood. Long minutes pass before the block indications change from dark to yellow, then red. There's a whistle and crisp, rapid exhausts followed by the flash of a Mars light and the growing glow of a silver smokebox. It's 8:34 a.m. when Extra 4449 East dances out of the mist beneath a cloud of its own creation, the glistening Lima storming past Signal 759 and into a clearing horizon at Milepost 76.

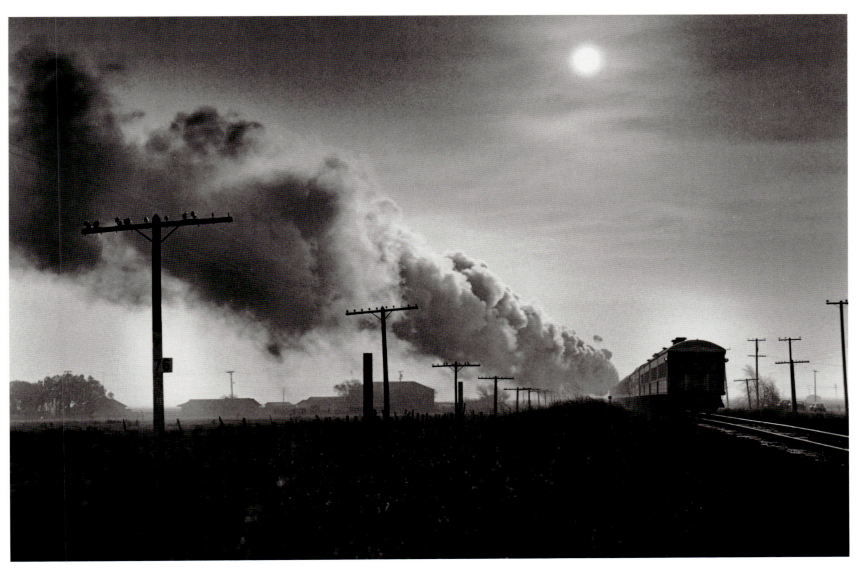

Steaming into '76—Eastbound *Freedom Train* approaching Tracy, California. 12/18/75

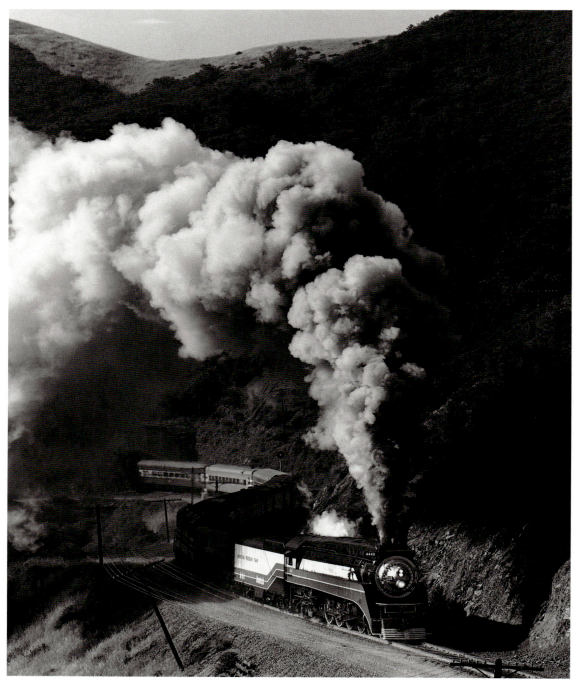

Running the ratholes on Santa Margarita Hill—4449 near Cuesta, California. 4/27/77

"Long after the diesel had absorbed the glitter else-where in the West," David P. Morgan wrote in the May 1955 issue of *Trains* Magazine, "there was occasion for strong men to weep when Southern Pacific's *Coast Daylight* swept into view...gathering speed behind a great silver-faced, double-eyed Lima 4-8-4 dressed in duplicate ducos. Some said Espee's GS-class engines were the handsomest ever streamlined in steam; certainly none who observed them seriously argued the point."

April 1977 finds a double-eyed Lima back in the Golden State, running the "ratholes" between Tunnels Seven and Eight on the Coast Line's 2.2-percent crossing of the Santa Lucia Mountains above San Luis Obispo. With her *Freedom Train* chores finished and an Amtrak-sponsored excursion in tow, 4449 heads home to Portland and an uncertain future. Fourteen years later, with the concerns of 1977 far behind a tender long-restored to *Daylight* red and orange, fireman Dick Yager tops off the tank at Black Butte, California, before descending to Dunsmuir.

It's April 1991, and the sight of 4449 on the Shasta Route is almost taken for granted. Gliding out of the forest above Redding, the shining GS-4 heads south for Sacramento and Railfair '91, a national gathering of steam power far beyond anyone's imagination during 4449's park days in Portland.

Water stop at Black Butte—4/28/91

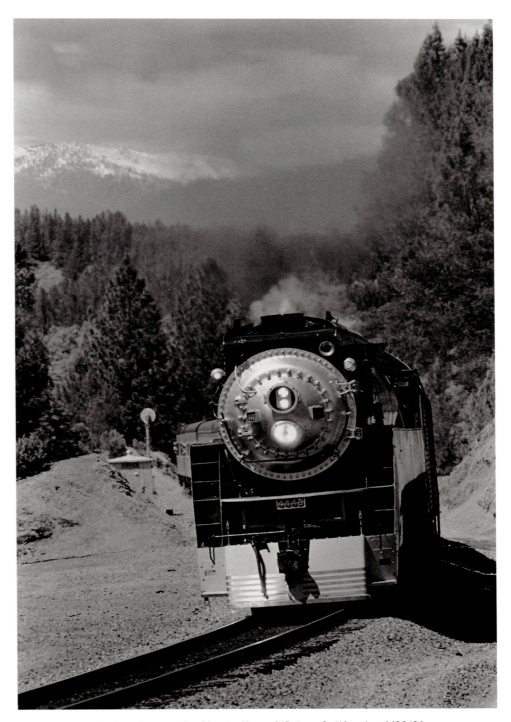

Making time on the Shasta line—O'Brien, California. 4/28/91

Reflecting the glow of a brilliant winter day—Roseburg, Oregon. 12/15/88

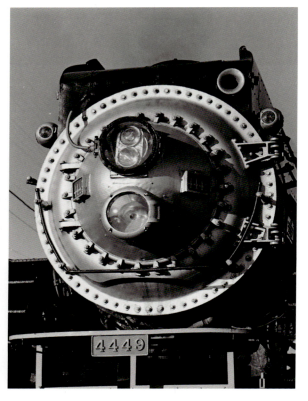

"A great silver-faced Lima"—12/15/88

December 1988: The "Spirit of the West" has come to Oregon's Siskiyou line, providing unparalleled visions of steam on the "new" Southern Pacific. Pulling a shippers' special at the request of chairman Philip Anschutz, the *Daylight* has been embraced as a corporate icon, transporting hope for a brighter future.

Forget the corporate unrest resulting from the merger with Rio Grande. For the moment, steam is alive and well in a GS-4 modeling paint accents from the late 1940s at Eugene and reflecting the glow of a brilliant winter day at Roseburg. North of Grants Pass, Extra 4449 West charges the 1.6 percent up to Louse Creek, the spirit of the old Espee embodied in a locomotive whose time is likewise gone.

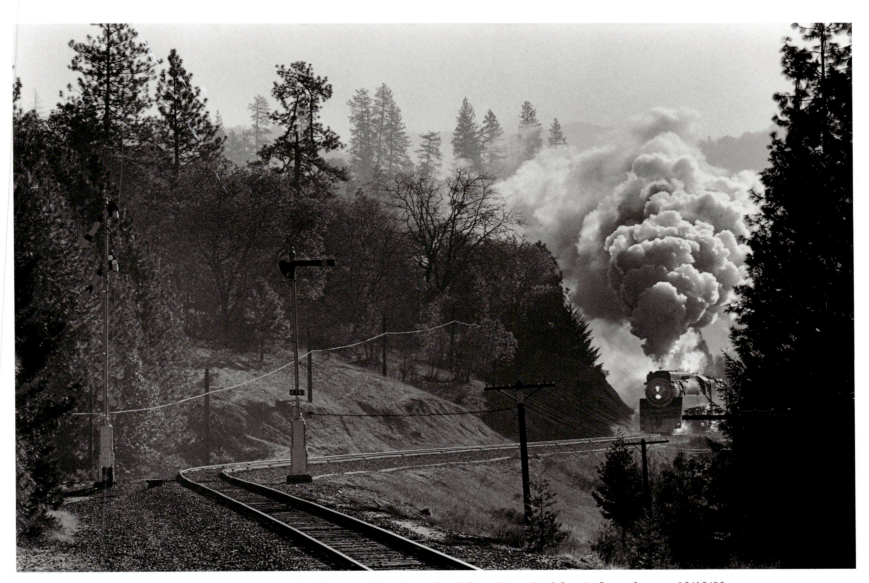

The old SP alive and well—4449 approaching Louse Creek Summit north of Grants Pass, Oregon. 12/17/88

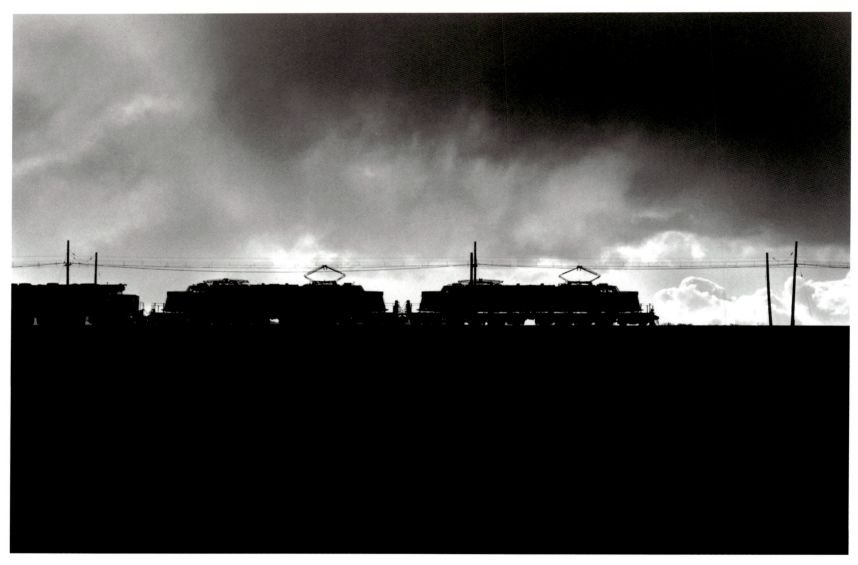

Before the storm—Milwaukee Road Number 263 descends Pipestone Pass at Newcomb, Montana. 5/10/74

THE RAILROAD OF MY FATHER'S YOUTH

As far as Dad was concerned, there was only one railroad in the world—the Chicago, Milwaukee, St. Paul and Pacific. Born November 17, 1909, six months after the railroad arrived on the coast, he grew up in Metaline Falls, Washington, where the CMSt.P&P was the most reliable link to the rest of Creation. His first working years were spent in St. Maries, Idaho, another Milwaukee Road town. When the Twenties roared to the tune of Prohibition, a perfect outing for the young bucks of St. Maries was a hunting expedition to "Conrad's Crossing" on the St. Joe River outside Avery. Following a weekend at the place where someone named Conrad was alleged to have seen a deer wading across the icy stream, the boys would load fresh venison into the baggage car of the *Columbian* for a swift ride back to civilization. While marriage and a call to arms took him away from Idaho, Dad never left the Milwaukee behind. It followed him to the Coast Guard station at Port Townsend, Washington, in 1942 and went with him in spirit to postwar California. For in the early years of fatherhood, when Fred Benson's son requested a bedtime railroad story, the carrier inevitably was the Milwaukee Road.

"Chicago-Milwaukee-Saint Paul-and-Pacific": there was music in the way the words rolled off my father's tongue, fueling another generation's fascination with a railroad whose name was a lesson in poetic geography. I went to Idaho with my parents once, in 1956. We stopped in St. Maries, where Milwaukee's crossing of Peedee Viaduct made a lasting impression, highlighted by recollections of a "rumor" about Mom and her girlfriends skinny-dipping under the bridge one summer afternoon when Bessie Vaughn was the pretty new schoolteacher in St. Maries and quite a romantic catch for the handsome young office manager at the Potlatch Forests mill. We visited Spokane, Washington, and Harold Wayne, Dad's hunting partner and a locomotive engineer on the Milwaukee Road west of Avery. Knowing my interest in trains, Harold took us to Milwaukee's Spokane yard for a personal tour of two shiny new GP9's, complete with a ride down the lead and a few tugs on the whistle cord. It was hard to say who was more excited—Dad or me. His railroad was mine now, and it was something we'd share forever.

We never saw the Milwaukee together again. I was my own man after college and subsequent trips to Idaho and

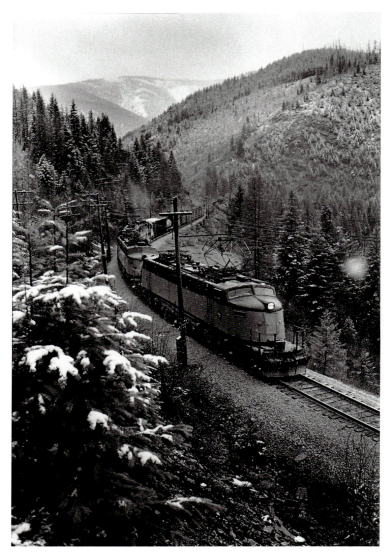

Joes at Snowline—Train 264 above Stetson, Idaho. 5/15/74

Montana were taken first with my wife, Liz, and a second time by myself. Eighteen years after my first exposure to the Milwaukee Road, I stood alone on the station platform at Avery, watching the spring snow turn to rain and feeling an ache deep inside—the pain of seeing a childhood dream vanish before my eyes. Harold Wayne was dead and the railroad wasn't far behind. "Chicago-Milwaukee-Saint Paul-and-Pacific": how long would the poetry remain?

There wasn't time for speculation that gloomy morning of May 15, 1974. I'd spent two weeks documenting the demise of Milwaukee's electrification and now I faced the end of a remarkable journey. Our first exploration of the Rocky Mountain Division in 1972 had concentrated on the west end from Avery to Deer Lodge, Montana. This time I focused on the line from Deer Lodge to Harlowton, coming back with a new appreciation for scenes of the Little Joes set against Montana's dramatic skies (page 120). Even greater was my admiration for Milwaukee's railroaders, people such as engineer Tom Buckley who upheld Harold Wayne's tradition aboard the last operating boxcab at Harlowton.

Now the odyssey had come down to one last photograph and one last train. Eastbound Number 264 with General Electric Little Joes E73 and E72 leading a pair of late-model diesels was the last electric freight I'd see. Somehow, someway, the picture had to put it all together —for the sake of the father, for the sake of the son, for the sake of the children yet to come.

I was thinking about Conrad's Crossing as I sloshed out of Avery that morning on the unpaved forest road, dodging the puddles in my faithful Ford Maverick... thinking about the boys from St. Maries sipping a little

mountain dew and trading yarns around a campfire. This picture was for them and the rails connecting their hearts to mine. Just east of the steel bridge above Stetson siding, the Milwaukee reached the snowline on a graceful reverse curve. With a break in the weather, trees tipped in white and the distant throb of turbocharged diesels, I knew I could go no farther. This would be my final stand.

Back home in a warm darkroom, the results didn't seem equal to the moment. The composition was traditional, the snow wasn't that heavy and one errant flake almost intercepted the E73's nose. It took three years to make my peace with the image and present a print to Dad on Christmas Day 1977. Seeing the smile on his face made me wonder why I'd waited so long. That winter the Milwaukee filed for bankruptcy, citing operating expenses in the West as a major contributor to the negative cash flow. It was hard to accept the railroad's demise. It was harder still to accept the fact that my father was also dying.

"I'm going back to Conrad's Crossing," Dad often remarked during his last painful months, gesturing toward the print of the Joes at snowline. I wanted to return as well, but my own impending fatherhood took precedence over trains. On January 11, 1979, six days after becoming a grandfather, Dad passed away.

A year later, the Milwaukee's last whistles echoed over Avery, bonding the man and his railroad forever in sweet memory.

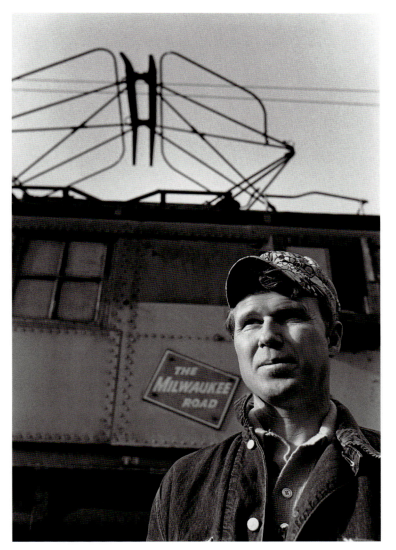

Upholding the tradition—Engineer Tom Buckley, Harlowton, Montana. 5/9/74

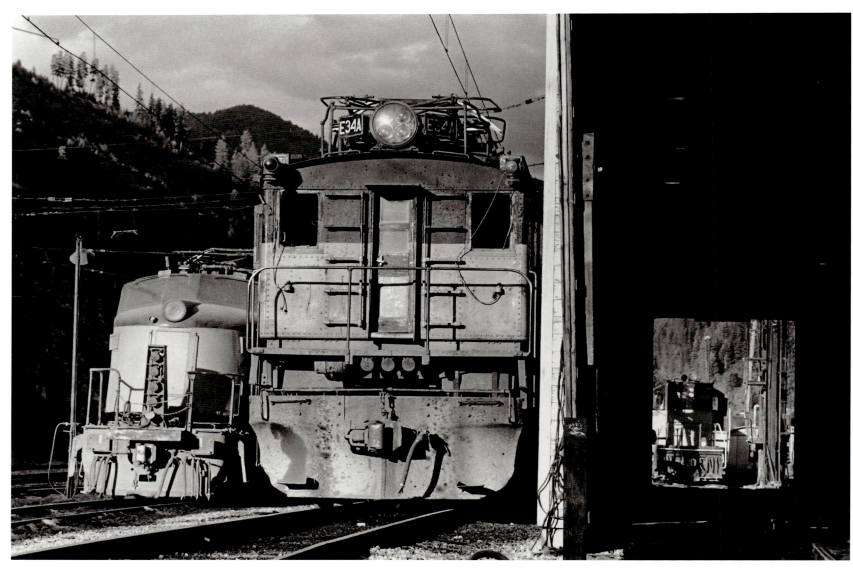

A destination for the determined—Milwaukee Road power at the Avery roundhouse. 7/13/72

Lines across time—Avery, Idaho. 5/13/74

The road to Avery, Idaho, was defined as "other highway" on the 1972 state map, one bulldozer blade beyond dirt. "Local inquiry may save time," Messrs. Rand and McNally advised. Thirty miles removed from the nearest Interstate, Avery was a destination for the determined. Two bars, one post office and a gas station defined downtown in a community whose population was generously estimated at 250. In Avery, you were either a logger or you worked for the Milwaukee Road.

Roundhouse, depot and lunchroom notwithstanding, Avery was more than a division terminal on the CMSt.P&P; it was a dividing line between time zones and a dividing line across time. For where else in the West could you find trains pausing to swap diesel power for electric? Where else would you see General Electric locomotives from 1916 and 1948 outnumber the ubiquitous GP9? Where else did all-American enginemen go to work aboard locomotives built for Soviet Russia and never reflect on such irony?

It happened every day in Avery, Idaho, electrification's Holy Grail.

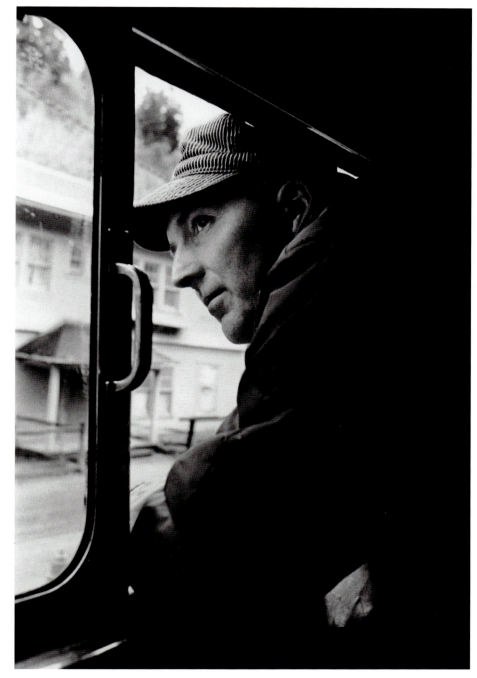

Watching for signals on the E77—Engineer Bob Richardson at Avery. 5/13/74

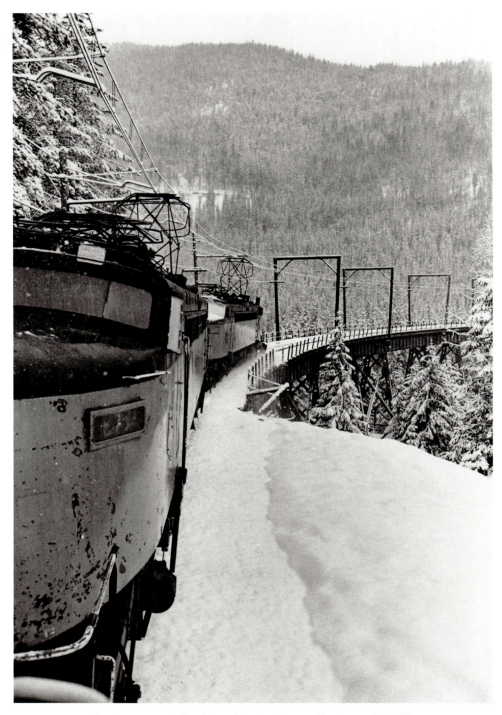

Spring snow at Dominion Creek—Bryson, Montana. 5/15/74

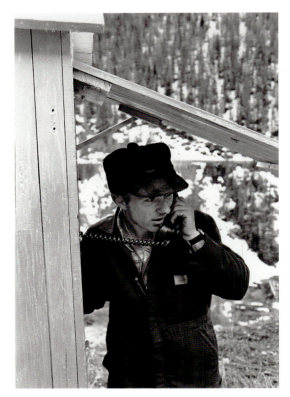

Track and time—Layne Dana, Adair, Idaho.
5/13/74

There was thunder rolling in the canyon of the North Fork of the St. Joe River, the chug of GE diesel power reminiscent of the handful of years when steam locomotives ruled St. Paul Pass. Completed to the coast in 1909, the Milwaukee began electrifying in 1914 as a means of lowering operating expenses in the mountain districts of Washington, Idaho and Montana. "Electrifying" was the adjective for the action that resulted over 656 miles of main line in the seven ensuing decades.

The power of "white coal" remained compelling in May 1974 as eastbound Number 264 assaulted the 1.7-percent ruling grade behind Little Joe E77 and a half-dozen raucous U-boat diesels. With rain at Avery forecasting snow in the higher reaches, westbound time freight Number 263 crossed Dominion Creek on the ascent of Bryson Loop, 5 miles below the summit at East Portal. Over the hill at Adair, section patrolman Layne Dana called the Deer Lodge dispatcher for clearance behind Train 263.

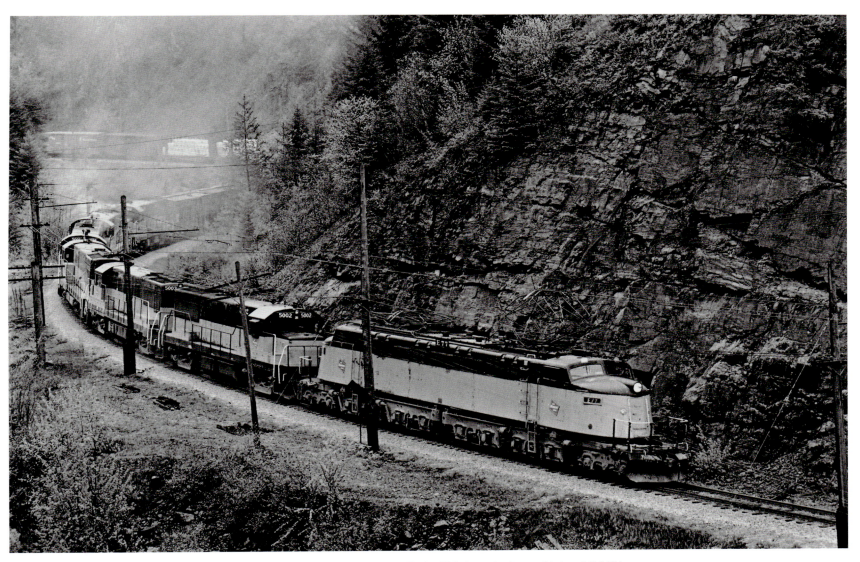

Thunder in North Fork Canyon—Train 264 departs Avery, Idaho. 5/13/74

The tale of the tape—East Portal. 5/12/74

The power of "white coal"—Substation operator Bob Williams,
East Portal, Montana. 5/12/74

Mother's Day 1974 found substation operator Bob Williams in the transformer room at East Portal, Montana, standing watch over an uneventful eight hours with nothing but diesels on the lineup for trains crossing St. Paul Pass. Straddling the Idaho–Montana state line at an elevation of 4,200 feet, East Portal's three 2,000-kilowatt motor-generator sets regularly put 2,600 volts of direct current into Milwaukee's catenary—a fact reflected on the graph charting the earlier progress of Train 261 over the Bitterroot Mountains.

Uncertainty mixed with an occasional snowflake in the leaden sky over East Portal on that moody Sunday afternoon. The electrification lived on borrowed time and that time was fast running out. Outside the abandoned train order office adjoining Substation 13, Williams pondered his future employment on a Milwaukee Road no longer "electrified to Puget Sound."

Pondering an all-diesel future—Bob Williams. 5/12/74

Two summers earlier, Milwaukee still featured all-electric operation on Trains 265 and 266, the twin tonnage drags ominously known as "dead freight." Leaving Avery with 103 cars and 5,300 tons behind a "Double Joe" and E45's three-unit boxcab helper, Train 266 limped into East Portal six hours and 24 miles later, doubling the hill with a pair of disabled "Pelicans" behind motors E20 and E71. Short circuits in the low-voltage cabinets of the old GEs would do it every time.

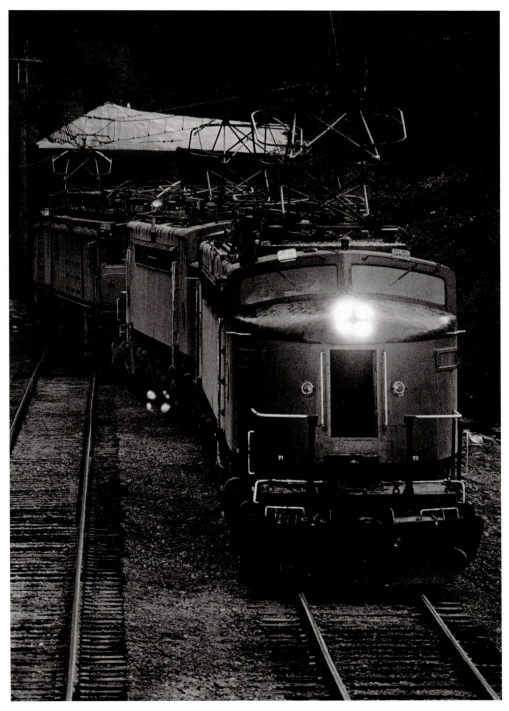

Doubling the hill on dead freight—East Portal, Montana. 7/15/72

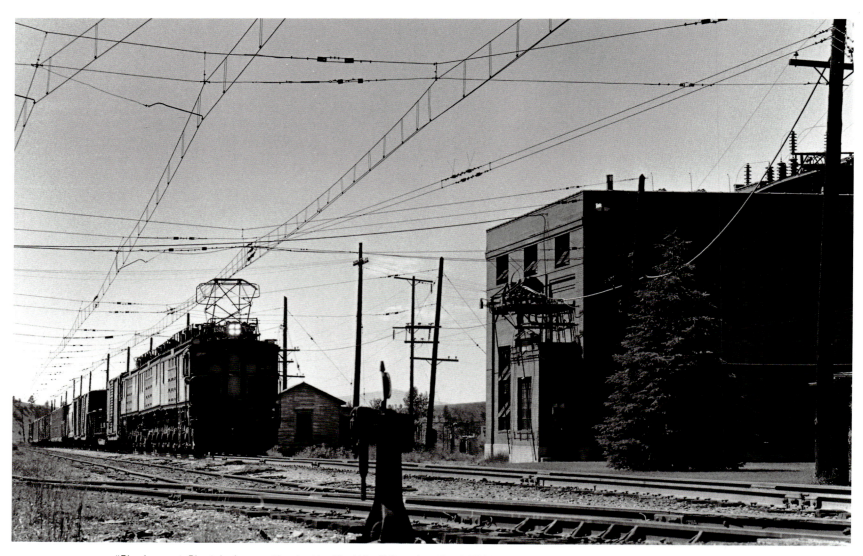

"The Largest Electric Locomotive in the World"—Milwaukee Road E50A on Number 266. Gold Creek, Montana. 7/17/72

Eastbound for Deer Lodge—Milwaukee E50A at Kohrs, Montana. 7/17/72

All considered, Milwaukee's gold spike at Gold Creek, Montana, should have never been driven. May 14, 1909, should just be another forgotten spring day. Never more than the "other railroad" in all its Western gateways, CMSTP&P got by on pluck—and the steel backbone of the GE boxcabs that anchored the electrification on the Coast and Rocky Mountain Divisions.

"The Largest Electric Locomotive in the World" when delivered in September 1915, pioneer freight motor E50A still turned in revenue miles 57 years later, crawling past Substation 8 at Gold Creek with Train 266 and crossing the Kohrs Ranch on the last miles into Deer Lodge.

Rejuvenated by the addition of 12 GE Little Joes in 1950 and the genius of chief electrical engineer Laurence Wylie, Milwaukee's electrification doubled its life expectancy to survive nearly 60 years. Westbound at 60 miles per hour near Gold Creek, Train 261 was a study in corporate defiance, uncompromising to the end.

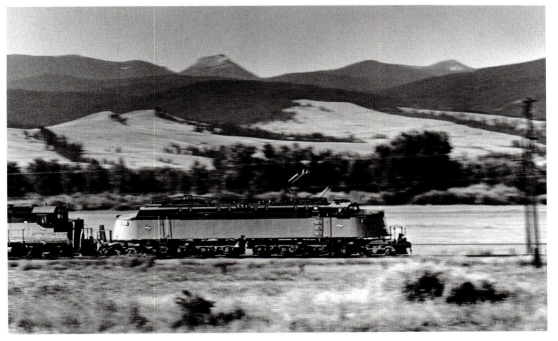

Sixty miles an hour down a deadend road—E74 near Gold Creek, Montana. 7/17/72

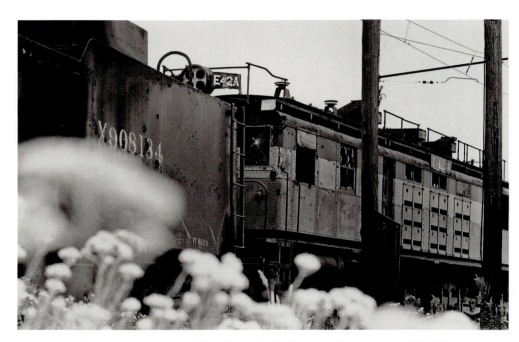

Put out to pasture at Tide Flats Yard—Tacoma, Washington. 7/24/72

Trapped and undaunted—Avery, Idaho. 7/13/72

Stripped of all but a battered pride, GE boxcab E42A slowly settled into the weeds at Tide Flats Yard in Tacoma, Washington, framed by the high fog and pulp-mill haze of a July afternoon in 1972. East of Tacoma, one last, lonely set of Pelicans assigned to work train service made sporadic use of the 216 miles of mainline catenary across the Cascade and Saddle Mountains. On November 14, 1972, the scene posed by westbound Number 263 at Othello became more than mere symbolism. The Coast Division electrification had reached the end of the wire.

The battle continued at Avery for one more season. The venerable General Electric freight motors waged war with gravity through the summer of 1973, crusading the cause of "white coal" right up to their final mile. It mattered not that Milwaukee's infrastructure was "as out of date as a carbon filament light," in the estimation of visionary rail executive John W. Barriger III. What counted was the company's spirit, as trapped and undaunted as a moth in the roundhouse window—throwing itself against unyielding reality until falling broken and dead.

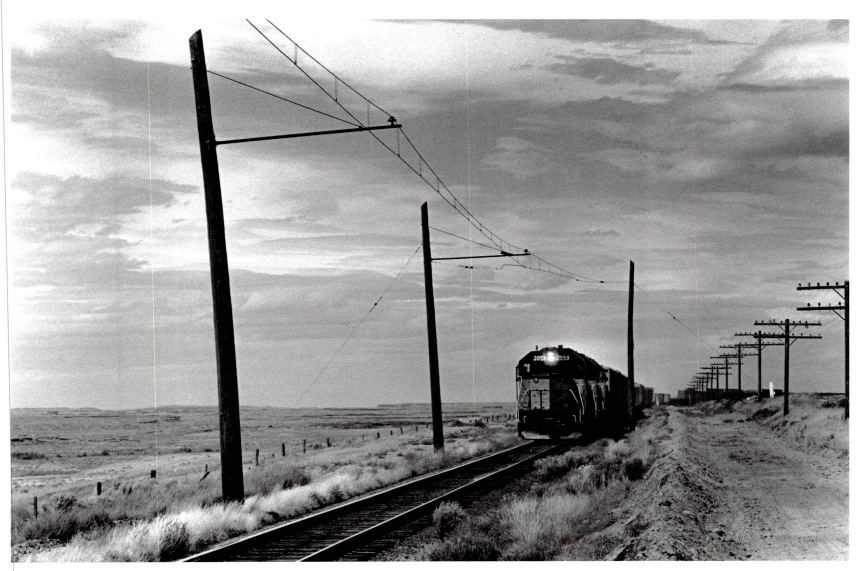

More than mere symbolism—Train 263 at the end of the wire, Othello, Washington. 7/12/72

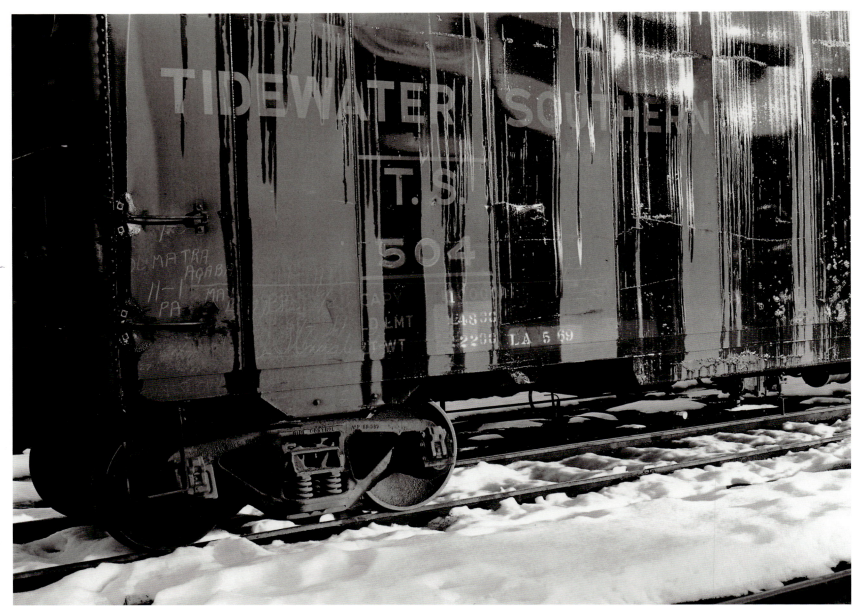

Fantasies melting like spring snow—Keddie, California. 4/9/82

LIVING BEYOND THE DREAM

Across the fields of yesterday
he sometimes comes to me,
a little lad just in from play;
the lad I used to be.

And yet he smiles so wistfully
once he has crept within;
I wonder if he hopes to see
The man I might have been.

The words of "Brother Nelson, Hobo Evangelist" remained penciled on the wall of the Southern Pacific depot at Westwood, California, a decade after their inscription in August 1961, a poignant reminder of better days in the old Red River Lumber town. The former end of SP's Susanville Branch, a valuable train order office on Western Pacific's Inside Gateway, Westwood remained open long after the big road left the Lassen woods. Westwood's closure in 1970 reduced the 112-mile Keddie–Bieber line to one open agency, foreshadowing untold economies to come. Awaiting the bulldozers in July 1972, the poetry on the depot wall inspired reflection on the future of the WP —and speculation about the railroad it might have been.

The "what-if" Western Pacific—now *that* was a fine topic for conversation. For a railroad born of poets and dreamers, a remarkable amount of evidence existed to support an even grander WP.

One black-bound volume from 1916 held General Electric's proposal for a 115-mile mainline electrification from Oroville to Portola. Powered by the growing number of hydroelectric plants along the Feather River, the catenary would ultimately cover 438 miles from Gerlach to Oakland. The locomotives suggested for WP? Boxcab motors "similar to those currently in use on the Chicago, Milwaukee & St. Paul."

Another intriguing tome outlined a staggering string of branch lines from southern Idaho to Monterey Bay. The highlights included Sacramento Northern absorbing the Petaluma & Santa Rosa and the Stockton Delta Electric, a fanciful feeder through the fertile crescent of the Sacramento and San Joaquin Rivers featuring floating bridges instead of fixed draw spans. Tidewater Southern to Fresno was again the subject of speculation, but reality melted expansion plans like the spring snow on a TS boxcar at Keddie. Sixty years down the road, WP was living beyond the dream.

What happened to those grand visions for the reorganized Western Pacific Railroad of 1917? GE concluded that WP's traffic levels couldn't support the expense of electrification. Paved roads left most of the branch-line empire in the proposal stage. But the death of those dreams didn't phase Arthur Curtis James, who completed WP's north-south link with the Great Northern in 1931.

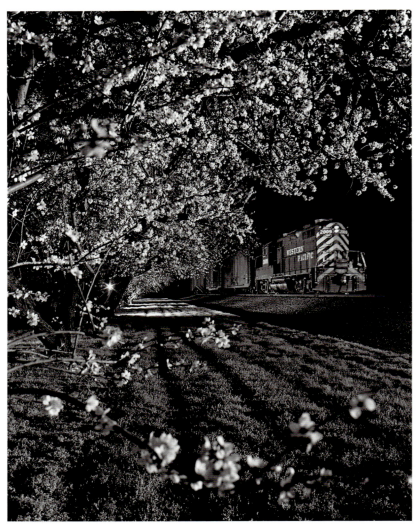

Blossom time on the Tidewater Southern—Modesto, California. 2/28/82

Barring the Depression, a San Francisco section of the *Empire Builder* would have come down the Inside Gateway. It was easy to envision a Keddie wye in 1949 where a California *Builder* behind green and orange GN diesels waited to follow silver and orange Little Joes down the canyon with the electrified CZ. The WP that might have been could keep a model railroader happy for life.

The Western Pacific that existed in the post-*Zephyr* 1970s was a vastly different creature. For one, it had Alfred Perlman as president. Unfairly blamed for the somber green paint that replaced CZ silver on WP diesels two months before he took office in November 1970, Perlman's management team extended the common-sense approach of the Feather River Route. Stockton's new diesel shop replaced wooden roundhouses at Oakland and Oroville. Motive power was pooled with Burlington Northern on the Stockton–Seattle run. Crew districts were expanded and Centralized Traffic Control closed the last telegraph office on the High Line. Agency consolidations closed freight offices all over, including the Tidewater Southern, where steady industrial growth brought power such as Western Pacific GP20 No. 2009 to prowl the blossoming almond orchards north of Modesto.

Al Perlman's legacy was a railroad run by fewer Willing People in 1980, a Western Pacific that was lean but far from mean. No amount of streamlining could separate the Feather River Route from its folk roots. The "Wobbly" remained a carrier of colorful characters who enjoyed an open door to the front office. Still, camaraderie alone couldn't tame the unstable terrain of Feather River Canyon or increase traffic with Southern Pacific. Ultimately, Western Pacific became an irresistible object for the Union Pacific, whose WP-Missouri Pacific merger of 1982 triggered the complete reordering of Western railroading.

An irresistible object for the Union Pacific—Stockton, California. 3/26/84

This much is undeniable: Al Perlman was the savior of the Western Pacific. Perlman and his successors provided the stewardship that enabled the railroad to survive and thrive into the 21st century. Compared to the fate of a secondary transcontinental such as the Milwaukee Road, a WP in Armour Yellow wasn't that bad. Still, you had to wonder—what if they'd built the line 20 years earlier? What if they had a larger market share—or built branch lines from the start?

Pondering the Union Pacific's Feather River Division, you couldn't help thinking about the railroad that might have been.

A showcase of corporate pride—Painting the 913 at Stockton. 4/20/78

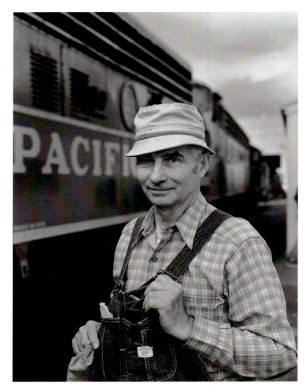

Ed Hale and his F units—Stockton, California. 3/13/78

Western Pacific was still the railroad of the Willing People in 1978. One was Mike Flannery, Al Perlman's successor as president. Others were blue-collar heroes such as locomotive engineer Ed Hale and painters Art Alvillar and Henry Casarez. Number two on the seniority roster and number one in the esteem of his co-workers, Hale was regularly assigned to the San Jose Turn with WP's final four Electro-Motive F7 diesels, the last "covered wagons" in California. Stalwarts with over 2 million miles on their odometers and no replacement power in sight, the weary cab units became instant celebrities when Flannery ordered them patched up and painted in the spring of 1978. Reacting to employee suggestions for boosting morale, engine 913 was returned to *Zephyr* silver and orange.

By the time Alvillar and Casarez began applying orange lacquer to WP 913, the Stockton paint shop had become a showcase of corporate pride. Returned to service in April 1978, the 913 and her three green sisters transformed their regular work into a daily railfan excursion. Roaring out of the summer night with the eastbound *Santa Fe Autos*, Extra 913 East rattled the windows of Tracy station as though it were 1958. One year earlier, who could have imagined?

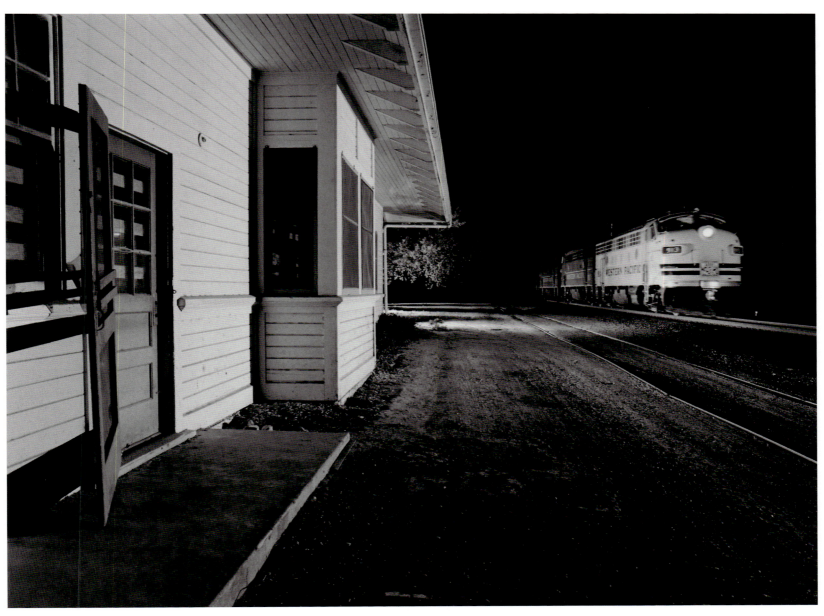

Roaring out of the summer night—Extra 913 East passing Tracy, California. 7/14/78

Sally on the midnight shift—Bieber, California. 11/26/83

The flash of *Zephyr* colors on WP's First Subdivision couldn't camouflage eroding traditions elsewhere on the railroad. Less heartening were the scenes along the Inside Gateway as the bloom of the early 1970s began to fade. Expanding crew districts brought the end of the Keddie-Bieber trainmen's pool in 1974 with engineers joining the Bieber–Oroville run-through in the spring of 1978. Late on the afternoon of April 30, veteran "hogger" Jim Boynton studied the Sunday *Sacramento Bee* in his modest cabin at Bieber, waiting for the call to return to Keddie. Summoned for Burlington Northern Train 139 at 10 p.m., Boynton signed off on the Keddie engineer's register four and a half hours and 112 miles later, ending a ritual that began with the opening of the Northern California Extension in 1931.

Five years later, Bieber was nearing the end as an open agency. Three days before closing on November 30, 1983, Sally the depot cat stood watch after midnight as the thermometer outside the operator's bay hovered at 10 degrees. No longer BN's preferred connection following UP's "Mop-Up" merger in 1982, Bieber saw one train a day on each railroad. With expedited traffic going to the SP at Klamath Falls, nearly 15 years would pass before the Inside Gateway began to resemble the WP and GN of old. By then, SP belonged to Union Pacific and BN to Santa Fe.

Jim Boynton, Sally and the Bieber depot were long gone.

Waiting for the final call—Jim Boynton in his cabin at Bieber, California. 4/30/78

Intangibles too precious to ignore—Niles Tower, Fremont, Caliornia. 5/29/84

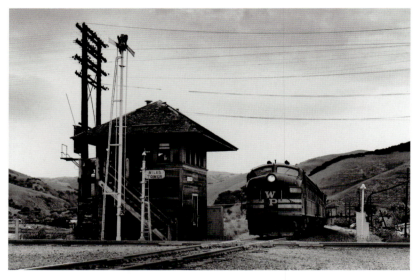

San Jose Turn at Niles Tower—4/3/78

Mark the date: December 22, 1982. Three days before Christmas, 526 Mission Street in San Francisco ceased to exist as an independent railroad headquarters. Five blocks away, Southern Pacific administrators at 65 Market Street felt a chill in their souls. UP's betrayal of its former partner was complete. Two years later, what little remained of the Western Pacific existed only in the railroad's unique sense of place.

No place better personified the old WP than Niles Tower. Built in 1912 to guard the intersection of SP's San Jose–Oakland line at Fremont, California, Niles Tower marked a spot where time stood still. The Electro-Motive F7's that thumped over the diamond during SP's last days of steam still rolled out of Niles Canyon in 1980. Two decades after Centralized Traffic Control had eliminated the need for train order operators on most SP main lines, the last light of day cast telegraphers' shadows across sun-burned tower walls as they stepped down to post instructions for traffic on SP's Niles Subdivision.

The old ways were there for the savoring: the staccato clatter of an Underwood billing typewriter pounding out triplicate copies of Form 19s, the clipped cadence of orders being repeated to SP's Roseville dispatcher, and a trainman's gentle swipe to pluck the flimsies off the delivery stand. By the autumn of 1985 they were intangibles too precious to ignore.

Form 19s to the Watsonville perishables—Niles Tower. 10/21/85

A world framed in the code of Morse—Nick Laba, Niles Tower. 1/7/86

In the end, Niles Tower became a shrine for believers in railroading's tried and true. For those weary of the road, it was a place to pause—to listen to Alameda Creek flowing under the SP bridge and watch herons rise up from the stream bed, silhouetted against waters of polished gold. It was a place to make the acquaintance of telegraphers such as Nick Laba and listen to tales framed in the code of Morse—a world soon to vanish at the hand of automation and a uniform operating code that eliminated the need for written instructions.

We came to savor those October evenings in 1985, knowing that the sight of Nick posting orders for SP's Hayward Turn would end come the first of November. Suddenly, I was back in childhood, recalling an August night in 1962 and Niles Tower standing bright against the evening sky. Little had changed, except the ability to give those memories a tangible form. Now the visions of a more poetic time would remain, captured in crystals of light.

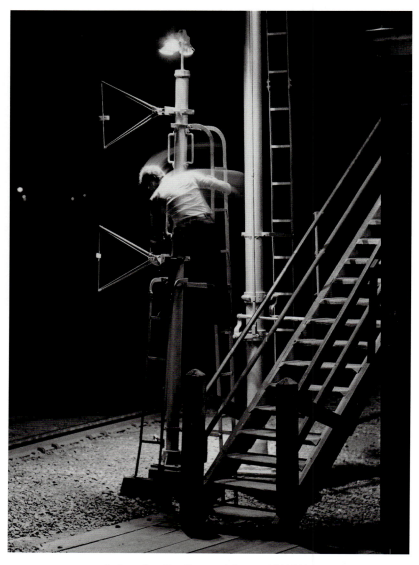

Orders for the Hayward Turn—10/29/85

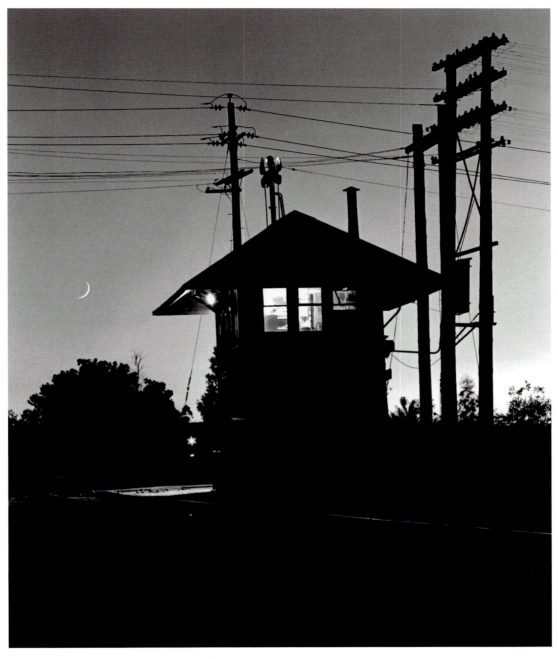

Visions of a more poetic time—October moonset, Niles Tower. 10/15/85

CHAPTER TWELVE

THE QUIET SIDE OF PARADISE

They arrive with the wind blowing up from Soledad, slicing the silence of an April afternoon as sundown paints the Gabilan foothills in hues of pastel gold. Clearing a meet at Bradley, California, Southern Pacific Extra 8292 East accelerates past Milepost 199 with 8,000 tons of sugarbeets riding the wake of 12,000 turbocharged horses, the early bounty of the San Joaquin Valley rolling 60 miles an hour over bearings of babbitt and brass. Thirty-four miles and 43 minutes later, the "East Beets" stop at Santa Margarita, awaiting assistance on the tortuous trail to San Luis Obispo and forwarding to Union Sugar's refinery outside Santa Maria.

More vegetable than mineral, even when it's empty, the Tracy–Guadalupe unit train is an embarrassment at One Market Plaza. Intermodal freight is the focus in 1987. Sugarbeets riding the friction bearings of composite wood and steel gondolas from the 1940s are something SP would like to ignore. The Coast Line, with its Automatic Block Signals harking back to Harriman days and single-track Direct Train Control one step removed from train-order dispatching, isn't far behind in Southern Pacific's dwindling regard for the ancient and arcane.

Tonight, SP stands at a crossroads. While waiting for the helper at "Margarita," crew conversation centers on the continuing management soap opera—a 20-year spin cycle of corporate culture gone wrong. It was 1965 when *Trains* Magazine proclaimed capital-intensive SP the "New Standard Railroad of the World." How did we get to 1982, when *Forbes* Magazine looked at SP's capital debt and declared the company "Doomed"?

Regardless of the path taken, merger moves in the early 1980s left SP seeking support from arch-rival Santa Fe. Considering the impact of Union Pacific's power play, Southern Pacific Santa Fe seemed a done deal—to everyone but the Interstate Commerce Commission. On July 24, 1986, the ICC rejected the SPSF merger.

Tonight, as SPSF appeals the decision, comes the news of Chairman John Schmidt's resignation—ousted over his handling of the merger. Could attitude be a factor? Both SP and Santa Fe were applying SPSF colors to their rolling stock a year before the ICC vote. "Know what 'SPSF' stands for?" a brakeman inquires, nodding toward a trailing unit in merger red and yellow.

"Shouldn't Paint So Fast!"

So where *did* Southern Pacific go wrong in the 1970s and 1980s? In the late 1960s, when both *Trains* and *Forbes* were hailing SP's business acumen, the company's strength came from non-rail holdings: pipelines, truck lines, minerals, timber and real estate. Often the rights of way were worth more than the rails they carried. As late as 1979,

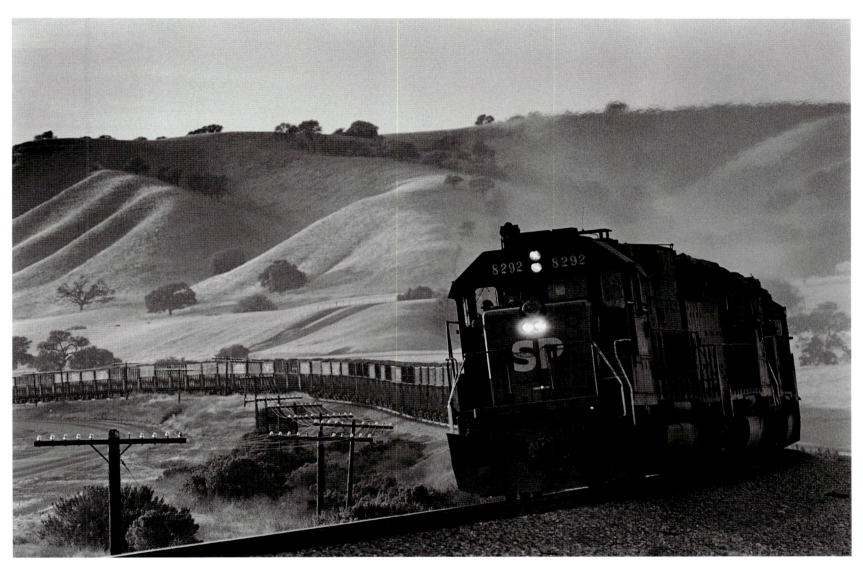

Slicing the silence of an April afternoon—Southern Pacific 8292 eastbound near Bradley, California. 4/22/87

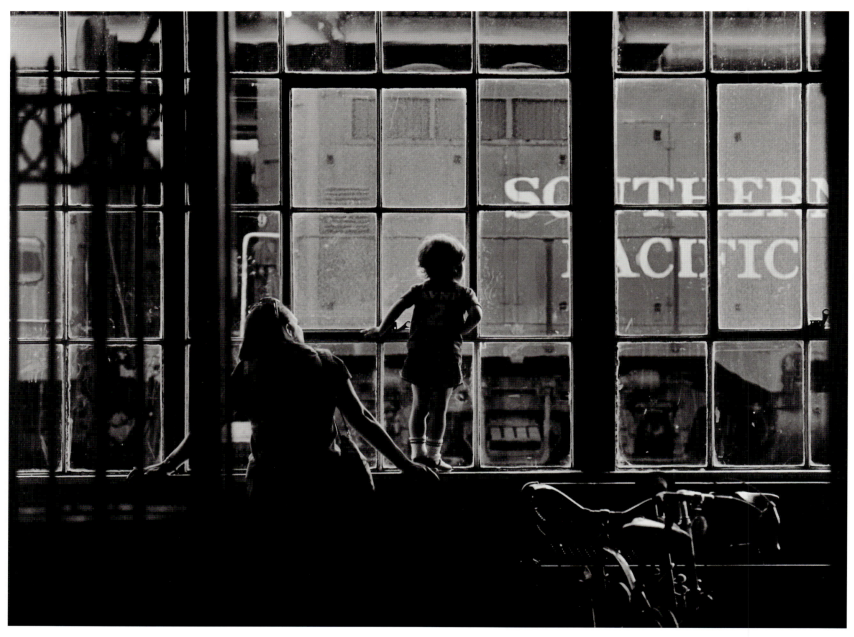

A New Generation of Railfans—Train 65 at San Jose Station. 6/4/85

when Bruce MacGregor examined SP's "hidden empire" in *New West* magazine, the railroad earned the second-highest freight revenues in the nation and was the largest private landlord in California and Nevada. "They are the last of the dinosaurs," a state public utilities staffer joked to MacGregor. "But watch out: they have learned how to skateboard on the glaciers."

Four years later, SP fell off its skateboard. Wrestling with the demons of reduced traffic, inflation and unwise diversification, SP lost the focus of its unique diagonal integration of people, products and services. Union Pacific's acquisition of Missouri Pacific and Western Pacific in 1982 drove a spike into the heart of Espee's central corridor. The time of the dinosaur had run out.

Merger was the sole salvation, but on whose terms? In the eyes of Chairman Benjamin Biaggini, the dance card was SP's. Biaggini ruled the railroad with "an imperial presence—a towering monolith of a man with a person-ality to match," according to *Forbes* writer James Cook. That personality already shared the blame for earlier failed merger attempts with Seaboard Coast Line and ATSF. On September 27, 1983, "Uncle Ben" looked down the gun barrel and blinked. This dance belonged to the Santa Fe.

SPSF as a railroad was finished on June 30, 1987, when the ICC upheld its initial merger rejection and ordered one or both of the rail lines sold. Stripped of its prime assets, it was no surprise to find SP on the block.

There was, of course, considerable consternation among the legion of photographers who had spent lifetimes documenting the railroad's history. Much more than a name would be lost with the demise of the Southern Pacific. Surveying the scenario presented SP's visual preservation-ists in 1985, Dick Steinheimer likened the situation to one of living in San Francisco in 1905 and knowing the earthquake was coming. What did we want to capture on film while there was still time?

For me, it was the quiet side of a railroad I had long taken for granted, the Southern Pacific that ran outside the spotlight of Donner and Tehachapi. It was the feeling of living history on the branches and secondary main lines that recalled a time when the iron horse stood "anxious to try his speed through the wheat field of Paradise," as one Modesto newsman reported in 1870. It was the sweet aroma of coffee brewing at Mendota station and the bite of burnt diesel fuel and brake shoes on Goldtree Curve.

And it was the sight of a new generation of railfans silhouetted in the station window at 65 Cahill Street in San Jose, where a mother and son watched Espee engine 3189 prepare to depart for San Francisco over the first 47 miles of a railroad that had once been the grandest on the face of the Earth.

There was no way of knowing exactly how the Southern Pacific story would play out on that June evening in 1985. The kid might never know what he missed.

It's probably just as well.

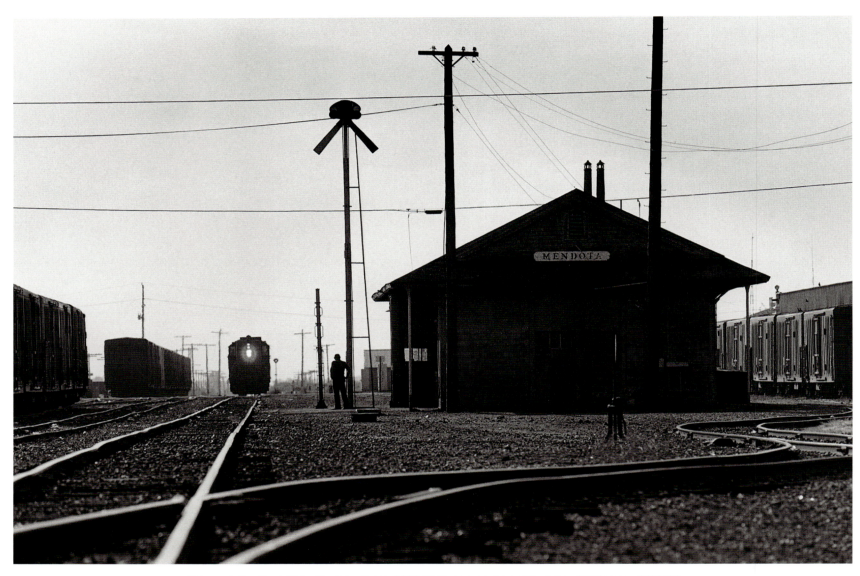

Fido and the West Side Hauler—Extra 3828 West approaching Mendota, California. 9/25/86

Treasures from the 1890s

"Drinking coffee and telling lies"—F. B. Pietz, SP agent, Mendota, California. 8/28/85

"I guess I'm what you'd call a public relations man."

F. B. "Fido" Pietz, Southern Pacific's Mendota agent, paused for a tip of his coffee mug. "Public relations—that's when you sit around drinking coffee and telling lies!"

There was no disputing the coffee. The pot was always on at Mendota, 35 miles west of Fresno on the secondary route to Tracy along the west side of California's San Joaquin Valley. Lies were another matter. No one had Fido's gift for storytelling and no one could argue his claims. In 1986, the old division point was the last open station on the West Side Line.

Perishables were Mendota's claim to fame. "When I came here in 1974, we'd ship fifty cars of cantaloupes a night plus thirty or forty more out of Firebaugh and Dos Palos. Switchers worked the packing sheds round the clock. Filled two haulers a day plus the Mendota Rocket that took the late loads back to Tracy in the evening.

"You wouldn't believe it now."

By September 1986, a good day in the Mendota district netted 20 waybills for the SP. Where did the business go? "Rubber-tired boxcars," Pietz growled, decrying the impact of trucking and deregulation. A steady stream of refrigerated trailers rolled out of the sheds while rows of derelict mechanical "freezers" rusted in the Mendota yard—every one bad-ordered and most bound for scrap.

Now, the West Side Hauler ran one way a day at the height of the harvest season. As silence replaced the departing exhausts of engineer Jimmy White's GP9's, there was time to reflect on such treasures as an agent's badge from the 1890s and ponder the inevitable for an agency that would end on January 9, 1987.

How did it feel to close a place like Mendota? Pietz paused, gazing at the empty tracks and collecting his thoughts.

"I'll tell you—every time they take a part of the railroad away, a little piece of you goes with it."

Pondering life on the extra board—Joe Fagundes at Volta, California. 7/24/86

Planning the day's work at Mendota—7/24/86

July 24, 1986, was no normal Thursday on the West Side. Two years of testimony ended in 20 minutes of deliberation as the Interstate Commerce Commission rejected the SPSF merger by a margin of four to one. Shock waves eddied from Washington, D.C., to the depot at Mendota, where Fido Pietz and conductor Ken Heard shared their disbelief as they lined up the day's work for the West Side Hauler. For once, the agent was speechless. Spotting the tomato cannery at Volta later that afternoon, engineer Joe Fagundes pondered life on the extra board as he thought of the men who taught him the trade: "Ed Tyner, Bert Corgiat—you wonder what they'd do?" Back in Mendota, the voluble Pietz found his voice, putting on a fresh pot of coffee as he reassured a despondent section foreman.

"'What are we gonna do?' I'll tell you what we're gonna do. We're gonna get up tomorrow morning, put on our shoes one foot at a time and go back to work, just like we've always done."

The sounds of a railroad at work rolled across rows of seedling tomatoes the following April as a Nathan M-3 whistled for a private farm road, followed by the familiar grumble of four 567C prime movers and the solid cadence of steel wheels turning in 5 1/2-by-10-inch journal brass. Westbound near Westley, the Dos Palos Turn moved spring sugarbeets toward the mainline connection at Tracy, three GP9's and an SD9 shouldering the loaded beet racks just like they'd always done.

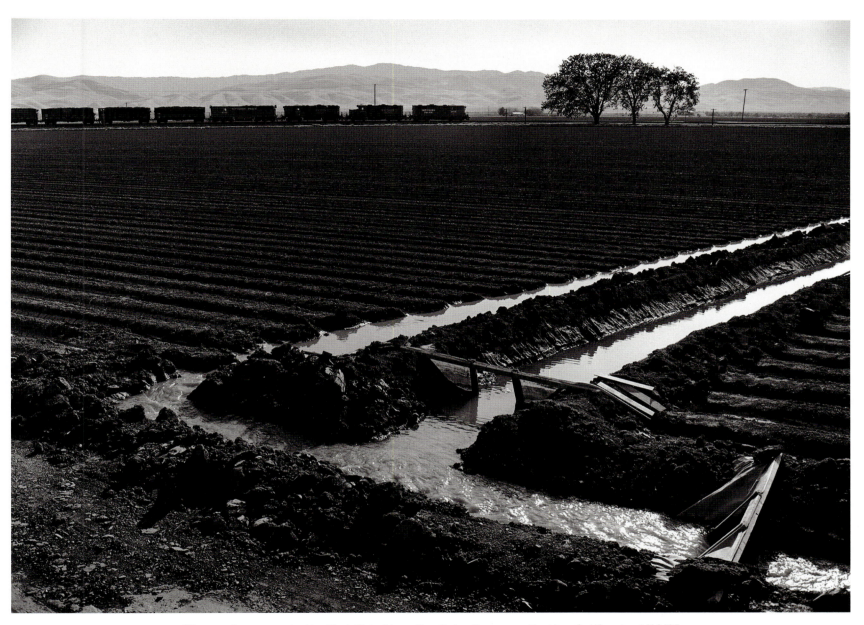

When spring comes to the West Side Line—Dos Palos Turn near Westley, California. 4/13/87

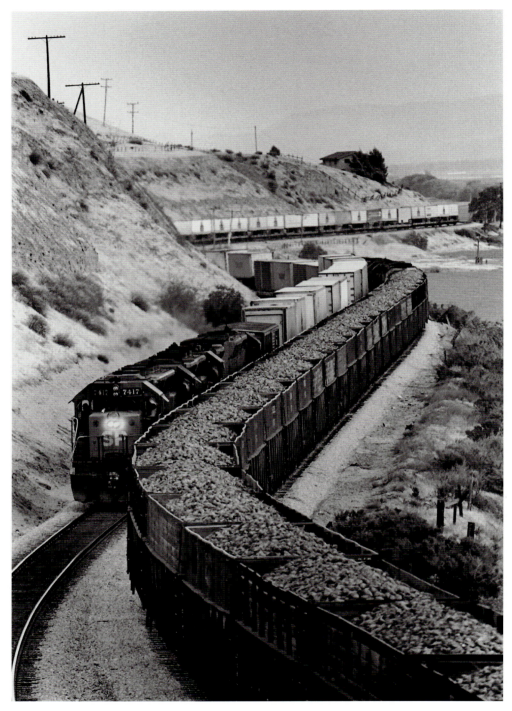

East Beets meet the Hot Block at Harlem—4/22/87

Twenty-four hours "east" of Westley on an overcast April afternoon in 1987, the Tracy–Guadalupe beet train held the siding at Harlem, California, for a meet with the *Los Angeles–Bay Area Forwarder*. One hundred air miles southeast of Tracy, the "East Beets" had traveled 238 circuitous rail miles through Oakland and San Jose to reach the desolate side track in the Salinas Valley, 5 miles south of Soledad. Here the beets took a breather, stepping aside for Amtrak Number 13, followed shortly by the "Hot Block." Clearing Extra 7417 West at 5:29 p.m., the TRGUU was back on the move, its 45-m.p.h. speed limit raised to 60 by a sympathetic Coast dispatcher (page 147).

To the untrained eye, the ragged gondolas with their earthy lading seemed as old as the hills funneling the Salinas River into the Santa Lucia Range. For the employees and suppliers of the Union Sugar Company, whose Betteravia refinery had been a landmark of the Santa Maria Valley for 90 years, the sight of the beet train meant extra fine granulated in the silos and money in the bank. Rail transportation had been a key element of Union's production "campaigns" since 1897. Few other commodities were as deeply rooted on the Southern Pacific.

One hundred miles and four days down the road, another TRGUU filled the Goldtree Curve with 4,497 feet of beets as 99 cars and 9,629 tons wound off the mountain above San Luis Obispo. SP 8320 East with swing and mid-train helpers snarled down from Chorro in full dynamic brake—an all-out war with gravity pitting three engineers and 36,000 horses against a 2.1-percent descending grade.

The following spring, SP annulled the San Luis helper job, forcing the beet haulers to cross Santa Margarita Hill in multiple sections. Mixing all their available dynamics with ample applications of air, the first half of Extra 7338 East passed Goldtree in a cloud of blue brake smoke.

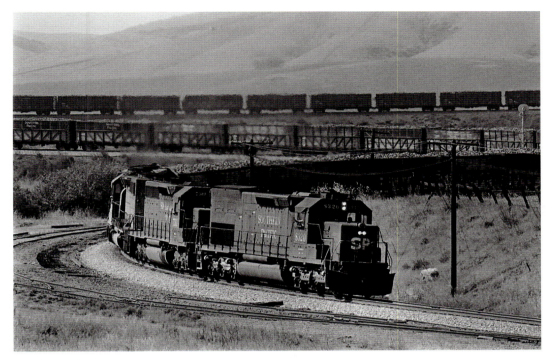

Snarling off the mountain in full dynamic brake—Goldtree, California. 4/26/87

Got a call from the county the other day. One of their environmental health guys had seen the beet train coming off the hill making a lot of smoke and he was concerned about the health risks of such pollution. I told him, "You should be a lot more concerned about a loaded beet train that isn't making smoke…that means we've got a runaway on our hands and you'd better get your ass out of the way quick!"

Del Green, Trainmaster
San Luis Obispo, California
April 1988

An all-out war with gravity—4/13/88

Marching to its own drummer—Schellville, California. 7/21/86

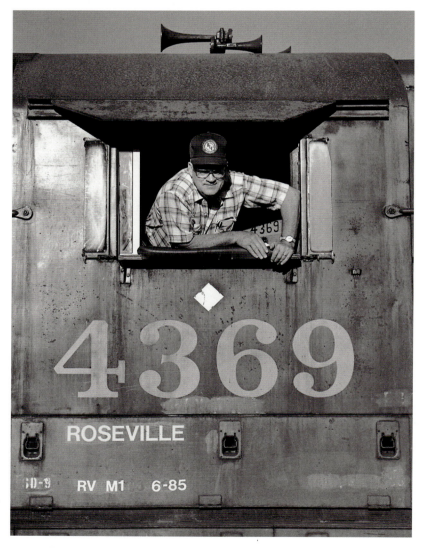

Cadillac Man—Northwestern Pacific engineer Bob Simonson, Willits, California. 8/15/85

It was six and a half miles as the seagull flew from downtown San Francisco to the ferry slip at Tiburon, California, but the spiritual distance between 65 Market Street and subsidiary Northwestern Pacific was the size of an ocean. Stretching 276 miles from the Golden Gate to Humboldt Bay, NWP rolled cut fir and redwood out of Eureka in train lengths measured by the board foot, traversing geology that was some of the least stable and most remote in North America. *Trains* Magazine once proclaimed NWP the "Clinchfield of the West." From the sequoia-shadowed "Avenue of the Giants" at South Fork to the oak-shaded vineyards of Hopland, NWP was a railroad running "No Where in Particular"—and did so in a manner unique unto itself. The big railroad may have provided the bankroll and motive power, but there was no denying the tone of the sign at the SP interchange in the Sonoma County hamlet of Schellville. Northwestern Pacific marched to its own drummer.

Long after Amtrak removed the *Redwood* from public timetables, NWP maintained its human touch through the ambassadorship of employees such as Bob Simonson, number one on the engineer's seniority roster when he commanded the throttle of the Ukiah Local in 1985. Breaking in on steam after the Second World War, Simonson added whiskers in the 1950s behind the control stands of diesel locomotives whose design seemed custom-made for the NWP—Electro-Motive's SD7's and SD9's. Tireless pullers that were easy on the track and crewman alike, the stocky six-motor hood units had earned a nickname commensurate to their performance.

"Are these units really *Cadillacs*?" Simonson responded to an inquiring admirer. "You bet they are!"

By the early 1980s, Northwestern Pacific's Cadillacs were the only aspect of the railroad that remained unchanged. Ravaged by a number of natural and financial hardships, the embattled NWP was on the ropes—fire, flood and inflation paving the way for a future that ultimately found Southern Pacific in full retreat from the Redwood Empire.

Yet on one August evening outside of Willits, none of the railroad's woes seemed to matter. The hills below Ridge had been ringing for half an hour as the Eureka–Roseville pool freight dug in on the 1.8-percent grade, curves and cuts bringing the sound steadily closer until Extra 4310 West was into the last reverse curve below the summit. Gyralite cutting crazy patterns into the trees, two Cadillacs out-shouting a trailing pair of GP9's, the ERRVY reached the east switch at Ridge where flashbulbs threw daylight into the night in a burst of scarlet and gray. A lantern waved a greeting from the cab of the 4310 as darkness reclaimed the forest. Then, all we could do was watch and listen as the train balanced on the vertical curve at Ridge and slipped into full dynamic brake as 2,674 tons of timber dropped off the mountain on the 3-percent descent to Redwood Valley. Silence returned to the hills above Willits, broken only by the occasional cry of an owl and the gentle rustlings of white-tail deer.

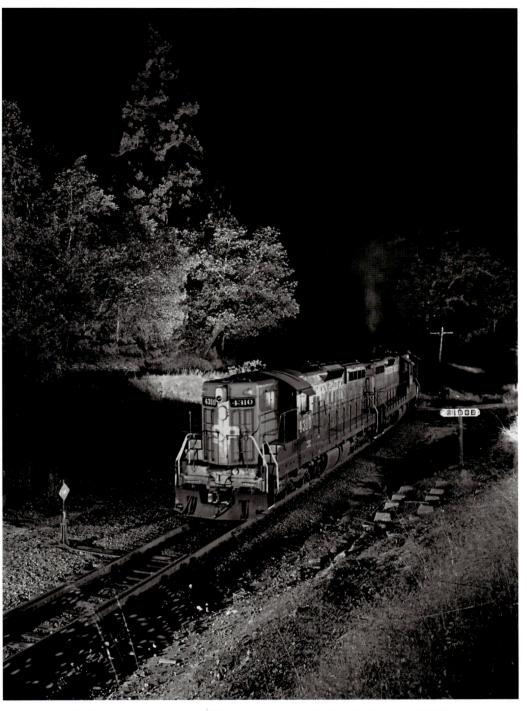

No Where in Particular—NWP pool freight at Ridge, California. 8/9/83

A railroad haunted by history—Goshen, California. 5/13/86

Southern Pacific found the promised land at Goshen, 34 miles south of Fresno, where branches radiating off the steel tree extended across the valley from the Coast Range to the Sierra foothills. Connecting the cattle country of Coalinga with the citrus belt surrounding Exeter, SP in the Land of Goshen was a railroad haunted by history. For it was here, in 1880, that angry settlers and resolute rail agents resolved a land dispute in a hail of hot lead. Before the guns fell silent, eight men lay wounded or dead and an Octopus was born. A decade after the battle at Mussel Slough, the land became home to the Robin Hoods of the San Joaquin, train robbers Chris Evans and John Sontag, who plied their trade with little public outcry. At the turn of the 20th century, few corporations were as hated as SP.

Eight decades later, the sons still paid for the sins of their fathers. Riding the cycle of regulation following SP's excess, the wheel had come full circle. Where SP officials once lashed out at junior employees who dared to peruse the pages of Frank Norris, regulatory bodies such as the ICC prepared to lash back, turning aside merger entreaties in the name of non-competitiveness. Deregulated trucks ravaged SP's once-thriving perishable business, leaving subsidiaries such as Visalia Electric to wither and die. In time, the rails themselves were put on the block, some falling heir to independent operators while others came out of the good earth. The future was set by 1986, when a weary brakeman grabbed a few moments of rest at Goshen while waiting to occupy the main line with the Terra Bella Local. Nobody said railroading would be easy. Sometimes you wondered why it had to be so hard.

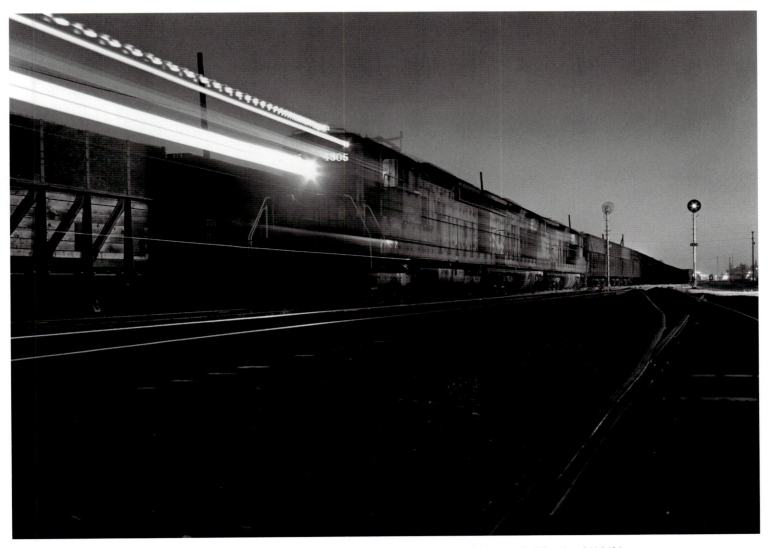

"Southern Pacific" in name only—Extra 4305 West departs Salinas, California. 9/12/91

Five years later, a different darkness crept under the fog blanketing the stars at Salinas, California. To the uninitiated, the SD9's and empty beet racks on the westbound Warm Springs Turn were a timeless personification of the Southern Pacific. Unseen in the shadows was the reality of the Espee in 1991—a 13,000-mile carrier owned by the 2,200-mile Rio Grande since 1988; a railroad with general offices in Denver, Colorado—"Southern Pacific" in name only. The old way had vanished forever with greater change yet to come.

AN ISLAND IN TIME

The high-school band played "Casey Jones," champagne shattered on a new diesel's drawbar, and fresh flowers graced the smokebox of a tired old 2-8-2. It hadn't rained in Jamestown, California, on April 17 for 11 years. The year 1955 broke the string on the day the Sierra Railroad bid "farewell to steam."

Sierra—there was the rub. "Scourge!" Lucius Beebe opined when the news reached the office of his Virginia City, Nevada, *Territorial Enterprise*, announcing that "the blight of diesel" would supplant steam power on Sierra's "picturesque and often photographed" railroad. A poem by Vaun Arnold was tacked to the Jamestown, California, depot door that gloomy Sunday, rhapsodizing the glory of steam and bemoaning how diesel's "streetcar clang and a cowlike cry inspires no heart at coming." Monday morning, April 18, 1955, Sierra Mallet 2-6-6-2 No. 38 worked her final 41 revenue miles back to Jamestown, turning west-bound freight Number 3 over to SRR Baldwin S12's 40 and 42 for the return to the Santa Fe and SP connections in Oakdale The next day, an unknown employee chalked "Steam Engs In Moth Balls" on the Jamestown machine shop wall. For Sierra steam power, it was literally all she wrote.

Or was it? Three years later, an article in *The Modesto Bee* featured the Jamestown roundhouse and Sierra's steam locomotives. Steam locomotives? I'd seen my first Sierra

freight train in October 1958, rambling over the hills at Keystone behind two red and yellow Baldwin diesels. Southern Pacific's last active 4-8-4 made a farewell run through Modesto the same month. Steam was dead—except, it seemed, for the Sierra Railroad.

That fall *High Noon* made its television debut. At age ten, I had no concept of movie trains. I had no idea that the engine and cars in the painfully cerebral film belonged to the Sierra. I didn't know "Hadleyville" was a half-hour drive from my home. All I knew was that the Sierra still had steam engines. On Sunday, November 23, 1958, it was more than enough.

Words can't describe the electricity sizzling through my skinny 10-year-old frame that overcast autumn afternoon as Dad lifted me up to a broken window at the Jamestown roundhouse to behold nothing but steam engines as far as the eye could see. We couldn't enter the holy of holies, but it didn't matter. The Sierra engines were there. By and large, they would always remain.

Forty years have passed since that Sunday and the dawn of my fascination with a railroad whose very name connotes majestic mountains and men to match. In that time, I've explored a carrier more than worthy of Beebe's inclusion as a "happy hunting ground of the ultimately sophisticated connoisseur of short-haul railroading."

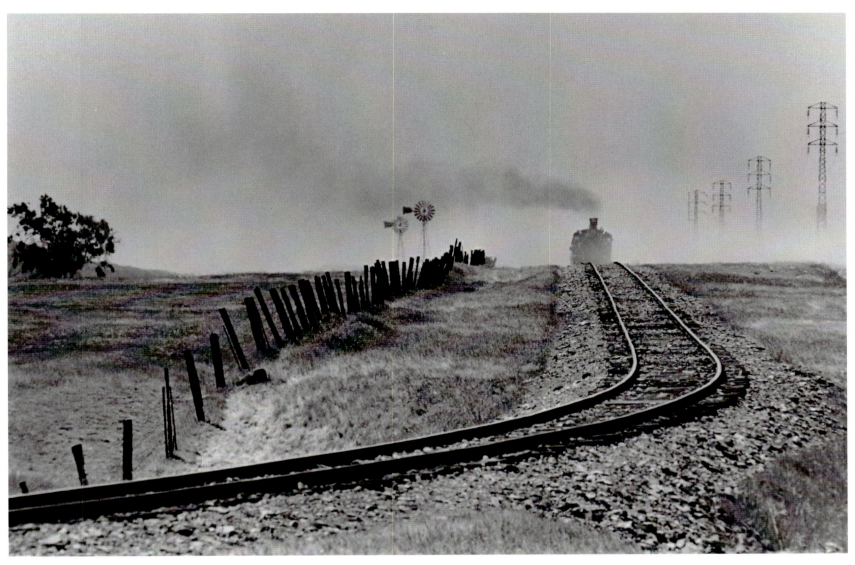

Thirty Four at Fifteen—Sierra Railroad Extra 34 East passes Milepost 15 approaching Warnerville, California. 4/22/72

Jamestown roundhouse—3/16/76

What qualities bring such esteem to a railroad with less than 60 miles of main line? You could start with Sierra's creation at the hands of an Arizona entrepreneur and an engineering genius, who, with the backing of a European nobleman and the Crocker family of California, provided the sole rail outlet for the gold mines of the central Mother Lode. A carrier defined by its public utility, a key player in the development of timber production and hydroelectric power, Sierra was a shortline that never thought small.

How else do you explain a railroad surveying a surfeit of scenery and rare rolling stock in 1919 and concluding it had enough to offer the motion picture industry to turn Tuolumne County into "Hollywood in the hills?" Eighty years later, film production remains a viable source of revenue.

How else do you explain a railroad so comfortable with its past that it became an island in time, welcoming the railfan trade as early as 1937? Sierra's faith in Mother Lode history moved the company in 1971 to turn Jamestown's moribund terminal complex into "Rail Town 1897," placing vintage railroading directly in the public eye. When economic reversals brought the sale of the railroad in 1981, it was the public embrace of Sierra steam that ensured Railtown's survival as part of the state parks system.

Sierra marked 100 years of service in 1997 still "delicately integrated to the region it serves," as Lucius Beebe noted in *Mixed Train Daily*. Following the edicts of "LB," Sierra is a railroad I have frequently ridden, "both head-end and in its coaches or caboose."

As a "truly perceptive reporter," it has been my pleasure to "drink whiskey with its crew members and talk crops." Season after season, we have watched our dreams grow along with our children and smiled in turn at ourselves growing old.

When it comes to motive power, I never discriminate against "docile diesels with a cowlike cry." Vaun Arnold never heard the staccato drum of 2,400 Baldwin horses lifting tonnage through Sonora, their melodic chime horns whistling over Washington Street. The sour sonneteer completely missed the chant of an EMD567C lifting westbound woodchips up Quinn Hill. It's his loss, not mine.

And the Sierra in steam? I never cease to smile when I pass that chalkmark in the roundhouse. It's been there nearly 45 years and the railroad still hasn't succeeded at putting the "Steam Engs In Moth Balls."

God forbid they ever will.

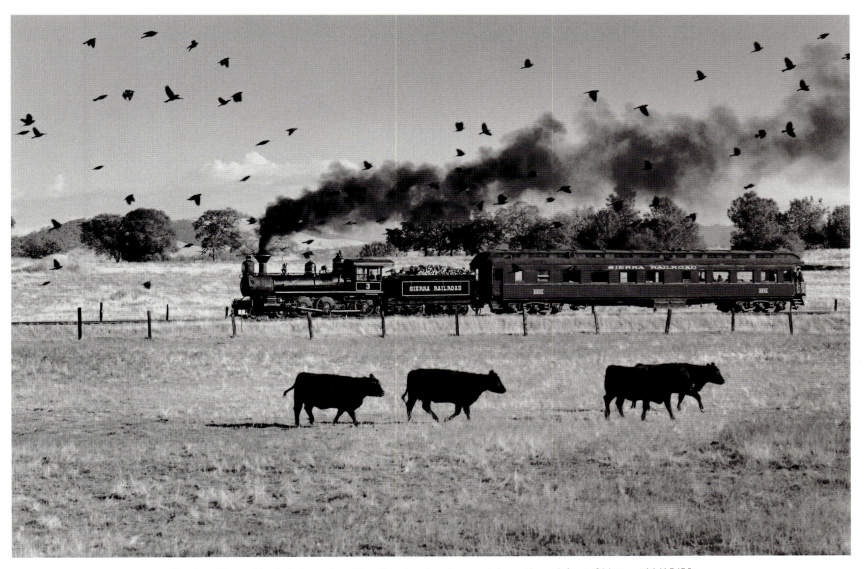

Number Three, blackbirds and cattle—Crocker family special eastbound from Chinese. 11/17/75

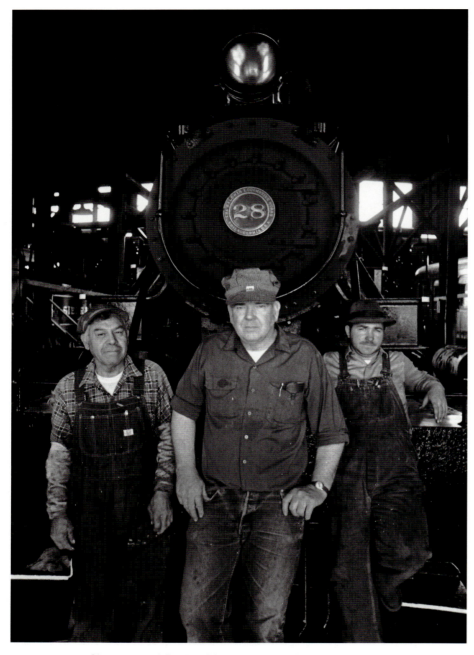

Shopmen and Engine 28—Jamestown, Californa. 4/4/73

Number Three at 100—3/26/91

Step into the Jamestown roundhouse in the 1970s and you'd be hard-pressed to prove that the Sierra had been dieselized since 1955. Motion picture and television producers kept internal expansion power alive while a growing interest in excursion service brought the creation of "Rail Town 1897" and a stunning schedule of regular steam operation.

Pausing for a portrait with freshly painted engine 28, Jamestown's shop crew of Pedro Esparza, Al Wilcox and Alan Lehr filled their days with the time-honored tasks handed down through three generations of machinists and boilermakers. Out on the road, engineer Joe Francis mixed a perfect combination of throttle and valve cutoff on Mikado 34, making the stack talk music to the ears on a summer afternoon east of Oakdale.

Twenty years later, a fourth generation of Jamestown shopmen had a fire in Ten-Wheeler No. 3 anticipating another movie job and incidentally celebrating the 100th birthday of the Paterson, New Jersey, graduate of the Rogers Locomotive & Machine Works on March 26, 1991.

Joe Francis on the plains—Sierra Railroad Extra 34 East near Paulsell, California. 9/5/71

Extra 28 East, arrival at Jamestown—12/12/76

There were ghosts in the darkness enveloping Jamestown as 2-8-0 No. 28 rolled a private charter home from Cooperstown on a December evening in 1976. On the surface, Sierra presented a marvelous array of excursion offerings. Full-service dinner trains, summer barbeque specials, wine and cheese samplers and short-haul "Cannonballs" that ran like weekend commuters gave the railroad a first-class cachet unlike anything offered in the "good old days."

But Sierra's timecard of 250 steam trips a year was a deceptive comfort for those equating volume with prosperity. As passenger mileage reached its zenith, freight revenues began an inexorable decline. The year 1977 marked the last freight profit Sierra would see for 20 years. By 1979, the romance of steam railroading had worn thin. Beset by fuel shortages, inflation and declining tourism, the railroad reluctantly brought excursion operations to an end. Symbolic sunsets reflected reality as the railroad showed its last guests to the door on New Year's Eve.

Yet Sierra steam was nothing if not resilient. Emerging as public property in 1983, Railtown State Historic Park embarked on a second campaign of "keeping yesterday for tomorrow," shorn of the excess of the 1970s while maintaining boiler pressure as a barometer of operating efficiency.

Sierra Railroad steam was dead.

Long live the Sierra Railway!

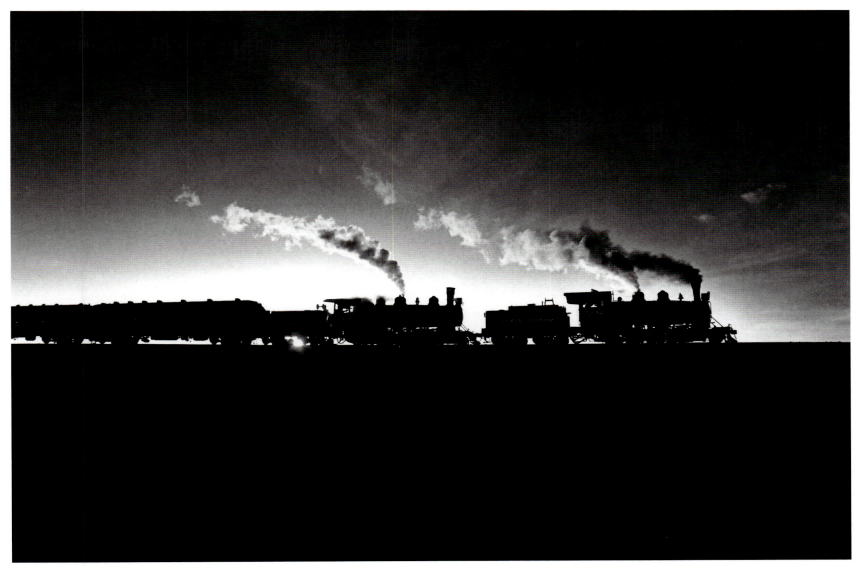

Sundown at Chinese—Engines 28 and 34 double-heading home to Jamestown. 4/24/74

Westbound at Milepost 48—Engine 46 above Sonora, California. 1/18/96

Seven hundred feet up the hill, the rain was turning to snow, blanketing the forests of cedar and pine with a mid-winter frosting of white. A few feet below the 2,300-foot elevation at Standard's millyard, engineer J. J. Gibbs kept a close eye on the brake pipe as Extra 46 West eased three loads of dimensional lumber down the 3 percent from Fassler station on a soggy January afternoon in 1996. A key player in local timber production since its inception, the Sierra had been hauling "the Sierra" for 99 years, its fortunes inextricably linked with the sawmills of Tuolumne County.

The early years of that relationship saw the Sierra connecting the outside world with the standard-gauge woods railroad of Pickering and West Side Lumber Company's last of the 3-foot loggers. The past 30 years had seen steady retrenchment with mill closures and multiple changes in ownership. By 1981 the Sierra was no longer under Crocker control, a situation reflected in the mix of red and yellow/green and white Baldwins descending Quinn Hill west of Chinese. By 1985, the railroad was a pawn in the rate-making game with long-haul truckers, living on wood chips and precious little else.

The Sierra and its two remaining sawmills changed hands again in 1995. Acquiring a GP9 to supplant the weary Baldwin switchers, Sierra applied its original diesel livery to a "new" locomotive built for the Southern Pacific in 1957. Carloading guarantees were negotiated with Sierra Pacific Industries, ensuring that perfumed trainloads of forest products would polish Sierra rails well into the new millenium. "One hundred years young" in 1997, the railroad once again lifted its eyes to the hills, a shortline long on hope, still daring to dream.

Changing of the guard on Quinn Hill—Sierra Baldwins Number 44 and 40 west of Chinese, California. 3/2/81

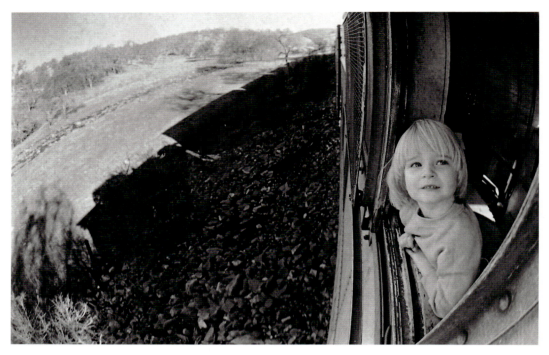

A railroad where you're always at home—Amy Benson at Canyon Tank. 12/14/84

At first there's only the sound of the birds, carried on the chill, gentle breeze wafting up from Quigley Creek—the carpenter's tap of an acorn woodpecker, the cooing of doves and the songs of a dozen others, broken by the occasional cry of a crow or a hawk's high soaring shriek. Quail tracks fill the cow path adjoining a lineside fence while killdeer and finch play tag in the bushes along the creek, serenaded by a bullfrog's croak. At sunrise, the world is so silent you can hear the stream roll over every rock in its path. To watch the first light come to Canyon Tank is to be still and know He is God.

Half an hour later comes the first note of man's intrusion in this heavenly garden. A sweet five-chime horn drifts over the hills from Keystone, announcing the departure of Sierra Railroad Extra 40 West on its return run to Oakdale. Sunrise trains at Canyon Tank are rare, especially westbounds. Knowledge of their impending passage is the sole domain of the railroaders—and those they include in the familial circle.

Inclusion in that circle comes from years of shared miles and memories, creating and preserving the history of a railroad some consider the most-photographed on earth. But membership in this family goes far beyond riding, running and taking pictures of trains. It's a family like any other—full of hopes, dreams, laughter and tears. It's a railroad where a young man's first caboose ride provides the prelude for a young father sharing the same joy with his own children. It's a railroad where, no matter how long you've been away, you always feel at home.

A pungent blue haze accompanies Baldwin No. 40 on the descent to Canyon Tank, easing past Milepost 23 at 5 miles per hour as enginemen Bill Coffer and Ron Peterson watch for conductor Wehman Caldwell's signal to stop and entrain the photographer. Scrambling aboard caboose No. 8, brakeman Jimmy Gibbs can't wait to ask "how did we look?"

The answer is a smile that lingers all the way to Oakdale and a memory lasting long after the brake smoke drifts away on the canyon wind.

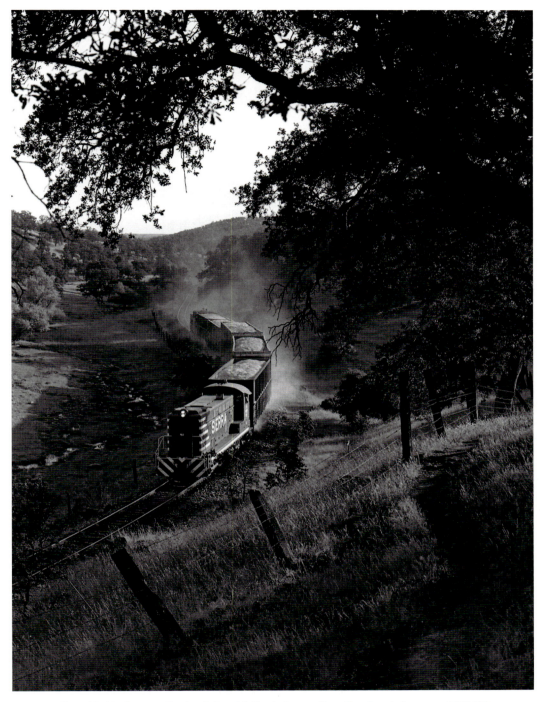

First Light, Canyon Tank—Extra 40 West descending Dry Creek Canyon. 4/29/85

MIDNIGHT AT TUNNEL TWO

Nocturnal elements of headlight and moonlight—9/16/94

Train up a child in the way
he should go,
and when he is old he will not
depart from it.

Proverbs 22: 6

The lights of Bakersfield dip beneath the crest of the road as a Ford Econoline van glides downhill from Sand Cut, passing a quartet of "carbonized" Tunnel Motors in the pocket track at Bena. Nothing unusual in Union Pacific's Tehachapi helper pool tonight—nothing that won't look better snaking through Bealville at sunrise tomorrow. Right now, life is imitating the art of Bruce Springsteen—I've got some beer and the highway's free—and with a full harvest moon rising over the Piute Mountains east of Caliente, the conditions are ripe for a Friday night camp-out at Tunnel Two. With a good ride out of Orange County, Dave Styffe should be close to Mojave. By the time the post-midnight "parade" begins, we'll have good music on the stereo and most of the world's woes firmly under control.

You ask what brings two reasonably rational individuals to midnight meetings in the middle of nowhere? For the uninitiated, the images on pages 86 and 92 are offered as evidence of the attraction of Tunnel Two. Situated astride a horseshoe curve carrying the shared main track of the former Southern Pacific and Santa Fe lines up a 2.1-percent grade from Caliente to Bealville, Tunnel Two is a magnificent stage for railroading. Reduced to the

nocturnal elements of headlight, moonlight and the surround-sound sonics of turbo-charged diesels and squealing steel wheels, Tunnel Two can be overwhelming. For my photographic dollar, no mountain main line surpasses Tehachapi.

But trains are only part of the reason for a weekend at Tunnel Two. As David and I readily attest, photography is often secondary to the camaraderie of railfanning. We're not unique in this regard: many rail enthusiasts enjoy friendships spanning a multiplicity of years. And as the circle of friendship grows, we in turn grow as children of God. With His grace comes the inspiration to rise while the sun's still a promise in the east, ignoring soot-slathered helper units to rejoice in the flash of a trailer train reflecting the first rays of dawn. As photographers, we're moths to His flame. Weekend mornings at Tunnel Two see breakfast being served at noon.

There's no shortage of heroes and friends to recall over coffee at a Tehachapi cafe. Few photographers find themselves trackside without some external influence. I can't remember a time when I haven't been fascinated by railroading, but I can easily point to a summer day in 1962 when I opened *The Age of Steam* in the Modesto public library and turned to page 142. Lucius Beebe's tribute to a time I never knew came to life in "an atmospheric salon study" of an SP helper engine and its crew "in the hot dark of the California night"—the first of countless compelling images I would see from the camera of Richard Steinheimer. At that moment, I knew photography would always be a part of my life. For the past quarter century, as hero, mentor and friend, so has Dick Steinheimer.

On the home front, it has been my inestimable honor to have enjoyed the wise counsel of two pioneers of rail photography and publishing. Guy Dunscomb and the late Al Rose welcomed me into the railfan family at an early age, offering encouragement and constructive criticism while fostering a profound appreciation of California rail history. Infusing me with an uncompromising sense of craftsmanship in every aspect of graphic presentation, Al and Guy have been father figures reflecting my own father's credo of excellence: "any job worth doing is worth doing right."

Furthering the pursuit of a job done right were the contributions of a number of educators and professionals. Wil Sims, Joe Swan and Jerry White charted my early course into journalism while Gordon Ham provided my first paying job in commercial photography. Larry McSwain and Ray Nish opened the doors of *The Modesto Bee* to a fresh-faced intern in the summer of 1969 while Forrest Jackson and Al Golub provided instant indoctrination into the never-routine world of daily photojournalism in June 1970. At first, I thought newspapering would be the point of embarkation to a greater world of publishing. It has been all of that and more. After 29 years, the thrill remains.

Eastbound intermodal traffic behind a mix of BNSF and Santa Fe diesels brings the conversation back to the present as we pull out of the restaurant parking lot to begin the afternoon's exploration.

Abandoning the Barstow-bound containers once they slip through the switches at East Mojave and set sail for Sanborn, we turn south on Highway 14. There's not much to keep us at Mojave anymore.

It wasn't that way in 1972 when I first visited the high desert oasis. Automation had yet to remove the human

element from "Mo-Harvey," where train crews wrapped themselves around chicken-fried steaks at Reno's Coffee Shop and telegraphers were quick to advise of impending arrivals. Railroading was a personable enterprise in those days and Mojave was as personal as it got.

Getting involved in rail photography means getting involved with people. Like most young railfans, my earliest heroes were locomotive engineers. Two now-departed hoggers who provided boundless inspiration and friendship were Ed Tyner and Jim Boynton. The tales of "On-Time" Tyner and his peers were a priceless memoir of the first half of the 20th century in the heart of Southern Pacific's Golden Empire. Introduced through the mutual friendship of Guy Dunscomb, Jim Boynton and I shared many memorable cab miles in his last dozen years of Western Pacific engine service. An irreplacable volume of oral history was lost with his untimely passing in 1992.

Countless other "rails" have made significant contributions to a lifelong love affair with trains. Many of their names and faces are depicted on the preceeding pages. While it's not fair to single out a handful of individuals from the hundreds who have enriched my life, I must admit that given the opportunity to go back in time, I wouldn't hesitate to (a) have another cup of coffee with Fido Pietz at Mendota; (b) spend another night shift with Nick Laba at Niles Tower and (c) listen to Bob Williams recount the history of the Milwaukee electrification in the substation at East Portal, Montana. The best days at trackside were never better than this.

South of Mojave, the radio scanner alerts us to a westbound train at Rosamond. We turn around at Ansel siding, chuckling at the desolation of a station bearing the name of a photographic giant. But this place is pronounced "An-SELL"—at 3 p.m. on a cloudless afternoon, the light is far from eloquent. Ansel Adams wouldn't have bothered. Three hours later at Tunnel Two, we're framing the train in the dramatic last light of day, capturing the moment in living black and white. Ansel would approve.

In keeping with Adams and other practitioners of the medium, my goals in railroad photography have always been simple. Considering my efforts as part of a larger body of work by many artists, I prefer black and white for its tradition, along with its ability to separate the viewer from the pure reality of color. Which is not to say I don't enjoy shooting in color, especially when it's Kodachrome. I just see better in black and white. And it's the sharing of the places I've been and the things I've seen that give *One Track Mind* a reason to exist.

One might inquire about the purpose of this volume. With images spanning four decades and honors for a lifetime of achievement, is it time for a retrospective? Hardly. The thrill of the hunt that spurred my first photo trips with high-school friend Tom Taylor in 1966 is the spirit that drives me today. As Dave Styffe jokes over a late dinner in Tehachapi, we're only young once, but we can be immature forever. As long as we remember the joy of that inner child, railroading will always be a source of unceasing discovery.

Sharing the miles and memories of places like Swede's Hi-Way 40 Motel and the Roper Yard Cafe have been such confidants and co-conspirators as Don Buchholz, Dick Dorn, Bruce MacGregor, Steve Patterson and Dave Stanley. Joining me on less-involved excursions have been

Jamestown, California—12/16/81

fellow travelers Steve Barry, Jim Boyd, Mike Del Vecchio, John Gruber, Charlie Hopkins, David Lustig, Ken Meeker, Vic Neves and John Roskoski. Sharing the memories in print are authors and editors such as David Ingles, Kevin Keefe, Karl Koenig, Greg McDonnell, John Signor, Lee Sherwood and Joe Strapac. Gone, but never forgotten, is the tutelage of David P. Morgan.

And beside me every step of the way, enduring me at my best and loving me at my worst, is my wife, Liz, and our children, Jessica and Amy. Deflecting the disappointments and celebrating success, they've been the light at the end of every dark highway, guiding a lonesome traveler home.

Ted Benson, July 20, 1999

Sunset on the Santa Fe. Needles, California. 9/10/73

And never have I found the limits of the photographic potential.
Every horizon, upon being reached, reveals another beckoning
in the distance. Always, I am on the threshold...

W. Eugene Smith